Edward Hicks

PAINTER OF THE PEACEABLE KINGDOM

Pennsylvania Paperbacks

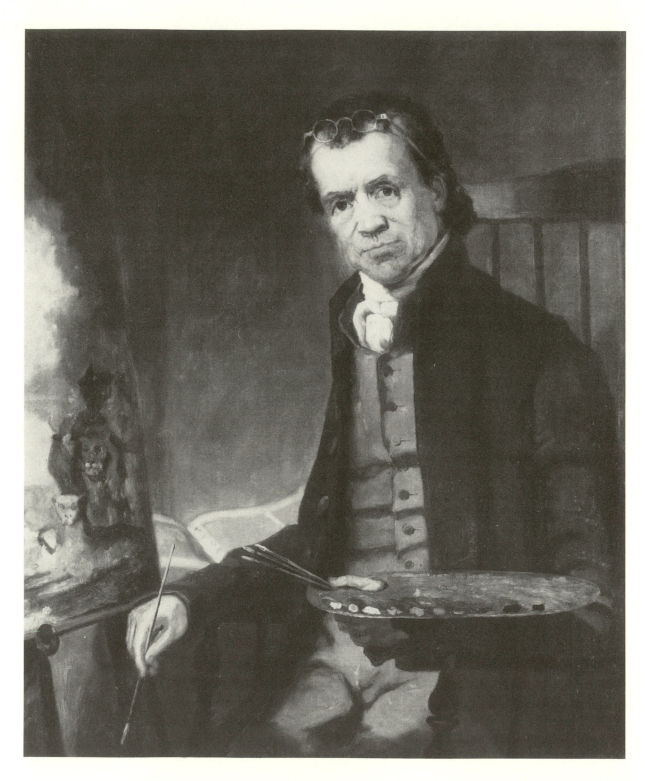

EDWARD HICKS

Edward Hicks

PAINTER OF THE PEACEABLE KINGDOM

———

Alice Ford

FOREWORD BY
CAROLYN WEEKLEY

University of Pennsylvania Press

PHILADELPHIA

10 9 8 7 6 5 4 3 2 1

Published by
University of Pennsylvania Press
Philadelphia, Pennsylvania 19104-4011

Library of Congress Cataloging-in-Publication Data
Ford, Alice, 1906–
 Edward Hicks, painter of the Peaceable kingdom / Alice
Ford ; foreword by Carolyn Weekley. — 1st pbk. ed.
 p. cm. — (Pennsylvania paperbacks)
 Reprint of the 1952 ed. with revised captions on the
illustrations and a foreword added.
 Includes bibliographical references and index.
 ISBN 0-8122-1675-X (pbk.)
 1. Hicks, Edward, 1780–1849. 2. Painters—United
States—Biography. I. Title. II. Title: Edward Hicks
III. Series.
ND237.H58F6 1998
759.13—dc21
[B] 98-34969
 CIP

Frontispiece. *Edward Hicks.* By Thomas Hicks. Courtesy
Abby Aldrich Rockefeller Folk Art Center, Williamsburg,
Virginia

TO THE MEMORY OF

SARAH WORSTALL HICKS (1858-1946)

granddaughter of the painter, daughter of his son Isaac. Her lifelong solicitude for the Hicks family letters and papers helped make this biography possible.

Contents

Illustrations

Foreword

This volume, unlike many other early American art historical studies published from the 1930s through the 1950s, continues to be a vital source for those interested in the artist's life and work. Alice Ford, a tenacious researcher and scholar, was responsible for unraveling much of what is known today about the extraordinary life of Edward Hicks, the Pennsylvania Quaker artist, minister, and ornamental painter. She delved into the large, often unwieldy body of primary materials, including a significant number of family letters and memorabilia, Bucks County records, and the extensive archival materials pertaining to the eighteenth- and nineteenth-century Society of Friends in America.

Ford had the advantage of time. A number of Hicks's direct descendants were still alive in the 1950s. Robert W. Carle, who contributed to the publication of Ford's book, was the artist's great-grandson. Like other members of the family, Carle maintained a strong interest in his ancestor, knew the ownership histories of a number of key paintings, and was acquainted with custodians of family papers and objects that Hicks originally owned. Many of them are now scattered and difficult to locate; others have found their way into museums and related repositories. Ford was fortunate in learning about the artist's life in this context, which was much closer to Hicks's own time and place.

The quantity of artwork Ford identified is impressive in its variety but small by comparison with the body of paintings now assigned to the artist, as is common in formative studies. Ford's volume covers well the chronological evolution of Hicks's easel art and ably provides examples of the range of subjects he offered to friends and patrons. Of greatest value are the documented histories of many of the paintings that Ford discovered. She firmly identified the style and tone of Hicks's easel art, which thus became the basis for later attributions to him. Several of the rare surviving letters from family and friends who received paintings from Hicks, such as the one from S. P. Lee of Virginia, quoted on page 91, are important commentaries on patrons' impressions of Hicks's *Peaceable Kingdom* and other paintings. Rarely have such documents survived, particularly for artists whose training was based in the trades and craft practice.

It should be noted, however, that the text occasionally weaves documented events and facts together with lively, although imaginary everyday events. The first sentence of the text is typical of Ford's colorful prose. In 1783, a young woman "called her carriage to a halt before a hitching post in Newtown." The person, place, and year can be documented; the rest is speculative at best. Nevertheless, the work's shortcomings are modest by comparison with its lasting value.

Ford's extensive quotations from a large number of historical materials give us a clear sense of Hicks's yearnings, difficulties, and occasionally joyous moments. As the story unfolds, the reader soon realizes that Hicks was not, as some have thought, a quaint, unassuming tradesman who worked quietly in a rural setting. A complex man, he was challenged by changes within the Society and often plagued by debt. Ford's prose makes the story of Edward Hicks's life more immediate and memorable. *Edward Hicks: Painter of the Peaceable Kingdom,* first published in 1952, was a remarkable achievement then and remains so today.

Carolyn Weekley

Acknowledgments

MY debt of gratitude to certain of the descendants of Edward Hicks is a very special one, and it gives me genuine pleasure to acknowledge it. To Robert W. Carle, grandson of the painter's daughter Susan, I first turned for approval of my undertaking. Not only was the latter granted, but my plans were recommended by Mr. Carle to his cousins in Newtown and others. After following the book's progress with the most encouraging and sympathetic interest, Mr. Carle contributed to the University of Pennsylvania Press a sum sufficient to provide two of the color plates and half of the black-and-white engravings. This he did in the belief that his contribution would facilitate a suitably well-rounded illustrative presentation of his great-grandfather's work. Mr. Edward Hicks Carle, his brother, generously contributed the cost of the third color reproduction.

Like Mr. Robert W. Carle, Miss Cornelia Carle Hicks, her sister Mrs. J. Stanley Lee, and Mr. Lee, allowed unconditional study of their fine collection of Hicks paintings. As custodians and owners of the remarkable collection of family letters and papers formerly the property of their aunt, the late Sarah Worstall Hicks of Newtown, they were in a position to serve the interests of this biography to the utmost. This they did most patiently and graciously, also turning over the library of Edward Hicks for my research.

Mr. Edward R. Barnsley of Newtown, cousin of the descendants, and the leading archivist of Bucks County, loaned letters, artisan advertise-

ments, news clippings, and other such valuable research items. He introduced the writer to exceptionally enlightening unpublished documents in the court house at Doylestown. Mr. Barnsley turned over to the writer the extremely rare heretofore unpublished shop ledger and papers of the painter and of the painter's father, Squire Isaac Hicks, presented by Mr. and Mrs. Lee to the Bucks County Historical Society during his long term as president. His unique fireboard is illustrated.

With the consent of the owners of the originals, the Frick Art Reference Library, New York City, provided photographs for the following illustrations: frontispiece; plates 1, 3, 9, 11, 17, 27, 31, 36.

For their much-valued coöperation, I wish to express sincere thanks to the following individuals and institutions:

Albright Art Gallery, Buffalo, N. Y.
Alexandria Public Library, Alexandria, Va.
 Miss Ellen C. Burke, Librarian
American Bible Society, New York City
 Miss Margaret Hill, Librarian
 Miss Katherine Davidson, Assistant
Arch Street Meeting (Orthodox), Philadelphia, Pa.
Mr. Alan Brady
Mrs. Jane Taylor Brey
Bucks County Historical Society, Doylestown, Pa.
 Dr. Arthur Edwin Bye, President
 Mr. Horace Mann, Curator
 Mr. James Bleyden, Cataloguer
Miss Sonja Bullaty
Miss Elizabeth Burchenal
Mr. Henry Cadbury

ACKNOWLEDGMENTS

Mr. and Mrs. Holger Cahill
Mr. Robert Carlen
Century Club, New York City
Mr. Stephen C. Clark
Colonial Williamsburg, Williamsburg, Va.
Downtown Gallery, New York City
Mrs. Peter Edson
Mrs. Laurence G. Fawcett
Miss Frances Canby Ferris
Miss Elizabeth Fitton
Mr. Bliss Forbush
Friends Historical Library, Swarthmore College, Swarthmore, Pa.
 Miss Dorothy G. Harris, Acting Librarian
Friends Home, Newtown, Pa.
Colonel and Mrs. Edgar W. Garbisch
Mr. Martin Grossman
Halladay-Thomas Inc., Sheffield, Mass.
Miss Agnes Halsey
Haverford College Library, Haverford, Pa.
Historical Society of Pennsylvania, Philadelphia, Pa.
Professor and Mrs. Rudolf Kirk
M. Knoedler & Company, New York City
Library of Congress, Washington, D. C.
 Prints and Photographs Division

Miss Alice Lee Parker, Acting Chief
 Mr. Milton Kaplan
Mrs. Nina Fletcher Little
Metropolitan Museum of Art, New York City
New York Public Library, New York City:
 American History Room; Art & Architecture Room; Print Room; Rare Book Room
New York State Historical Association, Cooperstown, N. Y.
 Miss Janet R. MacFarlane, Curator
Newtown Public Library, Newtown, Pa.
Philadelphia Museum of Art, Philadelphia, Pa.
 Mr. Henri Marceau, Vice-Director and Curator of Paintings
Mr. Charles Rosenbloom
Miss Elizabeth Roth
St. Etienne Gallery, New York City
Mrs. Victor Spark
Miss Sarah Field Splint
Temperance House, Newtown, Pa.
Miss Caroline Tomlinson
Mr. Massey Trotter
Mr. Charles C. Willis
Worcester Art Museum, Worcester, Mass.

The captions reflect changes in ownership of the works since 1952; however, present ownership could not be confirmed in every case. Also, reproduction-quality images of plates 8 and 27 were not available, and similar works have been substituted. The list of illustrations has not been updated.

Fourth of the Fourth Month

ON a winter's day in 1783 Elizabeth Twining called her carriage to a halt before a hitching post in Newtown. Her marketing accomplished at the county seat of Bucks in Pennsylvania, she was about to call on her Quaker friends the Janneys. She stepped forth, walked up to the knocker and dropped it resoundingly, and in a moment a Negro wench stood in the doorway. Elizabeth was bewildered by the unexpected sight of a sickly, poorly clad white child clinging to the servant's skirts and peevishly crying. She asked who the boy might be. Mrs. Janney appeared and spoke to the question, and the answer left Elizabeth wordless with amazement.

The three-year-old, Edward, was the son of Elizabeth's late dear friend Catherine, wife of Isaac Hicks, a prominent young Crown official. The turn of events in the Revolution had cast him not only from grace but into ruin. The Negro wench Jane, a Hicks family slave, had been obliged to seek refuge with her people, and she had mercifully taken the lad along with her. To make ends meet she was working by the day among the neighbors.

Elizabeth Twining, mentally rebuking herself, remarked that she had seen "Kitty" scarcely a year before with the infant in her arms, both of them decked out in handsome, even rich apparel. The recollection seemed impossible in the light of the privation she now saw before her. She had heard of her friend's death in Burlington, New Jersey, but it had come at the moment of Cornwallis' surrender, in days of unparalleled tumult. She supposed the three youngsters were with their father. Seeing the abject truth of the situation before her, she ceased to wonder that the slave spoke sharply to the child. How Elizabeth wished that she might take him home with her to the farm, that very day! Turning suddenly to Mrs. Janney she exclaimed, "If only my husband would allow it, I'd take this child and bring him up as my own!"

Isaac Hicks, hearing of all this, and still hard put to it to solve his heavy problems, decided to approach Elizabeth and plead that she take his youngest son beneath her wing. He reminded her that no more respectable home or worthier guardian could be imagined. Of course he would gladly pay a fair sum for the boy's board and lodging. But such a decision did not, alas, rest with the great-hearted woman. There was her redoubtable husband David to convince. The sixty-three-year-old lord of a thousand cultivated acres, member of the Provincial Assembly and town library founder, was an entirely unsentimental and practical personage. Of his industri-

1

ous wife, forty-three, a full generation younger, and of his four daughters—all grown but one—he expected and received a kind of servile respect toward his sternly governing position. Only Isaac's attractive offer of twelve pounds per annum decided David in favor of harboring the child.

Late in May 1783, Isaac drove up the Twining road into the farmyard with little Ned. He handed him over to the kindly Elizabeth after first having paid David a year's keep, though this was not quite as Elizabeth wished it. Might she for once have had her way she would have adopted the boy and reared him as the true son which Providence had denied her.

The farm, a vast rolling acreage, lay between Newtown and Four Lanes End,[1] no more than a mile or two from either. With the youngest of her daughters now fifteen, Elizabeth welcomed the role of "adopted mother" to a child scarcely out of babyhood. Yet her abiding and sincere devotion to him was never to efface his sense of loss of that real mother whom he could not remember but whose influence left an enduring mark beside Elizabeth's. On his infrequent reunions with his father, brother, and sister in the years just ahead of him he was to drink in their reminiscences about his mother with consuming interest. Speaking of Catherine Hicks toward the close of life in his *Memoirs*, he declared her, with mixed love and overly exacting standards, the very "reverse of a perfect woman," and one reared in "pride and idleness." Elizabeth, a dedicated Quaker, seemed to him like the woman in Proverbs. Proudly she would intone this passage which, for Edward, precisely described her: "Who can find a virtuous woman? . . . She worketh willingly with her hands . . . rises also while it is yet night . . . planteth a vineyard. . . . Her hands hold the distaff. . . . Strength and honor are her clothing . . . in her tongue is the law of kindness. . . . She looketh well to the ways of her household,

[1] Also called Attleborough; today known as Langhorne.

and eateth not the bread of idleness." Not until she was a grown woman had Elizabeth learned to read, but, when she had done so at last, she lavished all her belated aptitude on the Scriptures.

David Twining, pacifist, anti-Revolutionary, had belonged to the "Non-Associaters" of Newtown who had refused to take arms against the King. But his religious scruples protected his prestige from damage or suspicion, and he had not actively sought to thwart the Continental cause in the manner of the Tories. For nearly three weeks he had played host to the so-called "Lord Stirling," an American who fought gallantly with Washington at Trenton. As for his guardianship of Edward Hicks, at no time did he entertain any thoughts of his legal adoption, nor is there the slightest suggestion that he ever took the orphan to his heart. Small wonder it is that Edward, painting the "Twining Farm" and family long years later "from memory"—not that memory was needed, because the farm stood throughout his lifetime as it stands today, remarkably unchanged—showed his adopted mother as very old at fifty. Being wife to such a lord and master could not but have borne heavily upon her.

Leaving Edward, newly arrived at the Twinings, it is enlightening to leaf back the calendar to the pre-Revolutionary era of the Hickses in Pennsylvania, Long Island, Massachusetts, and England. Otherwise no real conception of the painter's fortunes can possibly be gained. The panorama, increasingly tragic as Edward's birth date is approached, traces not only family fortunes but American colonial history toward the republic's impartial crucible of social change.

Isaac Hicks, the painter's father, had been so beset by an ineluctable chain of failure for which he himself was blameless that he had been forced to part with his children one by one, "as the ostrich leaveth her eggs," to quote Edward's *Memoirs*. Through letters of descendants we come upon Isaac in 1772, at the time

of his marriage—one contracted without consent —to Catherine Hicks, his first cousin, an indiscretion which his father and her guardian brother looked upon with bitter disfavor. Perhaps they objected to marriage between cousins, or possibly to Isaac's being not only three years younger than twenty-seven-year-old Catherine but without a home for her or means to support a family. With his father, Gilbert Hicks, a Chief Justice for Bucks and a leading Crown official, and William Hicks, his brother-in-law, holder of four Crown commissions including that of Prothonotary, it seems as if forgiveness should have been easy. Then William fell gravely ill and, having recently lost his wife, went with his five small children to near-by Burlington to be nursed by Mary Searle, an elderly cousin who had brought him up. Although he allowed Isaac and Catherine the shelter of his Newtown house, it was not long before Catherine was on her way to see him, braving the ill-will he bore her and her bridegroom. Her letters to Isaac during this death vigil—and they survive to this day— are touching in the extreme.[2] His will, which had spoken in her favor, he now revoked with a sharp and bitter codicil against her sharing— not that he had much to leave to his sister save his late wife's jewels and fine furs and clothing.[3] William Hicks had been rich in civil connections only. Richard Penn, grandson of Pennsylvania's illustrious founder, had given him all four of his Crown commissions.

That Gilbert Hicks should have objected to his son's marriage to the daughter of his brother Edward is ironical in the light of his own matrimonial beginnings. On April 24, 1746, he and Mary Rodman Hicks of Long Island had dared wed against the wishes of her Quaker father, who objected to her marrying outside her faith, which then meant "disownment" or excommunication. Rodman had relented in time, and had sent them to his six-hundred-acre wilderness

tract in Bensalem township, twenty miles from Philadelphia, thriftily demanding their bond of three hundred pounds before he would grant them title. On April 21, 1748, Isaac was born to them in a log cabin of settlers on their tract, to which they had traveled by wagon. Gilbert, having loftier ambitions than farming, soon sold enough of the land at the ever-rising prices to pay Rodman back and have a goodly sum left over. In the nearest village, Four Lanes End, he bought farm land, built a mansion, established a tannery, and before long was traveling back and forth to Newtown in a fine coach as an officer of the courts.

Four Lanes End was a community of Quakers, but Gilbert's wife, though she clung to her "thee" and "thou," was never received by the local meeting. Nevertheless the couple stood out as town leaders. Their village received its name from having arisen where two old Indian trails crossed near the Neshaminy stream, on land within Penn's 1682 charter. Gilbert took naturally to officialdom, being the son of the leading Long Island justice of his day, who was also a colonel and for whom his son was named. That was by no means all. Gilbert Hicks's grandfather, Thomas, was not only the key progenitor whose two marriages gave the family tree such bright leaves as Elias Hicks the noted Quaker, Thomas Hicks the painter of the Lincoln portrait of the Springfield, Illinois, period and Edward Hicks of the "Peaceable Kingdom." He was also the first justice of Hempstead's courts and the son of an Oxford graduate who, with a brother, had come down from the Massachusetts colony on the advice of his father, a London tanner who had emigrated to the New World. Away, henceforth, with the legend of Edward Hicks's homespun background!

A month after Catherine's brother died—in May 1772—her twenty-four-year-old stripling groom Isaac was sworn in as the new Prothonotary, taking over all four of the late William's commissions. He was to pay from his earnings

two hundred pounds a year toward the support of the five orphans. Richard Penn, who thought this an admirable solution, had put that heavy price on Isaac's appointment.[4] Mary Searle and others, rather than Catherine and Isaac, were to board the children, a fortunate circumstance for the young couple. The following spring they had their first offspring, a son whom they named Gilbert after Isaac's brilliant parent Judge Hicks, who apparently had not only forgiven them but was proud of Isaac's sudden local prominence.

Isaac worked industriously to earn the respect of the community in Court Row. Unrest, however, was increasing in Bucks County and elsewhere in the Colonies under British rule. Crown officials were no longer looked up to so much, once the unrest began. Gilbert Hicks also sensed it, weighing its dangers. The trend troubled Catherine, at home with a young baby; but probably it struck her feminine reasoning as more of an annoyance than a cloud of dark portent. Fate was not supposed to turn its windmill on well-established patterns, or to upset conditions of life earned by generations of faithfulness to the King. She tried to dismiss her uneasiness, hoping that Fate would relent in its capricious course. She could not, fortunately, foresee the family picture lying in tatters, shattered by revolution; or look beyond to the days when the fragments would drift together, after a fashion—at least for Isaac. Striking division of sentiment made prospects for all uncertain. The sweet air along the Neshaminy began to be charged with recrimination. Quarrels and arguments were fairly frequent in the taverns. But, in the midst of local political intrigue, few people took the tension over-seriously. Often the quarrels were intermingled with differences of opinion on the lottery or local "coursings," which were nothing new.

4 Hist. Soc. of Pa. Logan Papers, V. 40: Estate of Wm. Hicks.

Lately, however, hard feelings and suspicion were on the increase.

In Gilbert Hicks's failure to discern the real mood of Bucks County, and indeed all the King's realm, lay his undoing. Resentment against Crown abuses grew: against "taxation without representation"; forced support of Royal troops and officials in their accustomed style; heavy taxation and limitation of imports to England; curbs on free trade with Europe.

On July 9, 1774, the Bucks County Committee called an important meeting, with Gilbert as chairman, to protest British policy and demand redress. It favored a General Congress of the Colonial Assemblies for discussion, and praised the work of the Continental Congress. It pitied the unfortunate people of Boston in their hour of suffering. Gilbert evidently believed these proceedings to be a kind of safety valve against such local demonstrations as the more violent "Tea Party" in Massachusetts. Lacking the zeal of an Otis or a Revere, Gilbert regarded such "pacific measures" as sufficient warning to the Crown. How misguided was his analysis he would soon discover to his sorrow.

That first public protest was mild enough, but other harsher ones sounded in Newtown in the spring of 1775, when a group of citizens met to approve the recent Provincial Convention's "resolves." A tar barrel was kept handy; objectors were invited to inhale its contents. The language of this meeting's resolutions, accusing Britain of indifference and of plans to use force, could not possibly have been Gilbert's. Now the citizens of the county were being urged to "improve themselves in the military art" in case of need. The dilemma of the Hickses, whose family position had rested on privilege for six American generations, was growing. Gilbert had much to lose by defying England. Though he must have seen the bloody writing on the wall the month before, with the news of Lexington and Concord, its powerful meaning somehow failed to move him. When fifty-one volunteers

formed a local company in answer to the call to arms, neither Gilbert's nor Isaac's name was listed. Nor did they join the "Non-Associaters," mostly Quaker pacifists but also British sympathizers. Among the latter group appeared names familiar in Edward Hicks's story: David Twining, who was to take Edward into his house; William Tomlinson, in whose shop Edward would work as an apprentice; James Boyd, minister and teacher, who would help rear Edward's older brother; and a Buckman, of whom a rejected suitor for Edward's daughter Susan's hand would be an unhappy descendant. Barely ten months after Newtown's militia was formed, America declared her Independence. But the Fourth of July 1776 only brought Gilbert nearer his worst miscalculation as to the people's temper, and nearer to a chain of misfortune beginning with the death of his wife Mary, who had come with him as a bride from Long Island.

In October, against all reasonable judgment, he elected to tell the people from the steps of the county courthouse not to take arms. Reading aloud to them the British General Howe's proclamation, calling for non-resistance, he suddenly sensed in the mood of the crowd his own madness. Aware of danger, he withdrew to his coach and hurried to Four Lanes End, where at once he had his Negro slave Ishmael don a suit of his clothing and ride to the hill to watch for approaching horsemen. When the riders were sighted by the slave he was to let himself be seen and then decoy them down the road, while Gilbert packed a few belongings and made for the woods. The expected happened; the ruse worked. That night Gilbert hid in the home of Moses Moon, Tory farmer, lingering in the neighborhood for about three weeks without detection. Within a month all trace of him was lost, and for four years his own family received no message.

Isaac, a month before Gilbert's folly, had decided to resign all four of his commissions

and, as the citizens plainly wished, make way for someone not in the King's graces. This cut off his only source of income and threw the orphans of William Hicks on the mercy of the new Assembly. Though Gilbert's action must have wrecked his remaining prestige, he chose to remain in Bucks County, having no inclination to turn fugitive and flee the Revolution. His accounts for those closing years of the 1770's indicate, without any suggestion of actual intemperance, the increasing use of spirits. They show also a lively interest in Newtown's lottery; but, as the Presbyterian Church was built in 1769 with funds raised through such tickets, the system was not then considered vicious.

On December 8, 1776, Newtown had its first glimpse of the enemy-in-arms when a party of English soldiers appeared for an exchange of prisoners. On Christmas Day General Wilkinson came from Philadelphia. Washington's secretary had already arrived; and next day, after the victorious Battle of Trenton, Washington himself appeared, and was escorted to the comfortable home of the Widow Harris, where he wrote two reports to Congress. Not since Penn had ridden through those woods and said to his companions, "This is the place proposed for my new town," had Newtown witnessed a more historic moment. Colonels Alexander Hamilton and Aaron Burr were attached to the General's suite, with no thought of their coming duel and Hamilton's death. Most of the Continental Army was encamped two miles outside the village, with but one regiment in Newtown, where flying colors and rattling sabers excited the populace. On the two days after Christmas a thousand Hessian mercenaries were billeted in the Presbyterian Church and the county jail. Twenty-three Hessian officers were assigned to taverns and private homes; four dined with Washington, the remaining nineteen at the Red Lion Inn as guests of the American officer who called himself Lord Stirling. Grim fighting lay ahead in New Jersey for the Continentals, who

raised glasses and made mellow toasts and speeches in the brief holiday respite. For the Hessians, soon to leave for Philadelphia, the war was over, and they knew by this time that the tales that the enemy would butcher and devour them if they were captured had been nonsense.

Washington rejoined his troops on the out-skirts of Newtown on December 30, and to-gether they marched to meet Cornwallis' approaching force of eight thousand men. The British leader said he would "run down the old fox and bag him in the morning," but on January 3 Washington attacked his rear guard at Princeton and sent the Redcoats packing.

So much a part of Newtown's proud history did Washington's visit become that when a popular engraving of Thomas Sully's noble oil, "Washington Crossing the Delaware," fell into the hands of Edward Hicks he copied it with his customary variations, at least half a century after the scene of heroism took place near Trenton. (The Sully oil was finished in 1819.)

The memoirs of Brigadier General John Lacey, Bucks County's fighting Quaker, reveal a wave of anti-Revolutionary sentiment in New-town and the county after Washington's departure. He noticed "a sullen, vindictive and malignant spirit," saying that "hostility to the Revolution was too apparent not to be noticed . . . only waiting a good opportunity to break forth in favor of England." The Tories were "poltroons and cowards" who "sneakingly continued to act under cover, giving secret information . . . ridiculing the American officers and using every means to discourage the Whigs and dissuade them from joining the American army or militia."[5] Nevertheless enlistments continued.

Catherine Hicks received a severe fright on February 22, 1777, when an official sent by the Philadelphia Council of Safety appeared on her doorstep. He demanded that all the Deed Books, Orphans Court Books, Will Books, and Court Records in her husband Isaac's possession —and also all such records belonging to her dead brother William—be surrendered. She herself could scarcely have wished an American victory, with a brother fighting for the British and a husband and father-in-law now public outcasts. But worse indignities lay ahead. The following month the Lancaster Assembly in vain called Gilbert to justice, along with twelve other traitors.[6] On March 3 Isaac was notified that he would have to be ready to appear before the Philadelphia Executive Council whenever they might choose to question him. Meanwhile he was bound to the state of Pennsylvania "in the sum of two thousand pounds," with the warning "not to do anything by word or actions against the United States of America."[7] Proof of his importance lies in the fact that others on the list with Isaac were under bond for but five hundred pounds. The broken young man had no thought of trying to flee from justice.

On May 18 the Newtown militia prepared to march. Word had come that the British, with two divisions already at the head of Chesapeake Bay, might strike in the Brandywine region by July. Folk were told to drive off their livestock or else have them seized by the Continentals in an attempt to cut off supplies to the enemy.

A month later, in June 1777, Gilbert Hicks —and where he was, no one knew—drew up his last will and testament, to be safe-handed to Isaac. It is still among the family possessions. Gilbert is believed to have been hiding in Philadelphia. The reading of Howe's proclamation had been his only treasonable offense. The document, with handsome royal seal and red ribbons on heavy rag paper, signed in a visibly trembling hand, conjures a picture of swift disruption. "In the name of God Amen," it begins, "I,

5 Buck.

6 Westcott. *History of Philadelphia.*
7 Hist. Soc. of Pa. *Provincial Delegates,* V. 5, p. 45: Recognizance of Isaac Hicks.

Gilbert Hicks . . . calling to mind the uncertainty of life, do make this my last Will and Testament." To his daughter Elizabeth went a hundred pounds and "the Negro wench Jude," with the reminder that this daughter was lucky to have had rent free from him so long. To his daughter Sarah went "my best Bed, Bedsteads, and all the furniture belonging to it, all my Plate, a Settee, a mahogany dining table, Six best black walnut Chairs, two large enamelled China Bowls, and my best large Looking Glass and all my Pewter." (Much of Sarah's inheritance is in Newtown to this day, in a descendant's house.) To Isaac he left his "Library of Books, Book Case and Scritoire," and "the Negro wench Jane," later to figure, as we have seen, in the rescue of little Edward Hicks by Mrs. Twining. To Isaac's three-year-old son Gilbert went the Negro boy Charles. A grandson, Thomas Kirkbride, came off with the prize: two hundred pounds, "to be put at interest" till his majority. To his son Joseph went all the other "furnishings" and "the Negro man Primus," and the grandfather clock which still strikes the hours in Newtown. The Negro slave Ishmael, inherited by none (already introduced, as a decoy, in the story of Gilbert's escape) was set free in the Tory's will. But Gilbert added the severe proviso that Ishmael "pay out of his Industry the sum of five pounds yearly," until he had paid the estate thirty pounds. Hagar—possibly Ishmael's wife—was also set free from slavery, and the legatees were to give security to keep her from going back to slavery in desperation. Isaac Hicks, as the will indicates, fared none too well in the division. Probably his father had confidence in his future; if so, this hints obliquely at Isaac's possibly non-Tory sentiments. Several of the books willed to him are still in the Library Company collection of the village, a library begun in 1760, the third oldest in the Commonwealth. Isaac, in 1824, was to give the library land on which to erect its first

building, and receive the only life membership ever granted.

Isaac, Catherine, and their infant had moved into Gilbert's Four Lanes End mansion for a short time after his disappearance, in order to avoid the tensions of Newtown; then it was confiscated as enemy property. The couple lived somewhere near, for some months after that, though the exact spot is uncertain. In the big house to which they would return and where Edward Hicks was to be born, the New Jersey Legislature had met before the Battle of Trenton "to consider the state of the county."[8] After the battle two hundred Hessians were billeted in Four Lanes End, Gilbert's house being used as a hospital. Several Hessians were buried in the rear lots.

What happier days had the fieldstone mansion seen, before it was brought to such dejection! Built in 1763, it stood at the village crossroads, diagonally across from the Richardsons' mansion, which was built in 1739, and was nothing short of lordly for that era. In 1731 the Quakers had replaced their already historic log meetinghouse with one of stone which was borne by wagon down the Durham Road. Thus Gilbert's house, still standing but now disfigured by a store front, is an architectural monument of more than two centuries. In it he and Mary Rodman and their four children, waited upon by slaves, lived in affluence and comfort.

By the autumn of 1777, Four Lanes End and its Quakerly love of the tranquil were being shaken to the roots by war's upheaval. On September 11, Marquis de Lafayette was wounded in the calf by cannon shot in the Battle of Brandywine, but tried to rally his American men and lead them back from a near rout into the fighting. It was his first day of service to the cause. That evening a Continental soldier galloped into the village and told the people of Four Lanes End to clear their homes and withdraw into corners to make room for the

[8] New Jersey Archives.

7

wounded. In a few hours the troops marched in, Lafayette among them. He had come by boat to Bristol and up the Durham Road, and turned in at the Richardson house for shelter. There, perching on the edge of a fine drop-leaf while his leg wound was dressed, his weight split the table and in that instant a precious heirloom was created. Across the way in Gilbert's house, to which Isaac and Catherine had moved back in desperation, the dying and the wounded were being nursed. Catherine, expecting another child by spring, can be pictured as trying to withdraw from the confusion. A Richardson family manuscript relates that in their own house across the street the soldiers "stacked their guns around the clock, put their camp chests in front of the guns, got hay from the barn and slept on the floor."[9] One slept in the big oven. The family cook, an old Negress, slept in the kitchen sink-closet.

Lafayette moved on next day, passing through Newtown as he headed for Bethlehem, where he would be nursed by French missionary nuns. But many Brandywine survivors remained in Four Lanes End throughout the winter, some never leaving their beds. The trees were felled one by one for firewood to heat the meetinghouse and Gilbert's home, both of which were being used as hospitals. On snowy mornings a small sled would draw up before the Hicks mansion while coffins were loaded upon it, then it would bear its burden of three or four boxes made by the village carpenter to the plot of one Mercy Stackhouse's land, where a single shallow grave received them. In the spring thaws, about the time of Catherine's confinement, the dogs scratched the dirt from the graves till the rude coffins eerily protruded. Neighbors joined in the doleful task of hauling earth to make respectable mounds above the resting place of 160 Hessians and Continentals.

Gilbert's house, hostel of death in the winter of 1778, was the scene of a birth that spring,

when on March 17 Eliza Violetta Hicks was born to Isaac and Catherine. With the babe in her arms, Catherine may well have been trying to forget the terrors and discomfort of that terrible winter. Only three weeks earlier a British Light Horse Troop had raided Jenks mill a few miles down the road, made off with clothing and supplies, and captured Newtown's Major Murray, to the distress of his wife and six children. Washington, hearing of this, wrote a letter deploring the outrage which had disturbed "respectable inhabitants" and cost his threadbare men two thousand yards of desperately needed cloth. Newtown also had a scare. The Bird in Hand tavern, being used as a clothing depot, was surprised about the same time by two Tories. They dashed up on horseback and frightened off the guard, who left behind a wounded soldier who had straggled into the depot a few days earlier. Only a nineteen-year-old youth was left to stand off the attackers. The boy, shooting from a garret window before the Tories killed him, was buried on the edge of town in an unmarked grave.

Catherine may be pictured as she sat in the month of April looking out of the window in the dusk at Howe's commissioners passing by on horseback en route to Philadelphia. For six days they and Washington's commissioners had been conferring in Newtown to effect a cartel for the exchange of prisoners. Failing to win terms by attempting to outdrink the Americans, they gave up at sundown and were put on their horses in a tipsy state.

The new baby and young Gilbert were by no means poor Catherine's only cares. Mary Searle had died, the couple were obliged to provide three of the orphans of William Hicks with a home, even though Isaac's source of income for their nephews had ceased two years earlier, with Isaac's resignation as Prothonotary. The Revolutionary Assembly had little money for such burdens. Had it not been for the distinguished John Dickinson, member of the First

[9] Bucks County Hist. Soc.

8

Continental Congress and an executor of William's will, Isaac would scarcely have known where to turn. On September 27, 1779, he wrote to Dickinson from Four Lanes End, by then called Attleborough, this letter voicing his extreme distress:

Sir

I am now about breaking up house keeping being obliged to it by the sale of my father's house I now live in, and as I am shortly to remove my wife's children and a servant into a neighbour's house with a large family, and going myself to the West Indies, I must request the favor of you to provide other quarters for the two children of the late Mr. William Hicks that is now, and have been ever since the decease of Mrs. Searle, with me. Ned is now old enough to go to a trade, but should Mr. Dickinson not have a place provided for him, rather than that he should be any expense to the Estate I will get him a berth among some of my neighbours for the winter. Dickey has been kept at school ever since he has been with me, but has latterly made but very little progress in his learnings, as the schoolmaster to whom he goes is but a very indifferent country one, and it is now necessary for him to go to a grammar school. I should have been very glad to have kept them from being any expense to the State, but it is now no longer in my power. Your immediate compliance with the above request will much oblige your most obedient, very humble servant.

I. Hicks.[10]

The auctioning of Gilbert's mansion at the county courthouse in Newtown on August 24, 1779, had occurred a month before Isaac felt compelled to write to Dickinson for aid. Catherine was again pregnant, this time with Edward the painter, her third child. It was a grim time for the family to be homeless. That matters did not improve is evidenced by a second letter to John Dickinson, dated "Attleborough, November 2, 1779":

Sir

The boys I have sent agreeable to your orders, which came in good time, as on Monday next the person who purchased my father's house (in which

[10] Hist. Soc. of Pa. Logan Papers, V. 41, p. 60.

I now live) is to move in, when I shall then be reduced to one room until I remove my family elsewhere. Ned has been for these ten days living with one of my neighbors for being very insolent to his aunt. Dickey, poor fellow, I should have sent clothed better had not my tailor disappointed me. I have done everything in my power for him and am sorry to send him in such a ragged condition. I am, Sir, with the greatest respect your very humble servant,

I. Hicks.[11]

Yet on that very day some miracle occurred, for on November 3 Isaac presented a certificate of payment of £4,030 purchase money signed by one George Wall as agent for his father's property and house.[12] How he managed this transfer is a mystery, unless Dr. James De Normandie, faithful family friend, came to the rescue. He had apparently abandoned the idea of going to the West Indies.

With the fighting a safe distance to north and south, and the mansion again in Isaac's hands, though heavily encumbered, the couple might have begun to feel some hope had Catherine's health not made them dread her confinement. On April 4, 1780, Edward Hicks was born to them. One fairly hears his howls of protest at being ushered into life with pain, a sensation he was to know full well throughout his days, without learning resignation or acceptance.

By the time Edward was a year old they had again lost their home. Isaac's accounts show that he went away for a while, leaving a "memorandum of sundry debts" due him, intended to carry Catherine over.[13] She and her children went to relatives in New Jersey.

Possibly Isaac went to see his father, who by then was hiding in New York with the British. Gilbert, unaware of the event, had written to Isaac the day following Edward's birth after several years of silence:

[11] Hist. Soc. of Pa. Logan Papers, V. 41, p. 61.
[12] Doylestown Court House: Deed Bk. D, V. 2, p. 18.
[13] Bucks County Hist. Soc.

My Son

The only reason why I have heretofore omitted writing to thee is that, if known to the ill-natured people amongst you, it might in its consequences operate to thy Disadvantage. I am very apprehensive that my Dear Daughter Sally must want many things, the which I would send provided I had the least hopes of it coming safe. . . . As thou art the head of my family in Pennsylvania, I must recommend it to thee, nay, lay it upon thee as an injunction to live in Brotherly Love with thy Brother and Sisters, and in friendship with all thy Neighbours without Distinction, which will endear thee to thy affectionate father,

Gilbert Hicks.[14]

Certainly Gilbert had done little to make easy his "injunction" for his thirty-two-year-old son, estranged from friends and in financial distress.

During Isaac's absence, however long it was, Catherine's delicate health continued to fail. But he returned before she died on October 19, 1781, a momentous day in American history. She herself did not know of Cornwallis' surrender at Yorktown. Thus ended the life of one for whom such trials as she had seen were unknown before the Revolution and her marriage. "Used to moving in the gayest and highest and most extravagant circles," Edward's *Memoirs* relate, she had nevertheless "lived to see her own affluent father, Colonel Edward Hicks, in financial ruin," after which her brother William became her guardian. Often, though reared an Episcopalian, she had attended Friends meetings, a fact which Edward believed could account for her insistence on a simple burial in St. Mary's churchyard in Burlington, New Jersey, instead of in a vault among her high-church relations. How her sister Mary, married to Bishop Seabury of New York City, regarded her wish can only be surmised. In those last months before her death she sat silently in tears with her Bible and prayer book. Edward's brother also told him that he would never forget how she looked when she led him and his sister in "sweet acts of devotion."

14 Hicks Coll., Newtown, Pa.

10

What was to become of the children? How was Isaac to keep them? These doubts must have plagued his mind as he lay sleepless in his bed the night of Catherine's death. Even as he wondered, a reeling town crier in Philadelphia was swinging his lamp and rousing the sleepy citizenry with "Hear Ye! Hear Ye! Basht dree o'glock, Cornwallis is daken, and a gloudy mornin'!"[15] The news did not reach Burlington till daylight, but it could scarcely have meant much to Isaac, with peace holding little besides uncertainty for him. Catherine's pitifully small cortege moved slowly through the boisterous crowds beginning to celebrate the end of the struggle for freedom. The little procession almost symbolized the passing of a doomed colonial tradition as Catherine withdrew from scenes wholly alien to the family code. She died without knowing the end, and the cheers and bells were too late to reach her ears as she was laid to rest that morning.

Her thoughts had been only of her children. She had prayed aloud for them. Gilbert, aged eight, and Eliza three, may well have been bewildered and confused by the excitement which was everywhere about them, with only a wordless, heavy-laden father to heed their questions. Edward, eighteen months old, could not share with his brother and sister the loss they were old enough to feel—and to feel the more deeply as they overheard some of the grownups' conversations. A certain blood-curdling incident which took place in Newtown soon after Catherine's funeral doubtless reached their impressionable young ears, a tale which must have struck terror in many a heart, not alone of children!

On the night of October 22, John Hart, Treasurer of Newtown, had just returned from Philadelphia. It was ten o'clock and he was sitting by the kitchen fire with his wife and a neighbor,

15 Bucks County Hist. Soc. *Papers*, V. 1, pp. 270-82, Jan. 21, 1885.

telling them all about the celebration—the fife and drum corps, the flying colors, roaring throngs, bells, booming canons and parades. The three chuckled as they thought about the Redcoat captains' refusal to hand their swords over to two rough American sergeants named Lincoln and O'Hara. They could fairly see Washington astride his horse at Yorktown, and Lafayette, De Grasse, and Rochambeau proudly looking on. In their mood of rejoicing that the terrors of war were past, they did not dream that danger lurked at that very moment behind the unlatched door. Suddenly a band of masked Tory bandits—the dread of the whole countryside for their brutality—rushed in. Dressed in brown linsey-woolsey coats, knee breeches of plush and sheepskin, small round-crowned hats of felt, rough hunting shirts lashed in with large kerchiefs, they brandished clubs, swords, muskets, and cocked pistols. The leader, Moses Doan of the notorious Bucks County Doans, was attempting to carry out a last raid—his boldest. The lantern-jawed bully reeked of whiskey and, despite his blue stockings and French-buckled shoes, scarcely cut the figure of a dandy. He demanded that Hart surrender the public funds and the Treasury key. His fellows began ransacking the house, and their violence wakened the Hart children, who climbed into one bed together. A thief held his candle above them and whispered hoarsely, "Don't cry there—no one's going to hurt you!"—whereupon he reached down and pulled a bag from beneath the bed. Finding it full of money he held it up and wryly told the youngsters, "We're only taking this up to your father's office." So saying he stuffed the loot in a pillowcase and dashed downstairs.

Hart, well aware that the Doan gang had often roped and horsewhipped those who tried to evade them, surrendered the key in order to save his life. The villains then raced up the street to the Treasury, and in a few minutes they were galloping toward the Wrightstown schoolhouse to divide £375 in silver alone. Only one was to hang for this crime, but not Moses Doan, who fled to Canada and safety.[16]

[16] Bucks County Hist. Soc. *Papers*, V. 1, pp. 270-82, Jan. 21, 1885.

A Brand from the Burning

WHERE Isaac went to live immediately after Catherine's death we know not, but that he never returned to the mansion in Attleborough is certain. That Jane, the Negro slave wench, took little Edward with her to her people we have seen. Added to Isaac's cares was the impending fate of his father Gilbert in New York, still a fugitive under British protection. On January 27, 1783, unaware of his son's destitute state, Gilbert recopied an earlier demand for cash, one lost en route, and ordered Isaac to send "ye cash" at once. He complained of his suffering "in the late contest in America," praised himself as deserving of a British pension for his "loyalty to the Sovereign," and added that he was going to Halifax to apply for one by May, when the King's commissioners would hear him. Isaac, he said, was to "strain every nerve" to raise the money, and call on Dr. De Normandie for help if need be. Gilbert had heard of Isaac's illness, and said he hoped that it explained his son's remissness toward a stranded parent who had "a right to expect attention."[1]

Poor Isaac, desperate and ill, had not even received Gilbert's earlier pleas. But he evidently made an effort to comply. By spring he had begun to gain a little ground by settling estates, drawing deeds, surveying land, and performing marriages, and by other services such as had been among his duties before the outbreak of the Revolution. But he was unable to keep his family together. A few weeks before the Twinings took Edward, Isaac sent Eliza Violetta off early in May as a boarding pupil to one Catherine Heaton, with whom she would remain to the age of eleven. In June he made a down payment on land in Newtown. By late summer he parted with the last of his children, sending young Gilbert to James Boyd, Presbyterian minister and teacher of Newtown and Bensalem, who would keep the boy till he reached fifteen and entered Dr. De Normandie's tuition to become a physician.

Gilbert Hicks's departure for exile was delayed. In November 1783 he wrote Isaac again, begging him to send his books. *Turkey Spy, Domestic Husbandry,* and the *New System of Agriculture* were the volumes of "utmost consequence" to him. He proposed that Isaac might prefer to deliver them to him in New York—at his expense—but within a week, as he would be departing with British troops about to evacuate New York City.[2] On November 20 he sailed; but his books stayed in Newtown, where they have since remained.

[1] Hicks Family Coll., Newtown, Pa.

[2] Hicks Family Coll., Newtown, Pa.

Gilbert's intention was to become a farmer, but his plans fatefully miscarried. The voyage north was broken by a seven months' pause on "Martha's Wine-yard," where he was the guest of a Presbyterian minister, a Whig and republican who overlooked his tyranny and treated him with "great humanity and friendship." Upon reaching Digby, Nova Scotia, in July, he wrote again to beg Isaac for sixty guineas—a sum to be extracted from the patient Dr. De Normandie, his lifelong friend. This letter, written with visible haste and uneasiness, was Gilbert's last. He admitted that his fellow "refugees, tories and royalists"—names given them "miserably enough, God knows"—did not compare with the "sensible republicans on Martha's Wine-yard." As if with a premonition of death he closed the letter: "Do nobly. Never meddle with Politics. Your father has made himself wretched by it." Shortly after, he was waylaid and murdered by robbers on a highway near Digby as he went to fetch his pension.[3]

The following year, apparently, Isaac Hicks remarried. But by late autumn, or so his accounts indicate, a lone boarder in the house of John Begg of Newtown, he was again a dour, disillusioned widower, well on the way to becoming the forbidding old Squire Hicks whom Fate had used badly.

So much for the family background of Edward Hicks, who by this time had become a part of the Twining household. His father fast receded into the past, all but forgotten save when he came to pay his obligation. Seldom if ever did the boy see his brother and sister.

Edward's favorite "adopted sister" was fourteen-year-old Beulah. He spoke of her years later in his *Memoirs,* describing her as an insatiable reader of popular novels, which she spirited to her room and read by moonlight lest her stern father catch her in the act. David Twining, director of the town's library, which was kept in a case beneath his roof, would

scarcely have approved. He had helped choose the first somewhat solemn library purchase, Locke's *Essay Concerning Human Understanding.* Edward felt that Beulah's having crammed her head with romantic nonsense explained why her "little bark" so nearly capsized in stormy waters, and why she chose to marry "out of meeting." Her divorce from a too handsome Presbyterian doctor had swallowed up her means and temporarily broken her health and spirit. Edward had been sorry to see Beulah leave the farm after the wedding that took place a few years after his arrival. He must have been overjoyed when Beulah returned to her father's house, despite the disgrace and gossip. Handsomely she won her way again into David Twining's graces, running the farm during his illness and decline. Her father rewarded her attentions by willing her the largest share of his expansive farm lands.

The last will and testament of Twining reveals him not only as frugal and exacting, but as oblivious to Edward Hicks's future. To his wife he willed a hundred pounds a year, and his feather bed, chest of drawers, tea table, six china cups and saucers and six silver teaspoons, one pewter dish, six pewter plates, a brass kettle, an iron pot of her choice, a tea kettle, three windsor chairs and three rush-bottomed chairs, one horse, and "one cow which she may choose." He added this rather heartless condition: "My said wife shall have, *during the time* she remains my widow and no longer, the use of the back room on the first floor of my house . . . and the liberty to wash and cook her victuals at the kitchen fire, and to bake in the oven, and to use the cellar and half of the large garden, and also to have her horse and cow well kept for her during winter and summer, the horse to be brought up to the house and saddled and bridled when she may require it, and the cow milked when she may desire it, also to have a sufficient quantity of good firewood found for her and cut into suitable length, hauled, and laid at

some convenient place near the house, and her fires made for her." Beulah was to perform these chores, he added, either personally or at her expense from the large inheritance of land and Newtown "tenements" he left her. His other daughters were to receive the rest of his acres— a vast total. His cousin Samuel Twining was to be given three pounds yearly for "cloathing"; and two grandsons were to be provided with "a large Bible each" by the executors. To one of the latter (should he live to grow into them) were to go the dead man's "silver buckles and greatcoat" and his "next best tight-bodiced coat."[4] He left not so much as a pewter mug or a parting blessing to his ward, young Edward Hicks, whom his wife loved as dearly as a son.

Isaac Hicks's continuing struggle could not have been unknown to David Twining when, gravely ill, he made his will two months before his death late in the year 1791. Only six months before, in May, when Isaac's remittance for Edward's lodging annually fell due, he had written to Thomas Ricke, a New Windsor official, a sardonic, pitiful and groping letter:

Newtown 15 May 1791

As no doubt among the circular letters, from the Governor to all the first characters of this county, you have one for pointing out the most suitable persons for Justices, etc., and as I am confident of your friendship and good will for my welfare, I take the liberty of thus troubling you . . . I am poor and I am proud and wish still to keep above the dirt. I have once been somebody but now am hardly anybody, although I have the vanity to believe I have supported a tolerable good character. I was once a Justice, and although that post is now or will be under our new Constitution much depreciated I should be glad to be one again. I have communicated this to Mr. Yardley who has a letter from the Governor and to one or two other of my particular friends. I live in Newtown and am here a free holder, having several lots . . . Murray, I believe, don't mean to continue . . . Now my dear sir, with your, Mr. Yardley's, and my other friends' assistance I could be once more made a little somebody. It's

rather a delicate matter for me to be soliciting for, but as I have so far dwindled to nothing, my friends would not think of me was I not to remind them of such a one

as your affectionate kinsman and most
ob't & H'ble serv't,
I. Hicks.[5]

Edward did not take to schooling, except for the Scriptures, which he loved as Elizabeth Twining taught them, reading to him aloud by the fireside. In 1789 the Library Company collection of books, too weighty for a boy's edification in any case, was carted to Newtown, after nearly thirty years in David Twining's care. By 1793 Isaac Hicks was forced to choose a career for this unscholarly thirteen-year-old son; unlike nineteen-year-old Gilbert, who was already equipped to practice medicine in the iron country village of Catawissa, he showed no professional promise or inclinations. Isaac, who had hoped to make him a lawyer, was deeply disappointed. The only solution seemed to be to bind him as an apprentice to some coachmakers in Attleborough, the Tomlinson brothers, artisans he had known all his life and could trust to fit his son for a practical trade. Although there is no determining, Edward may well have shown some talent for working with his hands in boyhood, a fact which may have prompted Isaac's decision.

One April day in 1793 Mrs. Twining packed his few belongings and saw him to the gate and a waiting wagon. They exchanged tearful goodbyes. Had she been able to guess the misfortunes in store for him, she might have wept all the harder.

Isaac had asked that Edward be allowed to finish another school term while beginning his apprenticeship with William and Henry Tomlinson. William and his wife took him into their home, but paid no heed to his comings and goings. Although he admired and was completely devoted to his masters for their "humble

[4] Recorder's Office, Doylestown, Pa.: Bk. 5, p. 280.

[5] Hist. Soc. of Pa.: Folio A. L. S.: Isaac Hicks.

industry," the change from the sheltered life of the Twining farm proved a trial "for a poor weak little boy." Formerly he had had his way at table, but now he was expected to eat what was put before him like his comrades, hearty men and youths who ate "for their lives," rose early and labored long. Their "low slang" and vulgar horseplay which lightened the tedium of shop routine shocked the impressionable Edward. At first, when he did not know whether to laugh or to cry, his fellows used his dilemma to tease him. Before long, however, as his *Memoirs* tell, he was doing his best to be like them and learning to drop an oath with the wickedest of these worldlings. His increasing levity and "natural fund of nonsense" soon changed him into a favorite.

After six months the shop burned down. To earn a living until the following spring when he planned to rebuild, William Tomlinson took over the tavern next door. He put Edward to work as "lackey, shoe-black hostler and bartender." In those days of the Western movement, military fanfare, "gross evils" and "brutality" were everywhere, his *Memoirs* record. So far had the "rough universe" succeeded in trying to make him like it that he was relieved to discover he could weep when William's little daughter died, a child whom he loved. Nor did his deliverance from the atmosphere of the tavern in the spring of 1795 free him from temporal dangers. This fifteen-year-old, ever mercurial and lively, was drawn to "applecutting frolics, spinning frolics, raffling matches and indeed all kinds of low convivial parties"—or so they appeared in the perspective of old age when Edward Hicks described them. "The weeds of licentiousness, intemperance, angry passions and devilishness" were possibly less "noxious" than in fact they appeared to him, looking back. Irreligious, he was unimpressed by his brother Gilbert's having turned Quaker in remote Catawissa on the Susquehanna, where he was practising among German Lutheran im-

migrants who worked in the iron region. Indeed, Gilbert was to become a minister among Friends some little time before Edward thought of joining.

Whenever a carriage was completed in the Tomlinson shop, all hands celebrated with "three or four gallons," with the result that Edward quite naturally took to "spirituous liquors," imbibing between times. Drink, he wrote, was less his "besetting sin" than that "licentious lewdness" which tends toward corruption, and which might have plunged him into a "vortex of dissipation" had he not resisted the devil's panderings. Nevertheless, he was "introduced by lechers and debauchees into the worst of company and places, both in city and country."

After he turned eighteen, "martial music" and "the feathered foppery of the regimental dandy" caught his imagination, leading him to join the local militia which drilled, marched grandly, but never saw action. He nevertheless referred to it in later years as if it had changed him into a full-fledged soldier. All manner of roistering came of this association, but after a year he began to rue his follies. This was during a pleasure trip to Philadelphia. A "direful disease" led him to think of forsaking his "strong passion for music, dancing and all those amusements" which had finally attacked his constitution. Home he rode to Attleborough, subdued and full of resolutions, aware that in another year his apprenticeship would be over and that he would be expected to settle down in a grown man's universe.

Finally, when the time came for Edward to decide as to his future, the Tomlinsons hired him to stay on with them for half a year as a journeyman in their pay. After that he set up in business for himself, but without any confidence that he could or would overcome his "weak and wayward" proclivities after shop hours. He relied on his family's fifty-year standing in the community to bring him custom, knowing that his clients would probably over-

15

look his "strong and tender attachments to young women" as but the frailty of a twenty-year-old. Although he fared reasonably well, responsibility lacked appeal. When a "mechanical genius" of near-by Northampton, Dr. Fenton, came along with a tempting offer, Edward closed his shop and availed himself of the chance to acquire some practical knowledge while helping the doctor build "a new-fashioned carriage." When that was accomplished he stayed on for about a year, painting the Fenton house and performing odd jobs. After he had attended Presbyterian services a number of times with the Fenton family, the doctor began his urging that Edward join the congregation, saying he would introduce him to its unwed heiress. This half-earnest, half-joking offer touched off a heated argument. Edward was astonished to hear himself saying that if ever he joined a religious group it would surely be the Society of Friends. The doctor's reply that the Friends were "simple and lifeless" he noted in his *Memoirs,* but only in his shop ledger did he record Fenton's other embittering offense, that of his paying a paltry ten dollars for a whole year's work.

His argument with his employer had served to turn his thoughts to religion as never before. The faith of his Quaker grandmother, Mary Rodman Hicks, seemed to be stirring in his heart. He resigned from the local volunteer regiment. At the debating society gatherings in Attleborough which he began to attend, the young leaders, John Comly and James Walton, typically idealistic Friends, voiced ideas which further colored his thinking. For more than a year, in fact from the end of his apprenticeship, he underwent an increasingly serious and questing turn of mind. The old Newtown Library records show a few of the weighty books that he was reading: Washington's *Letters,* Murray's *America,* Cowper's *Poems,* and by no means least, Voltaire as explained by the Reverend David Williams of London.

John Comly became a powerful influence. He himself was destined to greatness in Quaker history. His sincerity and eloquence profoundly stirred the impressionable young artisan. Yet their personalities were in every way different —John's quiet, Edward's volatile. John, a farmer by upbringing, would guide his plow with his Bible in his pocket and at the end of every furrow take out a leaf and read a verse. Just before he met Edward he had been headmaster of Byberry Friends School near Philadelphia, and then a teacher at the venerable Quaker seat of learning, Westtown. Though but twenty-one, he had already mastered surveying, finished Latin school, and written a widely used grammar and spelling book. The *Journal of the Life & Religious Labours of John Comly* shows how he looked upon Edward during those debating society days before his conversion:

Nov. 1800: . . . Spent the evening at James Watson's, in religious conversation with Edward Hicks, who has lately taken a more thoughtful turn, and I hope is on his way to the promised land. Divine love attended my mind, and my prayers were offered up in secret for his protection and establishment on the immovable Rock, Christ Jesus. His natural vivacity, and light, airy disposition will doubtless occasion him some sore conflicts; but the Divine Power, at work in his soul, is all-sufficient to give the victory.[6]

He and James Walton imparted enough wisdom for the painter to become a real match for the argumentative Dr. Fenton, with whom Edward was still lodging.

A few months before Edward turned twenty-one, his full "reform" yet to be accomplished, he and a companion rode to Philadelphia for a lark. After a bibulous and carefree outing they traveled homeward through a heavy snow storm, which here and there forced them into the wayside taverns. Edward's raucous singing embarrassed his companion. Finally, tired, soaked through, hungry and more than willing

6 Comly, p. 81.

16

to be helped into bed by the good doctor, he reached the Fentons'. He woke in the night feeling desperately ill—far worse than during his bout the year before. Though Dr. Fenton restored him to health he was so overwhelmed with "pain and remorse" that his "appearance changed from a sanguine to a melancholy cast" which was never to leave him. That this outward change was far more than imagined is proved by John Comly's journal:

Feb. 13, 1803: This afternoon had the company of Edward Hicks, profitably so, I hope, as his sobriety and seriousness stirred up the pure witness in me, and my mind was brought into a state of more inwardness and humility, and though the channels of free converse were much closed, I trust silence was profitable for us. Hence an important lesson may be learned, that to dwell deep and inward is far better than a loquacious, superficial appearance of friendship.[7]

After his narrow escape from death Edward drew more and more unto himself, avoiding his companions for frequent rambles "in solitary places." It was during such an introspective walk one day that he found himself not far from Middletown Meeting. He decided to go in and sit down among the worshipers, and it proved such a fortifying experience that he resolved to attend regularly. After that he began to walk five miles from Northampton every First Day, or Sunday, to be present at meeting.

About this time a coachmaker and painter of Milford (now Hulmeville) made him an offer. Joshua Canby, a Quaker, suggested he join him as junior partner. The decision seemed a difficult one for Edward. Walking to Milford to talk things over he "wept nearly all the way" from uncertainty, depression, and inner turmoil. He was unable to give Canby any definite assurance, but decided to linger in Milford that night in search of cheer among gay young friends. They called on him to sing, and not only did he oblige but he kept it up till all hours of the

morning. Next day, his dark mood returning, he began to weep again bitterly that he should have indulged his "wonted cheerfulness and vivacity," instead of seeking food for his hungry spirit.

In Philadelphia a few weeks later he again could not resist the whine of a violin and the chance for a fling of song and dancing. This time, however, he did not wait until morning to repent. In the middle of a dance he abruptly left his gay companions and ran out of doors into the night. He met one of the comrades of his old "regimental dandy" days as he trudged along. Seeing something was amiss, this friend tried to cheer Edward, who only stared at him, vacant-eyed, and walked on.

That was the last of the singing and dancing. A new, serious personality was emerging, which felt deep need of religious expression. Increasingly inclined to Friends' ideas and their simple dress and speech, he began to attend meeting regularly, to say "thee" and "thou," and to wear his already plain clothing with conscious humility. Quakers became his constant companions.

In August 1801 he accepted Canby's offer. He roomed with the Hulmes in Milford. John Hulme's professed contempt for higher learning impressed him, even though he was to see Hulme wrecked, many years later, by personal ambition after rising, entirely uneducated, to the Pennsylvania Legislature. Nevertheless this man was among those who early convinced Edward Hicks that humility is the "step of the latter (sic) that leads to the kingdom of heaven."

Isaac Hicks, we judge, knew nothing of his son's baptism of fire. They were nearly strangers. But in 1802 they were in touch; Edward bought a piece of land in Attleborough from his father, who referred to him as "coachmaker" in the deed. There is no hint of how he hoped to use it. For the moment he continued to work with Canby for thirteen dollars monthly. He had Thursday mornings free for the walk to Middletown Meet-

ing which, in the spring of 1803, he asked to receive him as a member. With "open arms" he was accepted by those Friends whom he loved so dearly that he hoped they would meet again in heaven.

Encouraged and at peace at last, he went to Joseph Worstall in Newtown and asked for the hand of Sarah Worstall in marriage. Joseph, a tanner and Quaker of long standing, gave his consent. Edward and Sarah had been friends from childhood. He declared her to be the one enduring love of his youth. They were married in meeting at Middletown on November 17, 1803.

Peace Disturbed by Passion

WHAT had Comly and the Waltons to say of Quakerism which stirred Edward Hicks so profoundly?

The story of humble George Fox, the inadvertent founder, had its effect. Born in Leicestershire in 1624, this son of an English weaver was a sensitive, over-serious child not unlike Edward. An advocate of "humble industry," Fox's writings afforded consolation to the coach painter, whose father had been disappointed in the boy's inability to enter a high profession. His ideas reinforced Edward's disdain for the latter. Fox had been a social reformer to the point where he attracted followers enough to form a sect which used his preachings as dogma. Though they called themselves the Religious Society of Friends they came to be known as Quakers. Their quaking and trembling during prayers, in their desire to experience the rapture of the primitive saints, led Justice Gervase Bennett to give them the mocking name. Both Edward Hicks and Fox may be called *originals*— steadfast individuals. To Fox, truth and repentance were more important than all the ritual and trappings of seventeenth-century Christianity, or complex theological education and cant. He declared that an "inward light" took the place of the medieval sacraments. His concept of spontaneous inner devotion completely magnetized Edward. Grasping it at first emotionally, because it helped him collect and set aright his conflicting impulses, it swiftly became a tenet of his intellect, all the more acceptable because it came from a man who had also begun *his* working life as an apprentice so as to become a shoemaker and glazier earning a living with his hands. Fox had also served in an army. He bore suffering like a martyr, and thus became Edward's ideal Christian, who would die, if need be, for his beliefs. Both men were given to visions and premonitions. All this they had in common.

Edward saw that the Friends would not dangle Heaven high above him like a beautiful apple, only to be caught and grasped by obfuscating dogma. They would not harass him with threats of Hell and damnation. His brooding and impressionable, orphan-child mentality, still smarting from his brother's superior scholastic competence, felt at ease among these people who were more oblivious to caste and the special privilege of the highly educated than any sect since Christianity began. Among them he felt free to resent doctors, officials, and schoolmasters with what became almost hatred and contempt.

Impervious to titles and the like, the Friends did not ordain and pay their preachers, baptize

or confirm their members. They gave equal voice to all in meetings. If Edward was baptized in his mother's Episcopal faith, no record existed. How then could he be expected to miss the Lord's Prayer which he had never learned? Friends professed that it is not the rituals called sacraments which save a man's soul, but the sacrament of daily living. This he could fathom and take to heart.

Squire Hicks, thinking his newly married son might live in Newtown, bought Edward a house close by him, but in vain. Thus an already strained relationship was widened. The obdurate young coach painter chose to settle in Milford, where he rented a house for about a year, then decided to build despite his poverty. To accomplish this aim he borrowed money, and because of the grinding payment of interest which he blindly resented, he learned to detest "usury" and "usurers" with fanatical loathing. His growing despondency over his financial condition led to a period of extreme truculence and excitability. He joined debating societies, followed elections and politics with feeling, avidly read the daily news. Reviewing all this later in his *Memoirs*, he saw his activity as regrettable. His shiningly new, furiously idealistic conversion made him an almost intolerable zealot; he rabidly condemned intemperance, pointing with pride to the fact that his own new house was the first in the county to be built without "one drop" taken among the workmen. He ridiculed those whose faith differed from his own, going so far as to insult one of his wife's cousins, a Deist who, innocently paying them a social visit, was rudely challenged for his views. The painter would like to have whipped him "till the blood ran down to his heels." He even began to find fault with Friends during this furious twenty-fourth year, applying to them the impossible standards of the newly reformed "sinner." Without quite joining the

Methodists he began to take up with them, until the visits of their ministers and their lengthy vocal prayers annoyed his Sarah, who "could have no unity with them." Then, one evening, a canny Quaker woman of few words brought him to his senses at a social gathering. She caught his eye in the middle of one of his vindictive outbursts and reproachfully stared him into silence. Stunned by her gaze he seized his coat and departed. Though her husband followed him and begged him to return, he went brooding on his way. After days of painful self-examination he began to see the wisdom of talking less and praying more, a resolution he was to renew throughout life in the aftermath of trouble.

He now entered upon a period of habitual dwelling on his shortcomings, with spells of anguish that ended in weeping and prayers to heaven for forgiveness. How his intermittent agonies, and ups and downs, must have weighed on Sarah, pregnant and worried about their debts!

On October 12, 1804, Mary Hicks was born, increasing the cares of the heavily burdened painter.

After his penitent return to the Friends, Edward had an overwhelming longing to be heard —or, to put it in Quaker language, he was "moved to speak." At a session of Monthly Meeting, when neighboring meetings joined together for business and worship, he felt the desire so keenly that he could not curb it. He let his voice silence his mixed fears and longing to be heard. The praise that he afterwards received for his eloquence pleased him, while making him apprehensive lest such flattery cause him to imagine "each wind and star" his admirer. His inclination for real ministry was wakened that unforgettable occasion.

One of his ledgers, though partly burned, enables us to study his early artisan activities, when his limited strength inclined him to the

painting rather than the building of carriages.[1] In 1804 and 1806 he was painting "floor cloth" on order, and judging by the lordly cost of $8.50 it must have been fancily decorated. His plainer floor-cloth decoration cost as little as $1.50. In 1808 the Tomlinsons passed along some coach painting to Hicks—bringing him $15.50 for old vehicles, $25 for new. His argumentative friend Dr. Fenton hired him to paint a carriage and the carpet within for a total of $16. Polishing and varnishing carriages were also a specialty, and also the lettering of "waggons." Earliest records of signs are those for 1809, with one for Enos Yardley at a cost of $5.50, and one for John Hulme at $50. A sign for one Daniel Larrew (sic) cost $50 at about that time. At such a price the latter two must have been extraordinarily handsome.

Hicks was painting "directors" or street signs in Milford in 1805. An old director now privately owned in Newtown and attributed to him shows his finely detailed craftsmanship, his bold clear letters cut in low relief and then painted.

He ground his own colors, listing the ingredients in his ledger after purchasing them at a local store. Along with numerous other articles from his shop, his old mortar is still on view in Newtown. In 1806 he was accepting such small jobs as the painting of a small table for 33¢, a bedstead for 75¢, a chest for 37½¢, a dough trough and candlestand for 50¢, a breakfast table for $1. That his furniture painting orders sometimes included decorative detail is certain; his own set of "winser" chairs, now a lovely faded green with hand decoration still bright on them, are used daily in the home of a Newtown descendant. Hicks noted in the same ledger that he had painted a cupboard in "white and ivy green." If such jobs were not precisely to his taste, the returns were nevertheless urgently needed. He made a weather cock on order, in

1806, but the purchaser called it unsatisfactory; it is the only such item in the book.

On November 9, 1806, the month of the couple's third anniversary, Sarah gave birth to their second infant, Susan, who as it turned out was the family's most glib and creaturely offspring, one to be heard from often and plaintively—and most colorfully!—in times to come. That year saw a poignant death as well as birth in their midst, for it was marked by the passing of Edward's beloved "adopted mother," Elizabeth Twining.

Edward's return to the fold found him as "uncommonly dogmatical a disputant" as ever, assuming a righteous and intolerant authority and disliking all who answered or disagreed. He knew that he talked too much between his saturnine silences, which inevitably erupted into exalted discourse. He frequently criticized all human nature with an unreasonable unearthliness which made him more and more ascetic.

He would brood endlessly over his paint jobs, while finding fault with that task because it kept him from "the Lord's work." It is impossible not to suspect that at times he felt shop work beneath him because of his religious calling. Be that as it may, the wielding of a paintbrush is thought-evoking. Between strokes, a multitude of thoughts will flow without particular order or logic. Thought colors painting even as it governs life. With his personal affairs worrisome, his religious concerns going both well and badly, his train of thought continued to mold him as he labored.

The vehicles which were brought to his shop, as recorded in his ledger, conjure nineteenth-century landscapes in panorama. The spectacle is almost as evocative as Whitman, the poet. All Bucks County of the past passes by on wheels and runners—in "chariots" drawn by two horses —two-wheeled "chairs" behind one or two horses —the "chaise," of either two or four wheels for

[1] Bucks County Historical Society. Shop Ledger of Edward Hicks. Unpublished.

one or two or more pairs of steeds—the "coachee waggon" and "coachee"—the practical little "sulkey, gig and shay"—the rollicking "stage-coach"—the "sled" and "sleigh"—the elegant "phaeton" and "barouche" often with two spirited teams before them—the good, dependable, serviceable "Dearborn"—the "pleasure carriage" with smart little top—the "jaunting waggon, wasp, dog-cart, trotting sulkey"—the plain "buggy"—finally, the open "hearse." While this parade passes in all its romantic pageantry, there is no reason to suppose that Edward himself saw it in more than workaday perspective. He was preoccupied with some coming Quaker meeting, whether to speak or remain silent. Once they were finished, these shop jobs were behind him, and his was not an imagination that would see wheels going forth, let us say, on errands of folly, mercy, necessity, and soul-saving, of guile and goodness, interspersed with mishaps, accidents, and narrow escapes as they rolled through open country under billowing skies, or under blankets of rainclouds full of lightning that alarmed the horses. The hum of conversations, angry, bored, amorous, or lively, would probably, from behind these carriage curtains, not have interested this man who preferred either to speak or be silent, a man all too seldom inclined to listen. As he worked away at the vehicles, he framed stirring speeches which he wished he had thought to utter at the last meeting, or hoped to deliver in the future—as a leader among Friends, an inspired disciplinarian, God's humble elect. But that time, he well knew, had not arrived.

Six years of hard work at artisan tasks and the thinking that racked his brain as he labored, resulted in a rising flood of words. The locks must burst sooner or later and yield to unrestrained expression.

"Weak and faint" from the mingled wish and fear "to advocate the cause of Christ" as a Quaker leader, he started out for Yearly Meeting at Philadelphia in the spring of 1810, joining members gathered together from far and near. When all were seated and the doors had been closed, his impulse to rise and speak was hampered by a certain appalling recollection. A Quaker with a similar desire to be heard had risen one First Day in Newtown and, after speaking at dreary length, felt a blow from behind that dropped him to his knees; after a calf-like "bawling out" from surprise and pain the offender was silent. The mere prospect of such humiliation "wounded" Edward—increased his "awful apprehensions" and "tender state." Perhaps because of his pugnacious nose, broken in an accident, he believed his appearance unprepossessing. His slight stature added nothing to confidence; for he was not, all reports to the contrary, a tall man.[2] Not even being a father of three (for a son, Isaac Worstall Hicks had been born in 1809) gave him the assurance needed to address this distinguished gathering. Only the swift thought that it might be his "last Call," if he passed it by, helped him overcome his terror; and his listeners perceived his state so sympathetically that he spoke on until all the pent-up fervor was expressed. Then he knelt down, trembling and weeping, and prayed, but his tears were all of joy. After meeting he did not wait to greet friends but went forth in a trancelike state. For weeks he was full of prayer and love for all about him.

His father, in the thick of affairs in Newtown, knew nothing of Edward's religious ecstasy. Indeed his own thoughts of the moment were none too godly, if judged by a humorous note that he scrawled on the margin of his docket, concerning someone's effrontery in questioning his charge of five dollars for drawing up a deed: "The damn raskel disputes, to hell with him."

That conquest of fear had given Edward the courage to speak again at home at midweek meeting, then on First Day; after that he reverted

[2] Unpublished notes of James Trimble, a contemporary. Trimble Family Coll.

to weeks of painful silence lest he weary his listeners. But the cause of temperance and his intense beliefs again led him to speak, and he bore testimony not only against the use of liquor but its sale by Friends. His fierce language had an instantaneous and disastrous effect on the members of his local meeting, particularly a "respectable old patriarch of Milford" who dealt with no little profit in spirits. Hicks turned on him there and then, menacing him and his sons with the warning that "a curse would attend their wicked traffic, and whatever they would gain over the devil's back they would lose under his belly." A shocked hush followed upon his words, and he at once knew by the ominous silence that he had far overstepped the bounds of Friendly propriety. So sharp was the ill feeling against him that before many weeks he saw that he must give up his shop, move away, or be ostracized.

In the autumn of 1810 he sold his house, agreeing to be out by April. Newtown seemed the best place to which to turn, but April came without his finding a house there. Isaac Hicks had long since sold the house he bought for Edward at the time of his marriage. Sarah, expecting a fourth child, began to dread the painter's return from the daily search lest at the last they be homeless. Late in March a glimmer of hope arose when it was rumored that a wealthy Newtown lawyer, Abraham Chapman,

might sell his home. But Edward's call on him elicited no promise. He could scarcely bear to return home next morning with the news, and when he had to face Sarah again and tell her that he was still without prospects they were both too sad and cast down to go to meeting. It was First Day. People were passing. He dreaded their inquiring looks and questions, fearing he would collapse in their midst from strain and humiliation, and knowing that he could not endure to let the old "patriarch" whom he had maligned see him so defeated. As he walked out to his shop and turned his back on the passing Friends, his conscience upbraided him and an inner voice accused him of letting false pride interfere with duty. The voice reminded him that he had not prayed humbly for the way to open. Edward turned on his heel and headed for meeting.

Scarcely had he begun to pray when "a tenderness and sweetness" filled his soul. Hearing the unmistakable cough of his brother-in-law, Joseph Worstall, he was puzzled by his presence. Joseph, who was not expected in Milford that day, rushed up to him after meeting and whispered the news that Chapman had relented. He would sell his house and lot after all if the Hickses would allow him and his wife and little son to stay on as lodgers. Edward, nearly overcome with joy, ran home to tell Sarah what had happened.

Care and Concern

ON April 16, Edward and Sarah and their children, Mary, Susan and Isaac, moved to Newtown.

What manner of village of nine hundred and eighty-two souls was this first Bucks County seat? Edward's *Memoirs* describe it as sadly iniquitous, with "every tenth house a tavern, and every twentieth one of bad report." Its four or five Quaker families worshiped near by at Makefield Meeting. The town's mainstay was county and legal business. "Religion and morals were at a very low ebb," wrote the zealous reformer in whose blood ran the puritan strain of New England's pilgrims, and whose father was a respected official of the community he condemned. Humanity moved in and out in a lively stream by post stage which for six years ran through Newtown between Quakertown and Bristol. Then and until 1816 two other stages dropped and took on passengers for Philadelphia and Easton yonder on the Durham and River roads.

As to what Isaac Hicks thought of Edward's shift to Newtown, available light on the squire's crotchety personality would suggest that he did not feel called upon to lend his son support—moral or otherwise. Since 1794 he had been a justice of the peace again, as well as a land surveyor, conveyancer, and trial judge. When-

ever his business lagged, the dour, restless old gentleman would seize his tall blackthorn cane and make for the open country, ranging the fields and roads that he surveyed. He lived alone in a small white farmhouse on the main street. According to Josiah Smith's unpublished history, he was "ill-natured and arbitrary . . . more feared than loved," although looked up to by the townsfolk. The heart of the white-haired man of proud bearing and scowling expression had not been mellowed by events. He must surely have known of Edward's recent indiscretion in Milford, and may conceivably have felt little enthusiasm for his arrival. In any event there is no hint of developing closeness. He had apparently not offered his home as asylum for the pregnant Sarah and her children ranging in age from two to seven.

The Chapman house stood—indeed still stands—in a block known in Newtown as "little Williamsburg," the site of colonial Court Row. With neat red brick façade, large, many-paned windows, dormer roof, and formal entranceway, it is set directly upon the walk, with lawn and grounds in the rear. Edward's paint shop was at the foot of the lot, no distance from the kitchen door. Whether the Hickses walked out among the crowds of the town on race days, during elections, county seat fairs and other frolics, to

meander among the cake-and-ale stands and itinerant performers, there is no telling. But the merrymaking and the free-for-alls of those ebullient days must have been peered at by them, at the least, from behind curtains or blinds, until 1813 when the county seat moved to Doylestown.

By late summer, 1811, they were sufficiently settled in their new surroundings so that Edward could think of carrying out an errand in Maryland. But he was waiting until after their fourth child should arrive. On August 24, Elizabeth, probably named for Mrs. Twining, and due to become her father's favorite because of her devotion to his religious ideals, was born.

About two weeks later he hitched his wagon and started off, stopping with friends overnight at Brandywine, where his eloquent praying by the graveside at a funeral caused all who heard him to declare his vocal ministry inspired.

Proceeding to Wilmington, he was invited to sit in the gallery on First Day, an honor reserved for ministers and elders, and one which required him to speak. His words dissatisfied him as mere "borrowed inspiration . . . other people's money." By the time he returned to Brandywine he was still so disappointed in himself that he called the renewed praise of his preaching "a sop calculated to send me out in the dark with the devil. . . . I knew the dose was poison but then it was sweet." The realization of his highest ambition—to speak God's word as he heard it in his soul—did not bring peace. If he spoke well and won praise, he despised himself for taking natural gratification in that praise. If he preached badly, he chastised himself and suffered. "I returned home," he wrote of this journey, "something like a head and shoulders higher than when I left."

The Friends at home heard his praises via the grapevine route. Middletown Monthly Meeting, not to be outdone by Brandywine and Wilmington, recommended and approved Edward Hicks as a minister among them. For the next two years he spoke regularly at funerals and meetings. By 1813 in Philadelphia, whither he went soon after New Year's, he expressed himself with overconfident bluntness when another's preaching incensed him at Monthly Meeting. A wealthy and "pompous" merchant hushed his heated words with the rebuke, "Young man, sit down—thy words have not the savour of divine truth!" The women then withdrew to their separate chamber, leaving the men to a session of reading queries from the floor, regarding Christian doctrine for answer and discussion by all and sundry. Edward, his mind in turmoil, departed, but as he walked up Key's Alley an old man trying to catch up with him told him to go back to his rightful place in the minister's gallery. This, whether wisely or otherwise, he did. He sat directly opposite the merchant who had told him to be silent. Ignoring the man's amazement, this country Quaker "spoke to" one of the questions, and before he resumed his seat he denounced his own treatment as disgraceful. He could forgive it, he said, only because he was graced to be able to love even a Friend so grievously in error, against whom he himself had perhaps spoken over-harshly. A member of a Bucks County meeting then rose and confirmed Edward's standing in home circles. From that day forward he became known to wider, cosmopolitan Quaker circles, and that night he was offered the hospitality of many homes. He chose to stay at Abraham Lower's. His buoyant feelings were shortlived. Early in the evening three elders called to question the wisdom of his remarks on "eternal reason," which, to their utter dismay, he had called the "highest faculty of the soul," reason being the recipient of the "Divine light" in much the way that "the sun gives light to the earth." A quarrel ensued. Edward denounced his critics with such unbridled venom that after their departure he was plunged into suicidal despair, a mood which lasted through the sleepless and troubled night. Had not an "inward voice" directed otherwise,

he would have headed for Newtown in the morning, but instead he went to Pine Street to another meeting. The spectacle of the well known and formidable leaders Nicholas Waln and Jonathan Evans should have restrained him. However, he dared to seize on a query read from the floor and to challenge its implications. The meeting's reaction seemed to hang silently in the balance. Then a man rose and said he was in accord with the sentiments of the stranger, after which twenty more voices echoed approval from floor and gallery. It was a triumphant and elated Edward who returned to Newtown.

As far as can be discovered, 1811 was the year when he painted his first more elaborate signs. For these he was nearly as famous later on in life as for his "Kingdoms" and Friends ministry. His ledger shows that one Samuel Hellings and a Joseph Merrack had him paint tavern signs at ten dollars each. The price was to rise to a much higher figure as his mastery increased. He engaged a helper named David Story that year; they came and went, his artisan assistants.

On April 1, 1812, a needed source of income was lost with the decision of the Abraham Chapmans to move to the new county seat in Doylestown, after a year of lodging with the Hickses. Their son stayed on, however, paying two dollars weekly for room and board.

The spring of 1813 saw a radical change in the village routine. On May 13 the jail's inmates, the furnishings of old Court Row's official buildings, the iron doors of the vaults, and the bell in the courthouse cupola were all loaded into wagons and carted away in a lugubrious line that headed for Doylestown. Some of the stone steps before the buildings of Court Row, erected in 1725, were also carried across the Neshaminy to Doylestown. One old bystander observed that only the prisoners could have enjoyed this nos-talgic day, because for them it meant a ride across country. With the wagons that went over the hill disappeared the light-hearted days of the quarter races, the lottery and fairs, the traveling shows, dancing bears, sleight-of-hand performers, lusty tavern and street brawls. With the transfer of officials, and culprits from jail, the trial scenes and other grist for the gossips became no more than a ghostly procession. A new quiet descended on the village.

Edward Hicks, because of his distrust of all officialdom, probably hailed the change as a welcome one. He took less and less notice of public affairs, priding himself on ignoring congressional speeches. Only temperance and abolition, issues of lively interest to the Quakers, earned his attention. So insulated was his world —first by Quakerism as he approached it during the earlier years after he became "convinced" or converted, and later by the Quaker schism— that the tumult of the nineteenth century was to him hardly more than a rumble in the background. It would be absurd to draw attention to current events that went on around his close personal preoccupations, so remotely did they affect him.

About the time of the removal of the county seat he felt a concern to travel, and laid the proposition before local Friends, who agreed that he should be allowed to preach at Abington and Philadelphia quarterly meetings, a journey of 160 miles altogether. This he offered to do at his own expense. From the days of Fox, Quaker ministers have reckoned such travel among their duties. Edward, increasingly respected, his sense of destiny growing by leaps and bounds, longed to sway others to his way of thinking and, perhaps unconsciously, to attain to a saintlike greatness and hence salvation. That he did reach eminence within Quakerism is a fact which, ironically, he was not to be sure of even at the end of his long struggle. His wider fame as a painter, to which he never consciously aspired, did not arrive until the present day.

That he himself would be astonished by it there can be no doubt.

On this first short preaching journey, as in others that lay ahead, he accomplished no painting. He expressed regret that he could not send money home to Sarah, or to his creditors, and later chastised himself harshly for imposing hardship on others in Newtown during these travels which, though arduous, often meant almost luxurious hospitality compared with home's austerity—his family's lot. It stands to reason that the frequent holding of two meetings a day obviated the chance, had he sought it, to accept commissions. Moreover, looking back on his travels from the perspective of the 1840's —the period of the *Memoirs*—he said that ministers ought to support themselves *during* their journeys by whatever "humble industry" they knew, and not impose privation on their families at home as he had. In fact he was not even sure that such migrant preaching could not be overdone. "Jesus Christ could walk on the water," he wrote, "yet the utmost extent of his journey did not much exceed one hundred miles . . . and, during the three years of his glorious ministry, I have no idea that he spent all his time without working with his own hands, for his mother . . ." This is an admission that he himself did none of the work of his trade while he wandered.

"Humble industry" became an obsession, in connection with education as well. But his fierce aversion to too much of the former developed decades before his theories on migrant preaching. Quaker boarding schools such as Westtown he condemned as "nurseries of pride and idleness." Princeton and Haverford were no better, he wrote, and children were surrendered to them, or deserted through them, by shirking parents willing to let them "be hatched by the beams of the sun," or be crushed and broken in "the wilderness of the world." Reading his sincere but provincial ideas on formal education, one suspects they were the product of his dis-

appointment. He actually and candidly despised the "humble industry" for which his limited education equipped him but, paradoxically, he continually implied that it was to be preferred to the vain-glorious professions. Were his reactions to be examined by today's methods the common inferiority complex might well be the diagnosis, because the more sophisticated forces —namely the minds of the professional and bookish—were inimical to his happiness and progress. "Beautiful primitive garments" gave him confidence. The sight of them on his fellows pleased him; scholastic robes were mere "dust of the earth." He advocated "useful learning" only, and wished that nothing more were available to young Quakers, preaching that it led to comfort and decency and enough goods. In view of this, it is no marvel that a homespun legend has been woven around Edward Hicks, the primitive painter, gripping the gullible public imagination. Born in a mansion, reared in upper middle-class surroundings, accustomed to eating from family china with ancestral sterling, which was set on hard wood of lovely colonial design and refinement, and eventually occupying a sound, handsome house on a good street in Newtown, he was hardly the one to pontificate on the spiritual beauty of poverty. The stark life was a condition about which he himself knew really little. The gnawing worries which arise from scarcity of ready cash badgered him always, but there was ever an aura of gentility and grace around the financially unstable Hickses. Seldom did he seem to allow for the fact that his country, which he loved so much, was governed by men of learning. Instead he focused on others whose academic advantages and industry were not unlike his own—the Nazarene, George Fox, and certain of the Apostles. "Humble industry" and greatness were inseparable in his thinking. He burned verbal incense before the idea of acclaim earned in innocence—minus pride—preferably with hands well calloused. A kind of sainthood, his own

27

goal, was the impossible one he recommended without stint to others. "Gentlemen dentists," "usurers," and doctors were among those who could not qualify for his heaven. They were potential criminals and villains. Thus spake a man, an artist and dreamer, who managed his affairs so fecklessly, borrowed so perilously, that he could sit in meeting on First Day and count the heads of his creditors till he began "sinking in the quicksands of despair." Yet his was the despair of self-pitying resentment, not of guilt for laxity toward obligations.

Enough about the subjective side of Edward's "humble industry," while the results of his work of 1813 are examined. His tavern sign for James Corson, costing the munificent sum of $25, must have been a beauty. It is lost now. It bore the coat-of-arms of Pennsylvania, with fine horses rampant and banners floating beside the shield. Discovering that he could do a good job of copying the horses from whatever example it was that he followed (and there must have been many about, to copy, in documents and papers) may have spurred him on to trying his hand at easel painting before many years. This tavern sign and sundry others dealt with inspirational themes of an historic and patriotic nature. The Corson sign coincided in time with the War of 1812. Fighting was still going on at sea with the British.

There was ample inspiration all about for the sign painter with ability and imagination. The Revolution was a vivid memory for most of the living. Only a summer before, an old veteran returned for a nostalgic walk about the village. He had been a sentinel at the Harris homestead while Washington stayed there. His recollections,[1] which must have reached the ears of Edward Hicks, were of December ground hard with frost as he marched with Washington's regiment—of men unshod and stockingless, their bleeding feet marking the way as they tramped

[1] Bucks County Historical Society Papers. V. 8, 1940, pp. 119-39.

through freezing rain—of disappointment when they reached the ferry and found too few boats for a rapid crossing through the floes in the night—of Washington's voice giving orders "quietly and calmly" to miserable souls responding until the crossing was accomplished by three o'clock in the bitter morning. The story may have contributed to Hicks's resolve to paint the scene, with some print of Sully's painting for inspiration. The frame around one version bears the acorn-and-leaf motif which Edward sketched on the border of a letter that apparently he kept in his pocket—one of his mother's love letters to Isaac, mentioned earlier.

Not all the Hicks signs of this era were so pretentious. The shoemaker Van Hart's, at $3, must have been lettering and little more. The ledger indicates another for Samuel Thornton for the middling sum of $15, with no hint as to the subject.

Not only did his first preaching journeys increase his assurance. They prompted him to recommend changes unwanted by his own Friends meeting. Near-by Wrightstown needed a minister; and, it being within the authority of his group to send him, Edward besought his fellows to do so. Jealousy flared around him, and unfortunately he conducted himself "more like a soldier than a Christian," his *Memoirs* confess. A pitched battle of words, though on a Quaker scale, ensued. He considered his adversaries doubly reprehensible for nurturing among them the "seeds of Orthodoxy" (a term which, within about a decade, would describe the body of opposition in the schism among Friends). Edward and Sarah, disgusted with the "jealousy and envy," withdrew from Middletown Meeting in favor of Wrightstown, for the second time resigning from one group to join another.

As minister of Wrightstown Meeting, Edward decided to alter his life course still more by abandoning coach painting. In April, always a fateful month it seemed, he bought an eighteen-acre farm tract at the upper end of Newtown.

Farming struck him as a more desirable kind of "humble industry" than his craft, and he willingly plunged into debt for it. The cost of the land, according to the Deed Book, was $1,357.62 but he could raise only $339.42 as a down payment, agreeing to pay the balance to a "usurer" with interest. Once the experiment had failed, Edward reviewed his dilemma in his own favor, saying that "the cruel moth of usury" had eaten his "outward garment" till he had turned into a "naked bankrupt." Had he received a loan without interest, it would have been proper charity, he insisted. "Oh! this borrowing money and then borrowing again to pay interest, or leaving it unpaid until the avaricious monster, usury, comes upon the poor debtor with accumulated ruin." His tirades on this theme run to thousands of words, with little self-condemnation beyond the plaintive admission that he was not cut out for farming.

Isaac could not help Edward. The removal of the county seat must have sent him into retirement; besides, he was nearing seventy. Isaac and Samuel Hicks, rich New York cousins, came to the rescue. Edward displayed an unabashed, almost child-like talent for gracious acceptance, never deprecating his position but only complaining bitterly of his misfortune, much as if he himself did not invite it. He knew these cousins little, although he was gradually to know them better; they, and Samuel's son Henry, were to make a Samaritan's charge of him on future occasions of importance. His grateful love was apparently their only compensation other than a painting or two presented later on, which they accepted politely, quite unaware of his extraordinary talent.

Sadly, Edward turned for comfort to Abraham Chapman's earlier counsel: "Thee has now the source of independence within thyself, in thy peculiar talent for painting. Keep to it, within the bounds of innocence and usefulness, and thee can always be comfortable." In his heart he knew there was no choice. He returned to painting, his true lifework, about which, nonetheless, he would one day express these outrageous sentiments in his *Memoirs:*

If the Christian world was in the real spirit of Christ, I do not believe there would be such a thing as a fine painter in christendom. It appears clearly to me to be one of those trifling, insignificant arts, which has never been of any substantial advantage to mankind. But as the inseparable companion of voluptuousness and pride, it has presaged the downfall of empires and kingdoms; and in my view stands now enrolled among the premonitory symptoms of the rapid decline of the American Republic. But there is something of importance in the example of the primitive Christians and primitive Quakers, to mind their callings or business, and work with their own hands at such business as they are capable of, avoiding idleness and fanaticism. Had I my time to go over again I think I would take the advice given me by my old friend Abraham Chapman . . . about the time I was quitting painting.[2]

One January afternoon in 1815, Mary Hicks, aged eleven, was whiling away an hour in the pressroom of the local newssheet of the moment, *Herald of Liberty.* Overhearing a sensational rumor, she dashed forth to tell the family that Mr. Robinson, the owner, had just predicted immediate peace with England. He offered a dollar to anyone who would go to Trenton that night to get the news. Next morning a crude sign with the word "PEACE" in sensationally big letters, hung on Robinson's door. His brief publishing career, soon to be drowned in rum, knew the joy of at least this one historic issue.

The news may have been Edward's excuse to buy more land. On March 14, 1815, he bought more property from Abraham Chapman for a homestead lot on the corner of Penn and Congress. How he managed is a mystery. At any rate he was not to attempt to build until six years later.

On Christmas Eve, 1816, the last of the Hicks children, Sarah, was born, the one to bring the

[2] *Memoirs,* p. 71.

least worry. After his return to the routine of artisan painter, Edward found himself so sunk in debt because of his ill-fated farming experiment that he had to work almost endlessly to meet his obligations. His health began to fail from the strain, and pulmonary symptoms were discovered. His financial plight was no secret in Newtown; that he deplored it before all who would listen may be taken for granted. Local officials gave him street "directors" or signs to paint, as well as "index boards," when he solicited this and any work he could find in order to keep himself and family.

His prominence as a minister was unaffected by all this hardship, nor did he permit his material cares to interfere with his religious leadership. For some time he had been anxious for local Friends to establish a meeting in their midst. The courthouse now being empty, the Newtown Quakers took a year and a half's lease, holding their initial gathering in April 1815, with Edward as first speaker. At that time the village which now, for a population of about one thousand, boasts no fewer than nine places of worship, had only the already venerable red Presbyterian Church. In 1817 the Friends overcame the objections of higher meetings to building a place for worship. Seven of them, all undaunted, raised funds for the solid plain stone structure. Michael and Joseph Jenks distilled and sold a quantity of apple whiskey to raise the hundred dollars they subscribed; several members of Bucks Quarterly chanced to be distillers and did likewise; by the time the sensitive temperance committee could take a stand, the building was on the way to completion. The committee consoled itself with an attempt to stop the sale of grain spirits by Quakers and limit trade to mildly fermented fruit liquors. Edward, like others, disagreed with the proposal, insisting that he did not approve of "going into the world"[3] to take issue on this question. His objection was that politics is abhorrent.

Each man's salvation was up to himself and not a legal question.

Again Edward was first to address a Newtown meeting on the day the new building was formally opened. His text was the beloved teaching of Paul and Matthew, given him in boyhood by Mrs. Twining at her fireside. He touched on many a sensitive topic—*temperance,* which he advocated resoundingly with the assurance that he himself knew the evils of drink from sad experience; *slavery,* which he said ought to be banished by man's voluntary action rather than forcibly through organized abolition and unholy civil meddling. The women on one side, in plain dress with kerchiefs about their shoulders and grey bonnets about their strict coiffures, and the men on the other in broad-brimmed hats and plain coats, listened to him with awe.

Pleased with its progress, Newtown Meeting soon set about providing daily instructions for their children. Neighbors School, across from the meeting house, resulted.

Edward's shop accounts[4] indicate fascinating activity during this year so important in Newtown's Quaker history. Under a provocative line dated only "Nov. 1" he wrote: "To a Landscape fire board." Its cost, the fabulous sum of forty dollars, hints at its splendor, perhaps now in oblivion. *For whom was it painted? What was the subject?* Near the entry is a list of the paint and supplies which he had lately bought: "Spanish brown, vermillion, red lead, blue, okker, linseed oil, white lead, spirits of turpentine, whiting, yellow okker, putty, glass paper at 4¢ a sheet, lamp black, ¼ lb. chromate yellow," costing $1.50. For his Quaker friend, the prominent William Watts, he painted a chimney board for $25, but again the subject is a mystery. He ornamented and lettered a clock face for 75¢ for Jabez Laverns; painted decorations on oil cloth; painted milk buckets; put cyphers on gigs; gilded and ornamented chairs and settees; and, last but foremost, he painted more signs. In April

[3] Kenderdine.

[4] Bucks Co. Hist. Soc.

1818, he produced a sign for his close friend Mahlon Briggs, and, considering the cost of other store signs at a dollar—"$3.50," "$2" and "$5"—this one for "$20" must have been a fine example. The small ones may have borne the proprietors' names only. His coach-painting trade also continued apace, and now he had these helpers: Thomas Goslin, John Hubbard, D. Twining, C. Shoemaker, and W. G. Bankson. The thriving Newtown carriage maker, Alexander Van Horn, passed on the painting of many vehicles at this time and over a period of years— especially in the 1820's. William Tomlinson, who had taught Edward his craft in Four Lanes End, did likewise.

One warm July day, Edward decided to take some time off and desert his shop chores in favor of Friends' doings in Rahway, fifty miles distant, and meetings near it. He had no foreboding of tragedy when he left. The worship at Rahway was almost wordless. During the silence, an oppressive foreboding seized him. Fully expecting to preach, for he had come there by invitation, he was nonetheless moved to rise and say simply that he had little to "communicate" to these Friends. His anxious manner so alarmed his companion that he seized him at the end of meeting and tearfully asked, "Edward what is the matter?" The painter only said that he wished to turn homeward. He himself did not know what was the trouble.

When he reached home, however, he learned the cause of his troubled mood in Rahway. A tragedy had befallen his sister Eliza Violetta.

Violetta, as friends knew her, was the wife of Thomas G. Kennedy, High Sheriff of Bucks County. She had helped him rise to his much respected post. They had three sons, and she was expecting another child when death overtook her.

The evening of the day of Edward's departure for Rahway, she called Augustin, her six-year-old, to come to supper. He had been playing along the Neshaminy creek across the road. She heard a scream, and rushing forth saw Augustin's arms desperately flailing the current. Her cries quickly brought her husband and some of the neighbors, but she was already well out in the stream when Thomas, never a strong swimmer, leaped in to attempt a rescue. It seemed that the three must go down together in the whirlpool. Violetta disappeared. Thomas and the boy were ready to give up when a Negro waded forth with a plank which he reached out for their grasp and pulled them to safety. Both were near death. Violetta was found downstream some hours later.

The unfortunate young woman left an infant son and one younger than Augustin. A virtual orphan herself at the age of three, she came to this violent end at thirty-nine. There is no certainty that her father was among the mourners the day they laid her to rest in the old Presbyterian churchyard. Edward's *Memoirs* hint of a difference between Violetta and the truculent Squire Hicks. Edward was all the more thankful that his last meeting with this sister whom he dearly loved had been "agreeable." For Violetta, a village favorite, the local printer Simeon Siegfried printed a ballad about her passing. Copies are still to be seen in Newtown.[5] Her brother Gilbert in Catawissa only learned of the tragedy months later, upon his daughter Eliza's receipt of an affecting note from Edward's young daughter Susan.[6]

5, 6 Notes.

The Searcher of Hearts

THE term "landscape" appears seldom in the heretofore unpublished and unknown Hicks ledger. On June 27, 1818, the painter listed two at $30 for his friend Abraham Chapman. On July 11, 1818, he entered one for Thomas Jenks at a cost of $15, but again left no indication of the subject. Not only are these references incomplete, but they by no means account for all of his easel paintings, many genuine works signed and inscribed by him never having been noted in this record. Also, he kept the now partly-burned ledger in highly erratic fashion. Its chief value is its extension of present knowledge of his varied artisan skills and versatile output.

He had by this time demonstrated clearly that he was no ordinary artisan. Yet painting continued as a more or less routine occupation for this man who, though he admitted his fondness for what he regarded as vain daubing, put his religious concerns before it. Quaker "primitive religion" was his life's passion and almost his sole thought, concern, and preoccupation.

In 1819 he again heard "the Heavenly Shepherd" telling him to travel, first to the south in the spring, then northward by autumn. He regarded the divine call as an act of mercy, for the rescue of his health which was being destroyed by the grind of work "both day and night." He himself financed this three-thousand-mile journey on horseback, for what he deemed a high and dedicated purpose. Part of the necessary sum must have been borrowed, so that he might also leave funds for his family's keep.

Isaac Parry, close friend and an elder of a neighboring meeting, whose son was one day to marry Edward's youngest daughter Sarah, joined him. So did his good Quaker neighbor, Mathias Hutchinson. The three set out on September 4, 1819, moving slowly across northern Pennsylvania towards western New York and Bath, on to Farmington and Rochester, calling meetings at all hours, and arguing about "speculative doctrine" here and there when the silent worship was broken. In Rochester a young Vermonter decided to ride along with the party for his health.

At Raga, a new town, the justice of the peace gave them shelter. All went well till Edward chanced to say in a sermon that men, like dogs, fight in their "unredeemed state," and often need no more than a dog fight to sink to the brute level. He did not know that his host, the judge, was even then in the middle of a lawsuit to settle a quarrel about a dog fight. The meeting, fully aware of it, was most embarrassed.

On they went to Shelby, Hartland, Stateland, and Royalton, over "the ridge road," almost "as great a curiosity as the Falls of Niagara." In

another new village named Sandy Creek they rode into the midst of a fearful scourge of yellow fever, only to learn that most of the citizens were dead, ill or dying. They learned from a miller who was a "walking corpse" that the tavernkeeper had just expired. They were urged to move four miles onward to the nearest lodging—and food, because the two remaining tavernkeepers were too ill to serve them supper and had taken down their signs.

Edward's joy on sensing the "divine presence" in the meeting at Hartland, and on seeing all moved to a state of "tenderness and love" was most strangely transcended at Royalton. After he had spoken, a poorly dressed man who had knelt throughout Edward's sermon, stood up, faced the crowd, and stirringly announced that he had traveled twenty hard miles on foot in order to be present. Then he left without another word, starting homeward.

At Lewistown they crossed the Niagara, went up to Queenstown Heights, and rode on to the Falls. Since reading Alexander Wilson's "The Foresters" in Newtown, where the long narrative poem by the "father of American ornithology" received a special printing paid for by the poet's brother Joseph, Edward Hicks had yearned to behold the magnificence of this natural phenomenon. The poem, as well as "the mighty wonder of the world," animated his desire to paint the scene. After leaving their horses at the inn, Edward and his friends walked to the Falls which he was to reproduce on a fireboard some time later.

The painting is the only known version by Hicks, who presented it to the noted Quaker physician of Philadelphia, Dr. Joseph Parrish, his friend. The richly autumnal colors and certain important elements of the composition are his own. But his handling of the falls, the boiling waters below, the funnel of vapor, the ledges and forests behind, indicate strongly that he did not depend on memory so much as on an engraving after the painting by Vanderlyn,

whose work was copied for single prints and also published from the print in the papers. After adding three men to the landscape—said to be himself, Isaac and Mathias—he added his more than ordinarily animistic trees and several characteristically American animals—a moose, beaver, eagle and rattlesnake of considerable grandeur.[1] The muted fall brilliance is that of the season when he beheld brilliance. As he never painted or sketched on his journeyings, he needed the Vanderlyn model for a point of departure when he sat down to create an improvisation on it, one which is fresher, more dramatic and stimulating by far than the original work by the famous painter of portraits and historic scenes. Around the border he lettered some of Wilson's poetic lines in characteristic Caslon. Hicks also painted a Niagara sign for a Newtown hotel, with a large moose dominating the scene; although the sign is no more, the Temperance House still stands.

The wayfarers' clothing was damp, and they were chilled through, when they returned to the inn, but their request for a fire in their room was ignored by the youth in charge during the landlord's absence. This rascally clerk only swore, and scowled unobligingly. His manner was too much for the mettlesome Vermonter who had joined the trio and was about to lose his temper and leave the place when Edward Hicks tried a different tack. "Young man," he asked agreeably, "art thou an Englishman?" To this the bully gruffly answered, "I am a Swede." Edward went on to remark benignly that he had always known the Swedes to be the "most hospitable, honest people in the world," adding that the boy would not prove less so. A warm fire was the immediate result, and a good supper, and comfortable beds in which they were "soon sung and rocked to sleep" by the roaring of the Falls. The Vermonter called Edward's stratagem a "Yankee trick."

Another day found them riding along the

[1] Notes.

Ontario shores. The "deep and dry sand tired their horses," and wearied them as well and they were grateful to come to a "poor little tavern" near Burlington Bay's outlet. Isaac Parry was nearly ill from fatigue, his ponderous weight causing horseback riding to wear him out sooner than the others. While they waited for their supper a stranger entered, asking which was "the Quaker preacher," the rumor of whose eloquence had begun to cover the distance before him. Edward, keeping a solemn face, nodded toward Isaac Parry, the most dignified appearing one of the three but an elder, not a preacher. The stranger treated him with extreme deference, and they were assigned the inn's two remaining beds.

Their mild adventures continued. In York, Canada, they were received by an old man whose family's odd attire astonished them. All were dressed in uncompromising black instead of gray, and in other respects, too, seemed anything but Quaker, particularly the father. His was a brand of English hospitality, and he prided himself on being exactly the age of King George the Third. They grew quite bored with his raptures about his spying exploits during the Revolution, for which he was rewarded with the royal gift of his Canada retreat. Isaac Parry told him that Edward's grandfather was Gilbert Hicks, the Tory. He turned to the staunch young Whig and hugged him impulsively, expressing delight at meeting the grandson of his good old friend Judge Hicks. Edward inwardly recoiled, while wondering whether this man was perhaps not the same who led "the blood-thirsty General Grey to the massacre at Paoli." "Anyone acquainted with my prejudices against the English, might conclude that I was not very comfortable. . . . They would have been quite disposed to join my friend Isaac Parry in the enjoyment of this scene," he afterwards wrote. The fellow was up with them at dawn, trying vainly to urge a dram of brandy on them at parting. "The grandson of an old Tory was truly glad to escape

another embrace from this patriotic subject of his Brittanic Majesty," concluded Edward.

The town of Young Street came next. There the Methodist minister, to whom Quakers were something quite new and unheard of, offered his new house for shelter and his church for meetings. His beautiful wife was none too pleased to see them coming, but the minister sang and talked while she cooked their supper. Edward was so upset by the odd schedule of meetings that he could neither eat nor chat, much less sing. The time came for facing the crowd, which witnessed his struggle for self-composure. The church was cold. The "wind and snow were driving through the weatherboards." After the last stragglers were inside, including his host and wife, Edward, shunning the pulpit, tried to induce a silence among the people. But silent worship was something foreign to these Methodists. Then he heard a voice within him say to "stand forth," stretch out his arm, and allow the power of the Gospel to sustain him. After that his preaching began to evoke lusty yells of "Oh Lord, Jesus Christ, seal instruction upon our souls! Halleluia!" Astonished, he urged the people to quiet down that he might speak above the tumult. However, his zeal caused a spiritual geyser, and it was some minutes before a "precious silence" descended on the throng, broken only by the sobbing of the ladies as Edward defended "the rights of women" to serve as preachers. His sermon succeeded so well that his host the minister said he ought to preach it over and over. He added that he thought Methodist wives and mothers were entitled, as Edward had assured them, to stand in the pulpit when they wished. His "lovely wife" was rendered quite wordless. Edward lightly dismissed all this praise, but the suggestion that he memorize a sermon and repeat it completely repelled him.

In the next town, four miles beyond Young Street, his meeting turned out to be "dull and stupid." This he blamed on his own "lightness

and vanity" of the day before, instead of fatigue from his exertions, where the blame belonged. He was beginning to "wear Christ's jewels like a spiritual harlot," he insisted, and to behave like those ministers "who split themselves on a rock" of folly by worrying about their reputations as preachers, looking too much to "pretty texts learned by heart."

At Black Rock on the Niagara the trio left Canada and crossed again into the States, angry waters and fierce winds endangering their lives.

Attempts to hold a meeting in Batavia were thwarted by Joseph Ellicott, "wealthy agent of the Holland Company." Though he called himself a Quaker, Ellicott assured them crassly that if they wanted to buy land he was ready to do business, but he knew no place for Friends meetings. Mathias and Isaac had gone to ask his help while Edward waited for them. As they rose to leave Ellicott they said they were sorry that Farmington Friends had led them to suppose he would wish to help them. At that he cried out angrily that they could not blame *him* for their failure. Then he subsided, asking who would preach. The name of Edward Hicks sent him running for his hat and cloak; in a moment he was off through the snow after Isaac and Mathias, all smiles.

The town's finest turned out for the meeting. Friend Ellicott sent a message to Edward that he must surely preach and not disappoint that very august assemblage. Reminded that Quaker services do not proceed by plan, and that Edward would preach only if he were moved to speak, Ellicott took his place apprehensively on a front bench. He need not have worried. The sermon which emerged from Edward was so warmly received that the response made him suspicious lest he had failed to say at least something to sting this perhaps too amiable crowd, especially the sycophantic Joseph Ellicott.

At Scipio the strain of these weary weeks of travel through all kinds of weather began to tell on Isaac Parry. Suddenly, looking very faint and

ill, he announced, "Friends, I feel full of fever, as though I might be stricken with what felled so many on the Ridge Road, a few weeks back. Yet I feel that if I take to bed now I can make my way to Newtown." He recovered sufficiently to start off alone, and with nothing like so grave as yellow fever. The young Vermonter had already departed. This left only Edward and Mathias to carry on the work. They proceeded to Skaneateles and Manlius to call more and more Friends meetings.

December days of brief daylight and chill winds increased Edward's longing for home and his racking cough. On December 8, 1819, he wrote this touching letter to his wife:

Hudson, 12 mo. 8th, 1819.

My dear Sarah,

I have just arrived at this city by crossing the North river among the ice, when I expected to have found letters . . . but was disappointed. I have received none except from John Comly and Stephen Comfort . . . Oh my dear, how often I long to see thee and the dear children. I could hardly believe it would have been so hard for me to be separated from you whom I have known for sixteen years. Time, too, drags heavily along. Every day seems almost like a week, and every week like a month. . . . I sometimes see children that look like ours, at the sight of which I can scarcely restrain my tears; and once in Canada I saw a little boy that so much resembled my dear little Isaac that I had to go out and take a crying spell. Sometimes I have thought I have seen some elderly woman that looked like my dear Mother that called to mind that affectionate woman. . . .[2] How is she? Give my dear love to her, and to dear father,[3] brother Joseph [Worstall] [etc.] . . . I have no language to express how dear you all feel to me, and particularly my dear wife—I have seen nobody that looks like her. Has she anything that is needful, and does she take care of herself and avoid improper exposure? I hope through divine favour to be restored to her in the course of next month. . . . I shall count the days. . . . Thy affectionate husband,

Edward Hicks.[4]

[2] Mrs. Twining.
[3] Joseph Worstall or Isaac Hicks.
[4] Hicks Coll.

But between that day and his return lay hundreds of miles of riding through winter blasts, over wretched roads. To the preceding letter, he added a note to Mary, saying that he knew his daughter loved him and longed for his return, and that he hoped she was trying to conduct herself prayerfully at meeting. He told her to watch her temper, help her mother, and be kind to her sisters and brother. He also wrote a note for Susan: "I am sensible that I am addressing a little volatile girl that possesses so much the disposition of her Father that I am fearful that she will never become an example of stability. . . . There is no better way than to begin in youth. . . . If I had my time to go over again I would strive to improve the season that thou art now enjoying, by meditation, and prayer, and by reading the acts and sayings of Our Lord. . . . Remember thy poor father in thy prayers. I want thee on receipt of this to go and see thy dear old grandfather Hicks. Give my love to him and tell him I often think of him. I want thee likewise to give my love to thy uncle Thomas G. Kennedy and his wife and thy little cousins . . . I expect you are diligent in the attendance of meeting. . . . Tell Isaac he must take good care of the calf, pig and chickens, turkeys, geese, etc. Him and Elizabeth must remember your poor father in their prayers when they lay down to sleep. . . . Tell Charles that I impose implicit confidence in him that he will take care of everything. It gives me such a pain in my breast to write that I can only scribble a letter. Thy affectionate father."

Edward might well be solicitous, for all was only passably well in Newtown. That the family was feeling hard times is conveyed by this message from Beulah Twining, his favorite "foster" sister, taking him gently to task and addressing him as "Cousin":

Newtown 10 mo. 16 day, 1819.
I have obtained the privilege of adding to the foregoing note from thy Mary—that the domestic concerns of thy family are carefully attended to, the winter grain well and seasonably put in. The Corn is gathered and Charles supposes there is about 40 bushels. The buckwheat is cut but not threshed; there will not be many bushels. . . . I was at the house yesterday. Sarah informed me that thee had [said] to sell the stoves and, with the amount, to purchase firewood. I think it is a pity, my dear Cousin that any sacrifices of that property should be made in thy absence, and will furnish thy family with wood until thy return. This, Edward, I consider a duty. I have some trees that I can spare and have requested Charles to cut and haul them, and leave the sale of the stoves until thy return. Sally says thee mentions in one of the letters making some remittances from upper Canada, but that she wants, rather thee wants, not to trust any money to pass through the uncertain medium of a post office and thinks she can do very well without it. Her concern appears to be wholly for thee. . . .[5]

Beulah's suggestion had not yet reached him when he wrote his homesick letter from Hudson. It would have done little to lighten his cares as he traveled onward.

The Quaker hospitality of Milton, a forty-mile ride from Manlius, was doubly welcome because it was given in the cold, windy hours of dusk, without the kind family's knowing that Edward and Mathias were Friends. The visitor from Newtown did not speak there on First Day, but instead listened to the preaching of a veteran of the War of 1812. He had not revealed his identity to his host. But when he was about to ride off towards Saratoga, he was amazed to have one of these Quakers confront him with, "Art thou that Hicks that was in the western part of our State two months ago and went into Canada? Why did thee not come up to take thy seat?" He persuaded the travelers to stay for dinner and an afternoon and evening of conversation, at which Edward confessed himself no match for these "descendants of the New England Puritans." He seemed to forget that he himself was one!

Saratoga was twenty chilling miles yonder.

[5] Hicks Coll.

There they crossed the Hudson and headed for Easton and sporadic religious trouble, the worst of which was brought about through a question put by an old minister, their host. "Does the devil really exist?" he wished to know. "The doctrine of devils was to me somewhat dark and difficult," Edward said in his *Memoirs;* the minister's notion of the prince of darkness confused him more than ever, leading him again to the fear that more and more serious internal discord among Quakers was on its way. One of the meetings found him "sullenly silent." At another, where he spoke overmuch, he said he reminded himself of "a half-baked cake, and those that fed on it were like Ephraim when he fed on wind." Only a funeral in Easton managed to inspire his best ministerial fervor, so exhausted was he by his spiritual marathon of weeks and months.

He visited Troy, Cooperstown, and Newburgh, and returned to Saratoga. Mindful of the approaching end of his travelling concern, he wished to give as good an account of himself as he could. When he spoke humbly he was pleased, but when he lost patience or became "drunk with a confusion of cogitations" he sensed his failure. None of his efforts measured up to his terrible standards. Aware of this, he began to think eagerly of home.

By early January, 1820, he and Mathias were on their way across southwestern New York from Newburgh, crossing northeastern Jersey, and travelling steadily for four days without taking any meetings till they reached Newtown.

Settling down proved a hardship for him, and within a month he was on his preaching way again. The seasonal slack in painting jobs had increased his restlessness. He decided to visit all the meeting of Westbury and Rockaway, Long Island. He was also anxious to become better acquainted with his distinguished kinsman, Elias Hicks, whom he had met in 1815 when he and John Comly attended New York Yearly Meeting. As for the financing of this latest journey, were it not for an item in his ledger showing an 1820 note due his friend James Walton, who accompanied him, the question might go unanswered. Perhaps the reason for his anxiety to see Elias was his uneasiness about the growing division among Quakers, a rift which he had sensed throughout his recent travels.

How much of this dread of an impending Separation was real, how much imagined? It was not merely threatening, but actually beginning to take place, as the writings of impartial observers of American life of that era more than hint. Not the least of these was Fanny Wright d'Arusmont, friend of the redoubtable English authoress Mrs. Trollope. A famed abolitionist, reformer and eccentric, this Dundee-born woman with a European education spent many of her mature years in our cities, agitating, criticizing, and writing according to her views. Quite early in her travels she became acquainted with the Quakers, who, also advocating free speech and abolition, gave her ample chance to penetrate their circles. Some occupied places of honor as her sponsors on the speaker's public platforms, as on the occasion of her inflammatory farewell speech in Philadelphia, when she declared that Washington was not a Christian because, by owning slaves, he condoned slavery.

She visited Philadelphia in May, 1819, the spring before Edward's first long journey. The Friends meetings which she attended were peopled by the very Quakers with whom he and Elias Hicks and the "Hicksites" were to break. They were the same with whom Edward had had an altercation (as will be recalled) in 1817. In the account of her travels published in 1821, entitled *Views of Society and Manners in America,* she wrote:

Though we have found some quietism in the Society, we have found less absolute Quakerism than we expected. . . . I at first felt something like disappointment when I saw not one drab-coloured

son of Penn in it. It is very true that a man is none the better for wearing a brown coat, but I have a notion that he is sometimes the better for being a Friend. I object to the term Quakers, which was affixed to them in derision by those who could perceive their peculiarities of phrase and demeanor, but were unable to appreciate the unpresuming virtues which distinguish them yet more from every Christian sect.

We may idly speculate indeed upon the silence and quietism that might pervade this now bustling world, were all its tribes and sects resolved into one Society of Friends . . . but there is as little chance of our all turning Friends as of our all turning angels.

She remarked on the visible changes:

The Society here has very wisely relaxed some of its rules. It is no longer necessary for members to forego innocent amusements, or any honest profession; nor considered as improper form to use the second person singular rather than the plural, or to prefer drab-cloth or pearl-colored silk. . . . They must be honest members . . . and then wear what they please. . . . Did the Society not in some degree shape itself to the times, its sons would gradually cease to shape themselves to it. . . . Applauding the good sense and liberality of this society. I cannot help observing that not only has it secured to itself permanency by this wise temper, but has made a better stand against the advance of luxury than it could by more obstinate resistance. . . . The young girls are often in feathers and flowers, and this absolutely in the meeting house; but it is not unusual to throw them off, as years kill vanity by killing beauty; and even in spite of them you somehow or other, by the air of the more *posée* matron of the house, or the more reserved address of the whole family, and by . . . portraits on the walls [depicting] round-eared caps and starched handkerchiefs, can distinguish the abode of the children of peace and good works from those of other men. It were needless to recount to you the many wise laws and humane institutions for which this country is indebted to the Friends.

Only a season or so lay between her words and the coach painter's sudden visit to Long Island. If it pleased Miss Wright to think and say that "the Society has very wisely relaxed some of its rules," her views were not shared by such Quakers as Edward Hicks.

He had no more than opened his mouth in Westbury meeting when he inadvertently insulted a "hireling minister," saying that the real men of God spoke spontaneously and without pay, the gift of such holy teaching being Godsent. A minister's livelihood must come from some kind of "humble industry," he averred, rather than from "priest-craft." He spoke with vehemence, causing all heads to be lowered. He alone was bemused when told what chagrin his remarks had caused.

The sentiments of Elias Hicks led to the ultimate secession of these Friends called Hicksites. His ministerial style differed from Edward's. An illustrious patriarch almost a generation older than his Newtown kinsman, the name of this religious leader is now enshrined in Quaker history. Usually a gentle but occasionally a fierce advocate of the simple beliefs, he opposed what he considered the outward grandeur and false pretense then finding favor among Christians including the Orthodox Quakers. Further departure from the "inward light" of George Fox in the direction of evangelistic fashions of the moment might, he feared, encourage an approach to faith more arbitrary than permitted by the simple Quaker Book of Discipline. He opposed an overliteral reading of the Bible lest it become an absolute voice, the breath of which might extinguish the inner beacon. He believed that the opposing Friends tended to regard the Bible as absolute and to reject the creative, questing faith of the Light.

The rising middle class, mostly city folk, inclined to Orthodoxy. They felt the need of single scriptural meanings and objective interpretations.

Edward was glad to see Elias again. He stood for ideas which his own mind could grasp. Elias had been a carpenter by trade, self-made and largely self-educated. Like Edward he was what

is known as a "convinced" rather than birthright Friend. Despite handicaps he had risen to eminence. He advocated "quietism," the eighteenth century concept of silent worship, to be broken only by spontaneous preaching, and also "rationalism," which was opposed to such evangelistic worship as that of Methodism, which was attracting some Orthodox Quakers. Gentle, dedicated, soft-spoken, he was long-suffering under hostile attack, unlike Edward.

How did Elias regard his relative? In February, 1820, he made an entry in his Journal which is a fair indication:

The latter end of the week there came to my house my much esteemed friend and kinsman Edward Hicks . . . on a religious visit to our parts, with his companion James Walton, an elder. I accompanied them the next day to a meeting they had appointed at Westbury. It was very large. . . . Edward had very good service . . . to open to the people many important doctrines of the Christian religion. I accompanied him to all the meetings he had among us except one, and in some of them had a portion of the service laid upon me. . . . I accompanied my friend to four meetings after this, in which he was generally favoured to open things suitable to the states of the people, his gift being searching and lively. . . . The day following . . . at Rockaway . . . my part was to sit in silence. After this meeting I parted with my beloved friend and his companion, in the fellowship of the gospel. . . .[6]

From then on their paths were often to cross. They engaged in a lively correspondence when the schism grew stormy, these estimable descendants of Thomas Hicks of Long Island.

The sprightly Susan, fourteen, writing to her father on February 18, 1820, indicates how much the family missed him and longed for his welfare:

Thy valued letter, my beloved Father, dated Goshen Township 4th of the month was received this morning. . . . Although it was directed to my dear brother I have taken upon me to reply. . . . We are all well. . . . We humbly trust that He who has hitherto protected our precious father in his

devious wanderings will continue to watch over him and permit him to return in safety and health to his grateful little family. It is truly pleasant to us to hear thee say anything like turning thy face homeward . . . It is a trial to be so long separated from thee, yet, my dear Father, we had much rather endure the privation a short time longer than that thou shouldst return before thee has fully relieved thy mind and accomplished thy prospects, or that thee should hurry thyself so as to endanger thy health. Thee has mentioned having a *heavy cold,* and our anxiety is greatly increased, fearing lest thee does not take sufficient care of thyself . . . thee never is very mindful of endangering thy own health. . . . If thee has any of thy clothes washed, have them well aired and dried before thee puts them on. There is great danger of taking cold in that way. . . . Very many are the inquiries made respecting our dear, absent father. . . . We have had some excellent sleighing. . . . One afternoon we were surprised by a visit from two Orthodox girls . . . but not one word was said about Orthodoxy, and they inquired very affectionately after thee. . . . There has been considerable excitement in this place respecting the stopping of the *Mail* on the *Sabbath*—a large meeting drew up a *Remonstrance* against it, and between 50 and a 100 signed at that time. . . . Our dear mother sends best love to thee . . . My Father, I think we have been wonderfully favoured in getting along. . . .

Susan W. Hicks.[7]

On his return Edward was delighted to find a long letter from Elias, a message which must have given him not only a longed-for feeling of something like parity with an important figure of Quakerdom, but of independent achievement. This letter, offered in part, was printed in full in Edward's *Memoirs:*

My dear Edward Hicks: Having thee often in remembrance of late, with feeling and affectionate sympathy, I was induced to take up my pen . . . since the return of our mutual friend and kinsman, John Hicks, who informed me that he was favored with some of thy company on his way from his western journey. . . . I learned thou was still on the alert, and closely exercised in guarding the frontiers from beasts of prey. . . . More than beasts . . . has thy poor Elias to struggle with, to wit:—

[6] P. 389.

[7] Hicks Coll.

false brethren. . . . To be clear of all such troubles would be a real cause of rejoicing.[8]

Elias grieved that the Orthodox were forgetting that "the kingdom of God is within us," and heaven and hell but states of the soul.

No sophisticate, Edward was nonetheless astute enough to recognize which tangents of Elias's thought were the Orthodox enemy's target. Elias leaned toward the vagueness of Unitarianism in his aversion to evangelical belief. He was suspected and accused of doubting the Immaculate Conception, the divinity of Christ and other doctrines which, in fact, he did not dispute.

At a Quarterly gathering in Buckingham, a few miles from Newtown, Edward took it personally when a rich visiting minister said he believed that all ministers should be chosen by more than a local meeting. He turned vituperatively toward the visitor, whose face turned "pale and distorted" before the stunning rain of abuse. Then, soon after, at Fallsington, his flouting of a "dangerous aristocracy"—added to the incident at Buckingham—made some Friends think him quite a "suspicious if not dangerous character."

The whole Quaker temper was sensitive, just then—in Pennsylvania, New York, Long Island and New England—with many disputes arising over doctrinal interpretation. Thousands of Quakers were engaging in verbal guerrilla warfare unworthy of Miss Wright's "people of peace." None, tragically enough, seemed aware of the gravity of the breach which had been opened by trivial polemical friction. Actually, Edward seemed to enjoy it, if his letters to Elias are any indication. Irony and diatribes flowed from his pen. Challenge whetted his self-importance and afforded a pretext for reaffirming his fanatical ideas. Unanimity would have afforded no such chance as this for a battle of heavenly wits. Besides, he had grown accustomed to

talking himself righteously into trouble, the inevitable by-product of his preternatural sensitivity. He wrote Elias that the "winds of envy and rage" were by no means downing him, that he was drawing "Leviathan with a hook or cord" in his fight against "priest-craft."[9] The siege was garnering him new enemies by the score, but "persecution" of himself, Elias, John Comly, and others was to be endured, he said, in the martyr tradition. Condemnations, as he told Elias in jest, were a mill which could never grind them to powder. Elias replied that the wind could not blow Edward down because "it was blew through a goat's horn instead of a ram's horn."[10]

They could write jokingly, but in their idealistic hearts painful uneasiness was stirring. Wondering how things progressed on Edward's front, Elias would write:

I love to hear how the warfare goes on, and whether the giants are all discomfited, and slain in battle, either by smooth or rough stones, for smooth stones will not do for all. . . . Sometimes we are commanded to smite the rock, and sometimes only to speak to it. . . . At some seasons the warfare rises so high as to resemble fighting with the beasts of Ephesus. . . . I should be glad to have thy views. . . .[11]

The bitter schism had its effect on Edward's painting. His own and Elias' tendency to refer to the "beasts" in the "battle," and their allusions in sermons to biblical passages where animals are presented in order to drive home some truth or moral, took hold of his creative imagination, which, of course, engravings and popular prints importantly assisted. During this decade of strife in the Society he expressed his despair, hope, and longing for peace. Indeed his paints and brush, as well as his sermons, were eloquent statements against the world's disappointments. Based on the eleventh chapter

8 *Memoirs,* pp. 89-91.

9 Friends Hist. Lib., Swarthmore College: dated Jan. 10, 1821.
10 *Ibid.,* dated Feb. 23, 1821.
11 *Ibid.,* dated Dec. 21, 1821.

of Isaiah, the "Peaceable Kingdom" was to be repeated by Hicks in perhaps a hundred lustrous, thickly coated versions, many of them superb primitive examples. He took this means of illustrating the transformation of the brute nature by love into an ideal state. Not only did he set the lovely prophecy to verse of his own making, but he had it printed to present to friends along with the canvas. Sometimes he would print a few lines on the four sides of the frame in Caslon letters, the style of his choice:

The wolf with the lambkin dwells in peace
 his grim carnivorous thirst for blood will cease;
The beauteous leopard with his restless eye,
 shall by the kid in perfect stillness lie;

The calf, the fatling and young lion wild,
 shall all be led by one sweet little child;
The cow and the bear shall quietly partake
 of the rich food the ear and corn stalk make;

While each their peaceful young with joy survey
 as side by side on the green grass they lay;
While the old lion thwarting nature's law
 shall eat beside the ox the barley straw.

The illustrious Penn this heavenly Kingdom felt
 Then with Columbia's native sons he dealt,
Without an oath a lasting treating made
 In Christian faith beneath the elm tree's shade.[12]

The final stanza refers to "Penn's Treaty," which Hicks often included as a detail in his "Kingdom" oils, with the Delaware Water Gap behind it. When the treaty scene was painted as a separate canvas by Hicks, as it was on an indeterminate number of occasions, with some print after the classic by West as model, there was mixed religious and patriotic fervor for the task. The Quaker minister was teaching the Gospel with his paintbrush, while drawing upon an historical moment. The painter Benjamin West was also a Quaker, but he was a more sophisticated man and a great formal master. He might have been shocked by Edward's addition to his familiar masterpiece, painted in

[12] Hicks Coll. (Hicks wrote a second version which varies slightly from the above.)

bold letters forming an elaborate panel or strip on the lower canvas:

PENN'S TREATY with the INDIANS, made 1681
without an OATH, and never broken. The
foundation of Religious and Civil
Liberty, in the U. S. of America.

Thematically, Hicks related the peace-making scene to favorite lines in Isaiah bearing on the Kingdom, as if to show the fulfillment of the prophecy, as long ago pointed out by Arthur Edwin Bye, Bucks County historian and artist.

The handling of this detail varies interestingly from canvas to canvas. But Hicks drew upon, while often simplifying, the Boydell print after the large West original oil now owned by the Pennsylvania Academy of the Fine Arts. Probably Hicks never looked on the original. Some of his variants, especially the vignettes at the left in the "Kingdoms," may even be copies of woodcuts, freely revised and rearranged. But the Boydell or Boydell-Hall engraving was his probable model. The order of the figures is exactly reversed as is always the case in the copying of oils for engravings, a technical result. Hicks's colors are not like those of West, further proof that he never saw the oil. With characteristic independence he added to the scroll in imitation of Penn's hand a large-lettered, plainly legible list of the signers' names not visible on the West scroll: "Wm. Penn, Thos. Story, Thos. Lloyd, James Logan, Samuel Jennings, William Mathews." He meant Markham, not "Mathews." The Indian in the spotted leopard skin is, like other details, his own creation. He does not appear to have referred to the N. Currier lithographs, these being not only correctly colored in general but probably too late, though the known Hicks examples are undated. In the Albright Gallery's "Kingdom"—a superlative piece—the treaty scene is an extremely free interpretation of what Hicks plainly regarded as a glorious moment in history. It denotes little if any reference to the West work or to its vast engraved progeny.

41

In some of the "Kingdom" oils Hicks substituted the Natural Bridge of Virginia for the treaty scene—also copied from one of the innumerable prints of that favorite phenomenon of nature. In at least one "Kingdom," one owned by Robert W. Carle, the big bridge is directly behind the group of animals, and the treaty group is off at the left.

Here it is appropriate to set forth certain observations concerning the "Peaceable Kingdom" which emerge from long and careful study. First of all, the group of one child, lion, and two or three other creatures which the painter derived from Richard Westall, as illustrated in these pages, would seem to be the first general type of "Kingdom" that he painted. Two Quaker booksellers and publishers of Bibles—Carey, and Kimber & Sharpless, both of Philadelphia—included the Westall work in editions of the New Testament over a period of years (1816 to 1829), the interval when Hicks began painting his earliest scenes, according to his ledger. Several engravers copied the Westall work.[13] In fact, Westall's pictures of the New Testament stories appear to have been very popular among Bible and Common Prayer book publishers; Collins of New York also had the scenes engraved. At least seven versions were found at the American Bible Society in New York in the course of this study, all of them in the above imprints of the two cities named. It might have amused Hicks, had he known, that the prolific illustrator Richard Westall (1765-1836) was Queen Victoria's drawing teacher in her youth. The Westall drawing, also entitled "The Peaceable Kingdom," quotes the famed lines of Isaiah so dear to Hicks.

From the comparatively simple Westall composition, to which Hicks sometimes added a Natural Bridge, or a Penn's Treaty, or a vision of Pendle Hill in England, Hicks went on to his more ambitious "peaceable" fabrications. Doubtless he continued the first type while developing the second, which, as time proved, was to lead him into a final period of greatest brilliance, in which the animals and children are integrated in a way which approaches that of formal painting. The striking, seemingly crowded middle-period "Kingdoms," with their bold, large beasts—especially the lion, ox and leopard—vary one from another, but all are imposed on the landscape like bits of collage. Comparison of many examples will prove that Hicks repeated certain specific lions—perhaps fewer than half a dozen pet models—specific leopards, children, and so on in fresh combinations. Rarely does one find two so nearly identical as the "Kingdoms" of the Metropolitan Museum of Art, the Worcester Art Museum, the Brooklyn Museum, and the Philadelphia Museum of Art. Even these crowded, busy examples have a subtle balance of weight and a logic all their own. The wolf, with upraised paw, varies perhaps least of all and appears with remarkable regularity in this attitude in the second general grouping.

Hicks's third period, his most accomplished, has not so much the suggestion of collage. The Grossman example of the "Kingdom" belongs to it, and dates about 1845 or 1846. Details of the "Noah's Ark" show him able to criticize and improve upon his model with skill and judgment. The last of his "Kingdoms," as well as one similar to it at the St. Etienne Gallery in New York, illustrated on page 161, have a truly pastoral pictorial quality, with no effect of markedly primitive crowding. The "Grave of William Penn," also of this final period, shows Hicks capable of new finesse and of drawing the animal group as it pleased him to depart from the lithograph which inspired him.

The handling of color by the artist progressed quite as subtly as his composition, from very thick[14] and rich to subtler (almost pastel, here and there) and generally lighter technique on

[14] Except for the fireboards, painting on board prohibiting thick brushwork.

canvas which came with years of practice. That is why the writer elects to place the separate "Penn's Treaty" examples in either the early or early-middle group of his works rather than in the last decade, his third period.

A study of Hicks's repetition of a certain child figure proves rewarding. The infant that is often held in check by a ribbon around it in the hands of an older girl child in the "Kingdoms"—the one shown exploring the cockatrice's hole or else holding the serpent—seems to have been lifted bodily from the arms of a Raphael Madonna in Bible engravings popular with Friends. An edition from the Quaker publishers, Kimber & Sharpless, shows the Virgin and Child in engravings after Raphael and Holbein, with the infant in the precise attitude, drapery and outline later appropriated by Hicks. The otherwise unaccountably crouching baby of his landscapes thus originated, unmistakably. The drapery in Raphael's "St. John in the Wilderness," among many other Renaissance examples by other painters that might be cited as inspiration, are commonly seen in Bibles issued by American Quaker houses of Hicks's day. The Kimbers, in fact, were his friends.

Sometimes Hicks's figure of the little girl in the Westall composition wears filmy pantalettes, other times a knee-length skirt. She may be blonde or brunette; the sprig she holds varies in kind from one oil to another. Often she wears a locket and a bodice. One such child seems derived from a beribboned cherub called "Happiness" in an engraving by B. Smith[15] after the painting by Rigaud. The latter print, with its companion entitled "Providence," hung in Hicks's bedroom until, and long after, his death. One wonders whether it may somehow stem from Major Archambault's period of residence in Newtown. Archambault was Napoleon's equerry. Old Squire Hicks, Edward's father, acquired a mirror which had been in the house

that served as headquarters for Washington in Newtown. Why could not the Rigaud prints have similarly come into Edward's hands from Archambault?

The painter's children and grandchildren occasionally visited art exhibitions, but there is no hint that Edward ever did so. To repeat at the risk of becoming soporific, let it be stressed that Hicks relied on indirect inspiration for all his output except some of his farmscapes; but at least two farm scenes also contain elements borrowed from illustrations. One or two animal woodcuts from periodicals are pressed in his Bible which, incidentally, he did not draw upon for inspiration, preferring other Bible illustrations. He expressed scorn for those who "paid money" to look on art. He said that truly devout persons only needed "their spiritual eye" to be able to recognize the same awful spectacle in themselves as the one portrayed by Benjamin West on canvas "in his celebrated picture of Christ rejected." The painting was being shown in a building especially erected for its exhibition, in connection with a fund-raising drive for the Pennsylvania Hospital. Edward's shockingly provincial and narrow attitude towards an art event for charity powerfully hints that he himself would not attend an exhibition of paintings, even free of charge.

For comparison or contrast, or relative appraisal, the name of Henri Rousseau (1844-1910)—that unlettered French primitive painter—is inevitably mentioned along with Hicks. Both were untrained, and if not exactly contemporaries they may be called contiguous in date; their fondness for depicting animals also links them. Both painted animals in idyllic settings. There the comparison might end, but seldom does. As to points of contrast, Hicks was at least Rousseau's peer if not his superior at that technical skill which artists term "finish," involving glaze, varnish, surface, and painted detail, but he was primarily a copyist. He did not permit

[15] Original presented to London, King George III and Queen Charlotte in 1799.

his creative imagination the unbridled and exotic range which marks the work of Rousseau, whose capacity for fantasy—sometimes enigmatic fantasy—was unashamedly boundless. Hicks's Quaker conscience, which constantly belittled and abused his "weakness" for painting, demanded sublimation to always inspirational heights—religious, patriotic. Rousseau, a poor *douanier*, escaped his prosaic Paris existence by painting tropical scenes which his soul could inhabit. Hicks's escape was into the Lord's promised "peaceable kingdom of the branch." He assembled his paradise from various sources, on which he imposed his own poetic concept of ideal beauty, with his own spirit the motivating force for creating his esthetic. He had a message, a Quaker message. Rousseau talked of paradise through his pictures, but the god which dominated the world of his escape was, simply, Nature.

Many Fiery Baptisms

THE winter of 1822 was one of anguish. While Edward was visiting Friends meetings in Philadelphia in the line of duty, his paint shop burned to the ground—with all its oil paintings, signs, and supplies. As if that were not adversity enough, he fell critically ill "with chill and fever" in a home where he had stopped to call on his way back to Newtown. For eight days he lay in delirium, near death. After trying the popular "bleeding" cure, his host sent for Edward's own village doctor five miles distant. Beulah Twining, the always dependable Beulah, drove Sarah and young Isaac to his side. Isaac, thirteen, after begging to be taken to his father, wept bitterly when he saw his condition. But Edward, after his case was pronounced hopeless, recovered, and with the immutable conviction that his life had been spared for some divine purpose. Reminiscing upon the ordeal in his *Memoirs*, he disclosed his predilection for supernatural meanings:

The only thing I remember at the friend's house was my son sitting, holding my head, and weeping. Next day they brought me home, in a carriage, and I can remember when they carried me into my own house. I am afraid I shall be tediously particular, because of something that was thought, by some, rather remarkable. During my delirium I spoke of the rotten state of a certain Bank whose credit then stood very high. One of my physicians being a director of said bank was made to marvel a little at my saying I saw men secretly at work in the dark, and some of them with plain coats on, in a fraudulent and clandestine manner, which must end in the failure of the institution. But it was still more marvellous that this prophecy in a delirium should be fulfilled in less than a year, by the disgraceful bankruptcy of that anti-Christian nursery of usury.[1]

Somewhat embarrassed by his clairvoyance, he conceded that this manifestation could, like most "wonders," be rationally explained. The cashier had died just before he himself was stricken. But they had met in the cashier's final hours and the dying man had tried to talk about the bank and his troubles. Edward had turned the talk to salvation, and when he became ill on the way home, his friend's only partly confessed anxieties returned to harass him. Elizabeth, sensitive and religious, had a premonition of her father's recovery. Seeing her mother and sisters nearly overcome with grief and worry, she took her Bible into a corner to read and pray; then, a look of exaltation on her face, she announced confidently to the family: "I think Father will get well, for as I read my Bible something seems to tell me that he will."[2]

When the rumor of his illness spread to Phila-

[1] *Memoirs*, p. 101.
[2] *Ibid.*

delphia, where the Friends had packed their meetinghouse to hear him, heartfelt concern arose for his recovery. The news also traveled to New York and Long Island. Elias wrote with sympathy and affection:

Jericho 9th of 4th mo., 1822.

Dear friend

I have, for a considerable time past, almost every day, anticipated the pleasure of communing with my beloved friend Edward Hicks face to face on Long Island. . . . I was recently informed that an accident by fire had consumed his covert of temporal amusement, and place of industry, (where, like little Paul of old, he laboured with his hands for his own and family's comfortable support), as also his implements for carrying on his work, with other materials of considerable amount, and therefore not a small loss. Added to that, I have been lately informed that, while engaging in labour in his Master's vineyard, he was seized with such bodily affliction as to unfit him for the present to proceed in his religious labours, and also to render him unable for bodily exercise, and labouring with his hands in his workshop, had it escaped the flames.

Now my dear friend are not these lessons of very deep instruction? They shew how very unfit, and incapable we are of laying out or making any appointments of our own that will insure to us any real good, either in temporals or spirituals . . . [God] keeps the reins in his own hand, like the well-advised husbandman when breaking the horse. . . . His first business is to learn him to lead, so as to follow his master cheerfully, contrary to his will; but this he never does until he makes himself very sore by his own obstinate hanging back, and refusing to go. . . . How very seldom is man brought to this completely passive state. . . . Jesus Christ was brought to it by the things he suffered. . . . Did men and women attend strictly and faithfully to the inward manifestations of truth . . . thousands would be soon brought into this happy passive state. . . . Many we see have not been able to endure those fiery baptisms. . . . But I hope better things of my dear Edward, who has passed through the ordeal of many fiery baptisms, and has been thereby induced to dig deep, through the sandy, superficial justice of tradition and superstition to the imperishable foundation, the rock that is immovable. Therefore stand fast, my dear friend, in that liberty in which the truth has made us free,

and be not entangled with any yoke of bondage. . . . "Every son that the Father loveth, He chasteneth" . . . and . . . "If we are without chastisement we are bastards and not sons." . . . I rest thy sure and affectionate friend.

Elias Hicks.[3]

This uncommonly devout message reflects the rare quality of the leader's ministry, manifestly superior to that of his aspiring Newtown kinsman, widely respected though Edward was for his gift of words. It will explain Elias' greatness to those unfamiliar with his rôle in Quaker history.

Samuel Hicks and his wife Sarah, kindly New York merchant cousins, were also moved to write to the hapless painter:

New York 2nd mo 28th, 1822.

Dear cousin

Our minds have heard of the loss of thy paint shop and its contents by fire. This no doubt is a trying circumstance, but we hope and trust thou art center'd in the quiet on the occasion, as thou continues to confide in that everlasting arm of mercy, which has in former seasons been thy support, I believe thou wilt also continue to witness it both spiritually and temporally. . . . We feel anxious to hear from thee respecting it, and wish thee to send an account of what thou mayst suppose is the aggregate loss thou hast sustained.

We have heard a rumor that thou wast likely to visit us soon. . . . I have a particular wish thou shouldst attend our Yearly Meeting, but whenever thou believest right and best for thee we shall be glad to see thee, and wish thee to put in practice a promise which thou made me, that when thou came again thou wouldst bring thy eldest daughter with thee. . . . Sarah H. Hicks.[4]

Sarah's suggestion regarding Edward's bringing Mary was a straw in the wind. Mary, the eldest, always sickly, was not to join him, but his quick, keen, and worldly Susan would go along. Indeed her whole life course would be changed by the visit.

Spring found Edward sufficiently recovered from his losses to be able to brood about the

[3] Friends Hist. Lib., Swarthmore College.
[4] Hicks Coll.

threatening division of Friends, and to wish he might travel and preach among them. How he managed to finance another journey, so soon after the wiping out of his shop, can be pieced together by means of available facts. Samuel Hicks of New York advanced sums. And on April 10, 1821, he sold the house he had bought from Chapman to John Comly for the exact amount which he had paid for it: $1,200. This meant cash in hand, though much of it must have gone toward the building of his new house at the corner of Penn and Congress on the lot bought in 1815. He also rebuilt his shop on the new home lot, and, a lively spring and summer coach-painting trade being in prospect, he decided to depart for meetings in Baltimore.

The journey was rewarding. It was the occasion for renewing and strengthening many old friendships, notably that of the Wilmington Quaker of the well-known clock-making family, Benjamin Ferris.[5] Though Ferris himself was a clever artist, nothing suggests that art was the bond between them; he was a conveyancer and surveyor by profession. (Later in life he was to become nobly involved in an appeal to Congress to aid the Seneca Indians.) The schism was the catalyst of this friendship, one so steadfast that, after Edward's death, the erudite Ferris would be asked by the family to write the preface to the Hicks Memoirs; why he failed to do so is unknown.

On the return, Edward's life was once more endangered. Far out in Chesapeake Bay the steamboat carrying him and his horse and carriage from Baltimore rammed into an unlighted schooner in the darkness. Stripped of half a dozen of its paddles, the steamer fared better than the sailboat, whose captain's son, asleep in the hold, drowned in the waters of the bay. The steamer limped along slowly, only reaching its destination by sunrise. Edward, enormously relieved to disembark, traveled onward by land to Philadelphia and Newtown.

By autumn the rigors of travel were quite forgotten, and the painter was off to New York for Yearly Meeting, an auspicious occasion. An English Friends minister who was present suggested that they dine one evening, but, afraid of his own intense prejudice, Edward declined, afterwards writing: "His blunt honesty of expression and my hot-headed Americanism coming in contact might make bad worse." The two antagonistic groups of Friends exerted feverish efforts to "strengthen their respective armies." The Memoirs recount how "something like a drawn battle was fought, when both sides claimed the victory . . . Elias was wounded, and as soon as he got in the carriage and the glasses were put up, he threw himself back and wept like a child." Edward hoped that Elias was comforted "by an holy angel" as Elijah had been in his hour of tribulation.[6]

The schism grew in malevolence. Many Friends came from England to champion the Orthodox cause, "spreading themselves over the continent" and, according to Edward, sowing dissension. Disposed to exaggerate in anger, and anxious to incite the Hicksites against "the enemy," he said the English were importing "machinery" for "disowning" or excommunicating dissidents, and advocating the hiring of lawyers and civil officers to quell them.

The wonder is that he finished any painting in those troubled days. In spite of all, his output was considerable. The numerous Hickses of New York, Brooklyn, and Long Island were providing a welcome flow of carriage-painting business. If the vehicles required repair he passed the work along to local wheelwrights. His correspondence as to such transactions is sheer delight, as for instance this letter from John D. Hicks, who described the rigors of a wagon trip between Newtown and Westbury, Long Island:

[5] His own book, History of the Original Settlements on the Delaware, is today a collectors' item.

[6] Friends Historical Library, Swarthmore College.

Westbury, 3 mo 7th, 1823

Dear Cousin Edward Hicks,

After we left thy house we went on without accident till we got a short distance this side of Trenton, when we were again disturbed by our wheel running off and loosing two of the linch-pins and the box out of the fore wheel. But we made out to get six miles to our own waggon and found it just finished. We went on to the tavern where we borrowed the one we came to thy house in, thence proceeded to Rahway or near it, where we stayed all night. The next morning proving very stormy we did not get under weigh till near noon and landed in New York that evening, meeting but the small accident of a wheel running near off and loosing the end board, thus ending a short journey but so replete with disaster as kept us uneasy and on the lookout. . . . I think I will not venture in Jersey again with a Long Island waggon in the winter. It was unpleasing, the ruts being so deep and cut up, and our waggon being two or three inches narrower than Jersey ones. Whitehead took a very heavy cold the day we got to N. York in the rain, which made him very sick for a week or more. . . . Uncle Elias returned to us again safe and sound, notwithstanding the inveterate war that was waged against him in your metropolis and head-quarters of knowledge and information, which many (and, I hope, some of the actors themselves) are grieved for.

I have been thinking about the carriage I spoke for at Newtown. . . . I will endeavor to come in five or six months, as I suppose it will do to travel in Jersey then with my horses, and bring it away. . . . I hope it may suit in every way, especially in plainness, as my going to Pennsylvania to procure a carriage has excited the curiosity of several friends and neighbours. I have been inquired the quality and price, which has excited surprise, several hardly believing so coarse a man as John D. Hicks would want a nice carriage. Others hardly think a nice carriage could be got even in Pennsylvania for $200, as they are much higher hereaway. It may be that A. Van Horn will have more custom this way if the carriage suits the taste of the friends this way, as several have desired to see it when it comes home. . . .

I heard Willet Hicks speak of sending his carriage to Edward Hicks to paint this summer. I, with many others of thy relations here, wish to see thee here this summer. Try to be ready to come with the carriage, and Mary too, and take Willet's carriage back to Newtown when you return. I believe I must conclude with mentioning that a great deal of love is wished to be sent to you all by your relatives here. . . .[7]

Edward helped the relatives order coaches from Alexander Van Horn,[8] Silas Philipps, and the Tomlinsons at bargain prices, obtaining the painting of each vehicle when it was ready, and, perhaps, a commission from the wheelwrights. The delivery system was most agreeable all around.

The New York Hickses became a kind of absentee power in Newtown. One had contributed to the building of the Friends school. Another helped finance Edward's travels, and also took an interest in his crises. It comes as no surprise to find Thomas Kennedy, who with his son had been rescued from Neshaminy creek a few years earlier, wondering whether Edward would ask Samuel Hicks, a ship owner, help his son Augustin become "a master of the art of navigation." His letter is one of no little charm and historical interest, and Samuel's reply is hardly less so.[9] Edward's continuing exchange with Elias, some of which has unfortunately disappeared, extends awareness of the personal and futile temper of the Quaker schism.[10]

The year 1824 found Edward Hicks at home attending to business. Phillips, the coachmaker, was passing along to him the painting of many gigs and wagons, a goodly number of which were ordered by Edward's Maryland connections, who preferred to have their vehicles delivered. Despite a brisk business he was still so deeply in debt that he was having to pay for quantities of coach paint by installments to one Isaac Cole, his ledger shows. It appears that he was even reduced to collecting petty sums for

[7] Hicks Coll.
[8] A Hicks ledger item shows A. Van Horn owing $16 as Hicks's share on a coach-repair job totaling $32.
[9] See Notes.
[10] See Notes.

small considerations from persons in the vicinity who owed money to his friends at a distance. Letters in the Historical Society of Pennsylvania show him being appealed to by a William Deans of Christiana Bridge, Delaware, to collect a note given for a gold watch, and another for a loan to a man whose fishnet Deans had purchased for him to set him up in business.

Squire Hicks, nearly eighty, moving along in a century to which he was a stranger, had seen his best days. Yet in 1825 he was busy with an amazing avocation which gave vent to his life-long love of books. He was writing a "Chronology of the Great Events, from the Creation to A.D. 1825,"[11] one of many such hand-inscribed amateur histories which were a fad among the retired and aged. With erudition both quaint and humorous, Isaac showed surprising familiarity with the classics and the Old Testament. Guthrie was his principal source. Possibly a book printed in Newtown in 1804—the first book to be published in Bucks County—influenced him to begin his ambitious work: The Reverend John Adams' *Flowers of Modern History; the Most Remarkable Revolutions and Events—with a View of the Progress of Society—to the Conclusion of the American War; designed for the Improvement and Entertainment of Youth.* One wonders whether his work on the chronology did not suffer, at least momentarily that summer, when he received the disturbing news from Catawissa that his son Gilbert's eighteen-year-old William was drowned in the Susquehanna. (Gilbert had known his share of grief, his first wife having died in childbirth.)

To whom were Edward's "Kingdoms" now going and how were they received? Available answers, though interesting, are by no means conclusive. They went to Friends and to coach painting clients in New York and elsewhere,

either as gifts or at prices which for the time were fairly high. The following letters, the first of which indicates no real awareness of his talent, and the second at least a flattering sympathy, may well be typical of others since destroyed:

New York 4 mo. 20th, 1826.
Dear Friend,
Thy letter dated yesterday was received and on perusing it the thought immediately presented that thou wast hurrying thyself unnecessarily in finishing my gig. Now my particular request is that thou wilt not give thyself any uneasiness about it, for it will suit me much better that it is finished in *thy time.* We are particularly anxious that thou shouldst attend our Yearly Meeting, and do not fail to bring thy wife. . . . Thou wilt very much oblige me by having a general cover made for my gig, to throw over it when not in use.
Martha unites with me in love to thyself and family. We received the Painting, and are very much pleased with it, and I shall not be found backward in remunerating you for it. . . . John Cheesman. [A prominent New York physician and Hicksite.][12]

New York, 5 mo. 1st, 1826.
Dear Coz Edward Hicks,
Thy letter of 4 mo. 7th was rec'd some time since, and I should have answered it immediately, but thee mentioned thy intentions of being in our City in a few days. . . . We have received the Painting thee was pleased to present us with. We feel much obliged and shall keep it as a Choice Memorial of thy friendship. A number of our friends have called to see it. They all united with us in its being executed in a masterly style, which must have taken a good deal of time and labor, which I, however, do not profess to be a judge of. I have enclosed for thee a check on the Schuylkill Bank of Philadelphia, made payable to thy order for one hundred dollars, which please accept.
I hope thee will not fail to be at our Yearly Meeting, as we shall be much gratified to have thy company, and shall probably need thy help, for the Orthodox continue to dispute every inch of ground with us. . . . from thy Coz,

Silas Hicks.[13]

[11] Hicks Coll.

[12] Hicks Coll.
[13] *Ibid.*

49

The painter must by this time have been fully identified with the "Peaceable Kingdom," both in his own mind and heart and among his many acquaintances. This mirror in oils of the idealist, dreamer, visionary, poet, mystic and, above all, religious perfectionist *is* Edward Hicks—pure and distilled, portrayed through traditional symbols of innocence and beauty. To attempt such a theme as sympathetically as he did, he had to possess such spiritual resources as cannot be purchased by tuition from an academy or borrowed from what he frankly copied, like so many rules or tools. Without a real measure of inner richness he could not have conveyed his message so movingly in oils that, at least to this writer, the result denotes genius and, in its more eloquent moments, great painting—spiritually— if not technically in the strict or formal sense of the term. On August 26, 1826, he completed an exquisite version for a friend of Fallsington Meeting, close by. Harrison Streeter prized this gift all his life, willing it to Charles Willis of Newtown, the present owner. It bears a large signature on the back: "Edward Hicks, Newtown, Bucks County, Penn^a, 8 mo^th 26^th, 1826." These paintings, often but not always inscribed to the recipient, were unfortunately not invariably signed or dated.

Quaker troubles intensified the artist's devotion to the allegorical theme of the "Peaceable Kingdom." It reflected not only man's conflicts and his paradoxical nature, with humanity's jungle components added, but it also expressed the painter's longing to be tranquil and at peace, free from his own ranting and fulminations.

Edward's somewhat confining year of shop-work was relieved by one stimulating event, the visit of Elias Hicks to Bucks County in December. On December 18 he preached a sermon in Newtown, one much to Edward's liking. Elias, nearly eighty yet tall, powerful, and patriarchal, was beginning to bear some scars from the buffetings he was receiving in the course of the

Orthodox siege. At Fallsington on December 20 he uttered truths which no doubt served as food for thought for the always ruminative Edward in the days that followed as he worked away in his paint shop:

There is much mischief done in the world by reporting hearsays in relation to men who have lived before us, and of men living now. . . . We ought always to know everything we speak to be truth. . . . Many great quarrels have arisen from this course. . . . I have not found in all my life and experience any way to come to a knowledge of God but by what is manifested in the secret of my soul. . . . Gather attention to God within, to the truth within, to the light within, to the grace within. . . .[14]

That Edward was endeavoring with all his frail and irascible might to follow Elias' bidding there can be no doubt. He had borne a year of such personal sorrow as would have served to make even a less stalwart soul turn to heaven for comfort. Beulah Twining, his favorite "adopted sister"—seen in the doorway of his painting called "The Twining Farm" in the Metropolitan Museum—died of cancer a month before Elias' visit to the region. Shrewd and hard-working, this woman who, forty years before, had returned impoverished to her father's house from a broken marriage, had become rich but left Edward not so much as a Federal penny. Childless and without heirs but for a few nieces and nephews, she might easily have willed him at least a token sum to ease his perpetual money worries. She knew of his struggles and had been observant and critical of his business fumblings. He himself would have us believe, in his *Memoirs*, that Beulah was carrying out his wishes by ignoring him: "I felt that I had lost one of my best friends, a loss . . . not relieved by any consideration of gain, for, agreeable to my advice, she left me not one cent of her estate, which has caused me frequently to rejoice when I saw myself clear of that ravening wolfish spirit

[14] *The Quaker*, V. 2, no. 6; Newtown sermon: V. 4, pp. 161-84.

that too often attends the settling of such estates." Perhaps the thoughts that followed disclose some bitterness. He said that Beulah's girlhood was a fine example for other young women to eschew, because she had filled her head with nonsense: "A young girl that will indulge her inclination to read novels will soon be prepared to prefer bad company to good; and hence, too, many lovely young women, when they come upon the stage of life, enter the wide gate and walk in the broad way that leads to the destruction of their peace and happiness in this world, if not in the world to come." That was not enough. He spoke to Beulah, by then safe from hearing: "Dear adopted sister . . . thy history would furnish materials for one of the most interesting pernicious novels."[15]

[15] *Memoirs*, p. 22.

51

Master of the House, Beelzebub

THE fateful year of the Separation, 1827, turned the tide of Quaker history. Local dissension had spread to sharp and widespread conflict. New York and Philadelphia, scenes of the final crisis, can be envisioned with the aid of such writers as Dickens and Mrs. Trollope. Both found Philadelphia attractive but with streets too monotonously regular, their row upon row of tall, nearly identical houses in chaste array more respectable than lovely. Both observers thought it a rather provincial city, preferring New York's attractions despite its crooked streets, bustle, and tumult. To Mrs. Trollope we are indebted for this description of an Orthodox meeting, peopled by adversaries of Elias and Edward Hicks:

At Philadelphia, I went under the protection of a Quaker lady to the principal *orthodox* meeting of the city. The building is large . . . without ornament; the men and women are separated by a rail which divides it into two equal parts. . . . I spied many pretty faces peeping from the prim headgear of the females, and as the broad-brimmed males sat down, the welcome Parney supposes prepared for them in heaven recurred to me,

"Entre donc, et garde ton chapeau."

The little bonnets and the large hats were ranged in long rows, and their stillness was for a long time so unbroken that I could hardly persuade myself the figures . . . were alive. . . . At length a grave square man arose, laid aside his ample beaver, and after another solemn interval of silence, he gave a deep groan, and [with] effort uttered, 'Keep thy foot.' Again he was silent. Then he continued for more than an hour to put forth one word at a time. . . . My Quaker friend regretted I had heard so poor a preacher. . . . A gentleman-like old man arose, and delivered a few moral sentences in an agreeable manner. Soon after he had sat down the whole congregation rose, I know not at what signal, and made their exit. It is a singular kind of worship . . . yet it appeared to me, in its decent quietness, infinitely preferable to what I had witnessed at the Presbyterian and Methodist Meeting-houses. A great schism had lately taken place among the Quakers of Philadelphia, many objecting to the over-strict discipline of the Orthodox. Among the seceders there are again various shades of difference. I met many who called themselves Unitarian Quakers, others were Hicksites, and others again, though still wearing the Quaker habit, were said to be Deists. . . .

The religious severity of Philadelphian manners is in nothing more conspicuous than in the number of chains thrown across the streets on a Sunday to prevent horses and carriages from passing. . . . What the gentlemen of Philadelphia do with themselves on a Sunday, I will not pretend to guess, but the prodigious majority of females in the churches is very remarkable. Although a large proportion of the population are Quakers, the same extraordinary variety of faith exists here as everywhere else in the Union. . . .[1]

[1] *Domestic Manners of the Americans*, V. 2, pp. 92-94. (Mrs. T. arrived in 1828; Dickens a decade later.)

52

Such was the comfortable, proud, urban citadel faced by the rustic, rural and humble Hickses, John Comly, Emmor Kimber, among others—not that all Hicksites were from the purlieus, but their leaders seemed cut from the homespun cloth of the English founder George Fox. Imbued with the mysticism of the masses, they distrusted too literal a reading of the miracles. They thought of Christ less as God than as prophet and reformer; they were apprehensive of accepting the Immaculate Conception lest it send Friends "full gallop to Rome," as Edward expressed it. Evangelism, Trinitarianism, and other such concepts seemed to them obstacles to silent worship and creative faith. The Orthodox, on the other hand, found the old eighteenth-century quietism too close to anti-Christ, except with its constant and literal reference to the Scriptures. These early Hicksites, advocating the "primitive religion," thought that higher education's importance could be overestimated; some of them—Edward for one—actually disapproved of its effects. They frowned on music and the arts as a waste of energy or emotion which belonged, they felt, in quiet religious channels. Religious scholars today point out that the Hicksite weakness which cost them some members was the ease with which silent worship could become a protective cloak to the less devout, who inclined to use it to hide their too effortless, rather routinized worship. The more vocal practices of the Orthodox required or encouraged visible or audible participation. The Hicksites were proudest of their artisans and farmers; the Orthodox had many doctors and lawyers among them. Both shunned public office; since the failure of Penn's "Holy Experiment" in the French and Indian wars, they were disinclined on principle to take oaths of loyalty.[2]

[2] The Friends are an independent rather than Protestant sect. There is a sentiment among Friends today, given annual expression through the newly formed General Yearly Meeting for Union (of Orthodox and Hicksites), that the Separation might well have been prevented, bitterness having been

Edward Hicks, visited by a portentous sign, believed it to be divinely created:

In the latter part of the second month of this year, 1827, John Comly came to see me. I had just received an anonymous letter. . . . The writer mentioned that he had dreamed that he was in a very large field, which had been planted with corn that had come up and grown some six or eight inches, but a severe frost had come on it, and it was wilting down. In this large field he thought he saw me very industriously at work, trying to hold up the corn or make it stand straight. . . . He thought in his dream it was such a pity for me to be spending my time to no good purpose that he tried to persuade me to give it up and leave the field. But he said he thought I answered I was determined not to leave the field until I tried to save some of the corn. . . . This letter I shewed John Comly [who said] the letter appeared to be significant . . . one thing appeared to him certain, that the Society was in danger of being scattered, and that something ought to be done immediately to keep us together . . . [and] to prepare for a peaceable and quiet retreat.

Finding that John was under great discouragement, I thought to cheer him up a little by telling him that he reminded me of Lucian in the Roman Senate when Caesar, with a powerful army, was approaching Rome to destroy the last vestige of the republic. . . . Lucian "confessed his thoughts were turned on peace and said it was time to sheathe the sword and spare mankind, that it was not Caesar but the Gods he feared." And, while I certainly ought to prefer the peaceful and Christian-like spirit of John Comly, I was too much like Semphronius, another Senator, whose voice was still for war.[3]

Edward, as he demonstrated at Bucks Quarterly Meeting in a fiery speech a few days later, was indeed like Semphronius. The visiting English Friend, Elizabeth Robson, disliked to hear him say that British Friends were declining into a mere "stronghold of anti-Christ." Fighting words for a Quaker! But then, here was one in whose veins flowed the blood of Ellis Hicks,

deeper than actual differences warranted in this not so holy division.
[3] *Memoirs*, pp. 106-7.

knighted on the field by Edward the Black Prince at Poitiers in 1356 for capturing the French colors—a fact possibly explaining the popularity of the name of Edward in the Hicks family. After his first clash with the English-woman he mused outrageously: "Happy would it have been for Friends in America, could that evil genius that is producing such sad effects have been kept on the other side of the Atlantic. . . . Let, then, the descendants of the worthy companions of William Penn stand firm as Christian soldiers in defense of the sacred boon, religious liberty, purchased at the expense of the blood and suffering of their honorable progenitors."[4] John Comly, for one, was alarmed and distressed by Edward's likening the schism to the American Revolution.

Next day, in Newtown, Elizabeth Robson bravely reappeared at meeting. Edward approached her as if nothing had happened. "Will Elizabeth Robson go home with Edward Hicks and take some dinner?" he asked her.

"I understand he is much opposed to English Friends," she replied.

"Edward Hicks professes to be a Christian, and, consequently, ought to be a gentleman and treat English as well as American Friends kindly, especially at his own house—come and see," he said.

Had she not promptly parried with this nettling answer he might have kept his temper: "If Edward Hicks professes to be a Christian and a gentleman, I confess I am at a loss to reconcile his false statements of yesterday."

He defied her to show him in what way he had spoken falsely. The companion of the infuriated woman stepped up and led her from the room. Without one visible trace of regret he reminisced in his *Memoirs* about this rude encounter, as though he himself were blameless:

I do not entertain hard feeling towards Elizabeth Robson, and am far from wishing to charge her with acting unladylike. She no doubt believed she

was right, but was deficient in information. Her companion [Benjamin Wister of Salem, New Jersey] waxed wroth and tried to cut off my right ear, or in other words, destroy my character as a man of truth, saying in a sneering manner, "There, don't lie, don't lie," and afterwards posted me as a public liar. But I trust that, like Peter, he was ordered to put up that sword, and is now with Peter in the mansions of everlasting light and love.[5]

John Comly assumed the duty of arbitrator in the schism, attempting to arrange a peaceful Hicksite withdrawal that might keep the all-important Philadelphia Yearly Meeting from too bitter a division. Appreciating Comly's qualities, Edward correctly prophesied that his name would "stand upon the pages of the history of the Society of Friends."

Peace attracted Edward less than righteousness. He missed no opportunity to condemn the Orthodox leaders, Jonathan Evans and Samuel Bettle, as "the English and royal Americans." He did so with a verbal ferocity that would have shocked his grandfather, Gilbert Hicks, British crown officer. Absurdly he likened the Orthodox attempts to quell the Hicksites to British policy toward America in 1775 when, he said, William Pitt hired "merciless Indians to set them as bloodhounds on their Protestant brethren." He called the Orthodox hiring of lawyers to prosecute resistance as bad as the hiring of Indians. Then he leveled the more serious charge that his Orthodox enemies were using Society funds to pay their lawyers to prosecute Hicksites.

By the last evening of Yearly Meeting, 1827, Edward looked on the widening breach as hopeless. He so advised the disheartened John Comly as soon as the large gathering went its ways. Then Comly and his confreres forgathered in Green Street to commiserate sadly with one another. Edward saw in these events a biblical parallel which he was to paint nearly twenty years later in his "Noah's Ark." He thought that,

[4] *Memoirs,* p. 108.

[5] *Memoirs,* p. 109.

had the mood of the Hicksites been as serene in the preceding hours among the Orthodox as it was in Green Street, they would have won out through passive resistance and Christian meekness, without resort to the law and courts. "They would have stood as a city set on a hill. . . . Thousands of the precious visited lambs [or Hicksites] would have left the barren mountains of empty profession and flocked as doves to the ark of the everlasting covenant, ratified by the blood of a Saviour, whose arm, as the great antitype of Noah, would have been put forth for their reception."[6] His belief must have helped him decide, in time, to paint the jewel-like picture now among the treasures of the Philadelphia Museum of Art.

He began watching for signs of what the enemy's folly was reaping. He noticed that many Orthodox farmers and mechanics were wishing to become doctors. They were realizing their ambition simply by buying a twenty-dollar license and reading "a few books" for a month or so, after which they began to experiment on "suffering humanity," he said. One of Edward's neighbors had bought a sulky and, like a real doctor, went cracking "a long whip along the road, and, first thing he knew, was deserting his wife and children for a younger woman and the ruin of soul and body." Another Newtown citizen, a youth with a mania for medicine instead of for his rightful trade as a mechanic, "experimented" on a girl who died during the operation, causing the community virtually to run him out of town—toward fresh adversity which brought him back as a corpse a year later. Amateur doctoring struck Edward as worse than "priest-craft." "A species of surgery" practiced in the lower section of Bucks County (presumably unmentionable and related to short practice) was, he said, changing revered social customs and creating "a monument to the shame" of those responsible—destroying "all the finer feelings of a virtuous youth." Midwifery was suffi-

cient for childbirth in his opinion; and he condemned as immoral "the tyrant custom" of bringing male medicos into the presence of "our wives, daughters and mothers at a time when they seldom want more than the protection of our Heavenly Father, and the sympathy and assistance of their female friends."[7] The villains, he added, had the impudence to charge from five to a hundred dollars for an hour or two with the confined—unlike the faithful midwife, on call at all hours like a blessed Deborah, a mother in Israel, whose fee was thanks only. These "unbelievers" and "hypocrites," however, their thoughts on the large bill they would render to help support some "hireling priest" or to buy a pianoforte—*they* were a far cry from Peter and Paul who performed great cures for nothing!

His frequent tirades against "usurers" have been mentioned. They were tinged with unmistakably personal bias. While castigating those who sought money for loans instead of lending without interest, he did not accuse himself of having resorted to their aid. Yet he was careless and absent-minded about his own obligations, and is not known to have painted any carriages for charity. When he made gifts of his oils, it was often in the spirit of willingness to accept any offer that may have been forthcoming.

His obsessional hatreds—of "usurers" and their ilk—were worked off in the painting of their opposite numbers. His benign lions, bulls, bears, and serpents may well have fended off something close to madness—madness from disappointment with the world as he happened to find it. With symbols he could retreat for an hour or two into the ideal realm of imagination. There he mastered all truculence and wiped out bestiality, evil, and human frailty.

His proposition for "the dear rising youth of America," exposed to the dangers of "priest craft and doctor craft," runs:

Let the present rising generation, both male and female, be well educated in *useful* knowledge, to

[6] *Memoirs*, p. 112.

[7] *Memoirs*, p. 114.

fit them for useful business, and let all scholastic learning that is merely *ornamental* be dispensed with, and substitute in its place the substantial parts of the science of medicine, particularly anatomy and botany. Let this be taught by competent male and female teachers.[8]

He viewed professional medicine as mostly "metaphysical abstractions," unessential if one acquired some physiology, a few herbs and minerals, and applied them with trust in the Lord, the real physician. However, he cited a few admirable exceptions among doctors of his acquaintance — the eminent Joseph Parrish (1779-1840), surgeon to Philadelphia's Alms House, whose services to charitable causes and to abolition are graven in the city's history. Dr. Isaac Chapman of Wrightstown, another exception despite his Orthodoxy, was praised by Edward for his low fees for both rich and poor, and his exceptional compassion for orphans.

He found that misguided Friends were pursuing, among other new things, the farming fad called the "Morus multicaulis" speculation, or the raising of Chinese mulberry trees for silk production in Bucks County (a trend which ended in a depression).

Instead of contenting themselves with "sober, serious testimony" against slavery and with the voluntary freeing of slaves, the Orthodox Friends, he regretted, were using meetinghouses for civic agitation, and permitting lecturers and lawyers from outside the Society to whip up feeling. In the same class he put the current rage for phrenology or the study of personality and aptitude by "bumps on the head," a delusion he called as absurd as the popular "animal magnetism" practice. The latter encouraged operations "on poor weak little girls at an age when the peculiar state of their nervous system" answered, he said, the devilish purpose of so-called doctors. Thus did his mind rove from one moral whipping-post to another, applying the lash of invective at will. What a cacoph-

8 *Memoirs.*

onous mixture of ignorance and common sense emerges from his now wise, now warped view of existence!

By the spring of 1827 the Orthodox majority in Philadelphia confidently believed themselves the victors. But the battle was not yet over. During the very week of Quarterly Meeting in that city, their voices were drowned out by the Hicksites in the hinterlands—at Abington, Salem, Concord, Shrewsbury, Rahway, and Western and Southern quarters. After gaining the floor at Burlington and Caln, however, the Orthodox headed for Bucks County "flushed with victory." Edward dreaded this contest, for if his own side faltered, this would quickly spell his "disownment" both as minister and Friend. For seven hours the two factions argued. Some Hicksites withdrew and went home, leaving Edward, six elders, and two loyal Philadelphians to the defense.

Next day the Orthodox "suffered a quick and smart defeat." Their share in the recent Yearly Meeting was roundly condemned in a written declaration approved by twenty-two among twenty-four potential signers. The net result of the seasonal meetings seemed to be that of defeat for the Orthodox, who could not foresee that within a decade or so they would win over many Hicksites from among the young, but only, in Edward's belief, because the young began "gamboling in the twilight . . . and flying in the dark" like summer insects.

In September 1827 the Orthodox organized themselves as separate. They began to "disown" all Friends who resisted their authority. They called on rebellious families and rebuked them—to Edward's sputtering indignation! Newtown Meeting remained united, a strong, proud Hicksite vanguard. So incensed were the enemy that they wanted to seize the Newtown meetinghouse, worth three or four thousand dollars, and deed it to the previous owner of the land, for

him to "convert it into a cocoonery or steeple-house."

Although Edward did not miss a session in the Green Street Meeting in Philadelphia, the Hicksite stronghold of that city, he once hesitated to attend lest he lose his temper. He wrote of his misgivings to his friend David Seaman:

I have just read thy letter and am not much surprised at the spirit you met with in the City of Brotherly Love. I should have felt more than a willingness to have been with you at Green Street, but I am fearful I shall not be able to attend on account of the illness of one of my children. . . . Elias has nothing to fear. . . . I feel great unity and sympathy with my dear friend, but I have anticipated that he would meet with difficulties in Philadelphia. The storm has been a long time a-brewing, but they cannot hurt Elias. . . . There are two considerations that discourage my coming. The first is my warm attachment to Elias (which involves a degree of prejudice against his enemy)—it might lead me into extremes so that I should overdo. The next is, these very friends have a greater objection to me than they have to Elias, and my presence might stir up a greater enmity. However, I will see what tomorrow morning will bring forth. Joseph Briggs has just now read thy letter, and I believe we shall be at Green Street tomorrow morning, or at least in the afternoon. Thine sincerely,

Edw.ᵈ Hicks.[9]

He was aware that not all took kindly to his methods as reformer. That fact may help to explain why, not long after, he delivered a sermon which denotes his ambivalent capacity for pure benevolence. No doubt he was pleased to see it published in *The Quaker,* whence comes this passage:

I am induced to believe that there never was, since the creation of the world, such a race of intelligent beings as are now upon the stage of action. I am not one of those who have been induced to believe that the world is growing worse—far from it. I am encouraged, at times, and animated with a hope of better things. . . . Mankind are on the advance, and have been ever since the manifestation of Jesus Christ in the flesh. Whatever may

have been the ups and downs on different parts of the globe, and in different periods of the human family, there has been, on the whole, an evident advancement. And in this happy land of America, the advancement has been peculiarly striking. To the intelligent man, who can look back sixty years, what changes and improvements present themselves on every side, particularly in this city—What changes in the state and country around—what changes in human society—what advancements! What are we not blessed with in this land, that flows as it were with milk and honey?

American citizens, of all the inhabitants of this globe, are under the strongest obligation to render thanks to their Heavenly Father that God has preserved in this land an asylum for the bodies and souls of the children of men; and that he has raised up a government that has become the admiration of almost the whole civilized world—a government mild and generous in its institutions . . . protecting civil and religious rights. And shall we, my dear fellow citizens, make a sacrifice of these blessings? Shall we turn our liberty into licentiousness. . . . ? I feel for you. . . . I full remember the temptations of my juvenile days . . . and the trials to which I have been exposed. Therefore, dear young men, beware of the first inroads to evil. . . .

There is a vein of evil that still runs through our land . . . a fondness for company. There are many gates to vice placed before you. Guard, then, against everything like making use of intoxicating liquors. . . .[10]

Mild warning from one whose sermons could wither!

As so often, he referred here to the "animal nature of man." At one point he spoke about redemption in a way which explains the detail of a leopard emerging from a hole in the earth in several of his "Kingdom" paintings: "The soul will come out . . . from a horrible pit, to sing praises from the banks of deliverance." In this sermon, as in the *Memoirs,* "the bottomless pit" suggests how deeply fixed was this symbolic imagery in the painter's imagination.

He preached in the afternoon at Carpenter's Hall. This sermon was also printed soon after

[9] Friends Historical Library, Swarthmore College.

[10] *The Quaker,* V. 2, pp. 145-74. Sermon . . . Aug. 19, 1827.

in *The Quaker*. It reflects Elias' ideas and manner of speaking; but, eloquent in its own right, it is the master of the "Peaceable Kingdom" at his best:

There is a portion of the spirit of God, which is light, given to every rational soul, and as they attend to it in journeying forward, keeping their faces always to the light, they will have the shadow behind them. . . . If we attended to this light of God in our souls, if we followed it, we should experience the day star to arise in our souls. . . . The light . . . will be as a guardian around you, and it will lead you at last, and be the heavenly passport to gain for you an admission into the heavenly mansions, where the morning stars shall join in singing hallelujahs, and the sons of God shall ever shout for joy.[11]

Those who woo the public ear must stand judgment. When Edward delivered these sermons in August he had already passed through baptisms of fire which may have led him to temper his later words. One of these fiery baptisms came his way when, two months earlier, two Burlington elders, Mary and Elizabeth Allinson, had challenged his fitness to speak "the Truth." "Recently," their joint denunciation began, "thou professed to rank thyself among those to whom the term of Whited Sepulchres might apply. We therefore hope thou wilt be willing, with sincerity of mind, to enter into impartial scrutiny as to whether thou wast, at that time, divinely commissioned to speak as thou didst." They said he was wrong to "excite a spirit of disaffection in the minds of the younger and more inexperienced classes of Society," and besought him not to do so again in "mixed assembly."[12] Within a matter of days they had Edward's blistering reply, which ran on for pages. Calling them "righteous hypocrites," he said: "It would not hurt either of you if, like myself, you were to rank yourselves with those to whom whited sepulcher would apply. . . . Women as well as men are liable to be deceived,

and when deceived are sometimes very mischievous and troublesome busybodies, and, by an impervious overbearing spirit, cause currents, division, grief and sorrow for the tenderhearted and humble among them. I hope better things of you, my beloved sisters." He frankly informed them that the whole Hicks family had read their letter, which had made "a very unfavourable impression."[13]

Another letter—one of spite, unsigned—made an even more baleful impression. The writer accused him of turning from his earlier "lovable" ways as a minister into a man "so loose and immoral in conduct, and so great a liar, that it was proverbial in the neighborhood to say that if anyone told a great lie it was as great a one as Edward Hicks could tell." Hicks, he added, "could get very little to do" as a result of his didoes which led to the "scandalous reports"; he offered to send Edward a list of his "principal enemies" if he could prove these shocking accusations as false and unfounded. Seeing the postmark was a town on the New York and Connecticut line, he prepared a denial and asked the postmaster to help him find the culprit. For its information about his shopwork his full denial of the outrageous charges is of special interest:

I am now employing four hands, besides myself, in coach, sign and ornamental painting, and still more in repairing and finishing carriages, and I think I should find no difficulty in doubling my business. I have done the painting for two respectable coachmakers for ten years, and if I am not mistaken, were I disposed to prosecute for such a shameful attack upon my private character, these respectable neighbors would furnish depositions in direct opposition to these backbiters. But, conscious that I have the unity, love and esteem of my friends and neighbors—living in peace and harmony with Presbyterians, Methodists, Baptists, etc.—conscious, too, that I have the unity and Christian sympathy of the great body of Friends . . . I would not go over the sill of my door to clear up a report that is nothing but an effervescence of the gall of bitter-

11 *The Quaker*, V. 2, no. 4, 175-207.
12 Hicks Coll.

13 Hicks Coll.

ness in the bond of iniquity. As to the names of those ministers and elders that spread the report, I should be sorry to know them, lest they might darken a long list of worthy men and women, who fill those stations and stand high in my esteem.[14]

The squabble ended amicably despite Edward's mischievous intention that the postmaster should first read his reply and start a flow of gossip about the guilty sender. He promptly received not only an apology, but an order for a new carriage, to be delivered at a certain place and time if agreeable to Hicks. The Orthodox Quaker came to a point about thirty miles from his home with horses and harness; he and Edward met "within minutes," and so delighted was he with his fine carriage that he persuaded some of his neighbors to patronize the painter. So amiable did the two become that Edward was invited to preach at his friend's Meeting, a roomy schoolhouse in a grove near Purchase, New York. But so well attended was it by "English and Royal American" Quakers that Edward surprised himself and the gathering by remaining completely silent. Hard put to understand why they came to listen to a Whig like himself, he wrote humorously that "the Orthodox might think to hear, out of curiosity, a mighty big liar." Nevertheless he was delighted that he went, having witnessed enough "astonishing, amusing and comforting incidents to fill a sheet of paper."

As to the effect on the standing of Edward Hicks which the Separation—the most tragic milestone in all Friends history—may have had, until one examines the records for the spring of 1828, the answer remains in doubt. Then the Philadelphia Yearly Meeting made the "first open attack," as his *Memoirs* express it, on his "public character." He believed the opposition wished to destroy him. Whether their "declaration" was a genuine attack or merely a defense

written in tones of sincerely felt injury, let the reader judge:

Edward Hicks, at the Green Street Meeting says, "I ask then the question," How did he (Jesus Christ) leave the bosom of his Father? Can we form no other Idea than that of a corporeal being, leaving a located place, somewhere above the Cloud, and coming down to this earth? Is this the coming into the world that is meant? I want us to go deeper—to come to the *spirituality of these things,* and to recognize a spiritual Saviour, rather than an outward and corporeal one. Because it is only a spiritual one that can save us from sin. That *animal body* that appeared at Jerusalem had its use and day, but the Spirit that was clothed upon by the fullness of Divine power, this was the Saviour—this is the Saviour to whom I looked for Salvation, and not by any means to anything outward or corporeal. This declaration corresponds with others which we have quoted, and is a virtual denial that Jesus Christ, who appear'd at Jerusalem, is the Saviour of men. The term animal body, used to designate our Lord, is irreverent, and unbecoming a creature dependent upon him for salvation.[15]

The record runs on to greater length in this vein (in a fine long-hand on handsome rag paper that should last forever), deploring the Green Street sermon of Edward Hicks, especially that passage declaring Christ's *inner* sufferings his real sacrifice rather than his bodily crucifixion. The accused, in his *Memoirs,* called the enemies "shamefully unChristian," hard-hearted for trying to harm his "moral character" and for using tactics called "mad-brained Orthodoxy." Actually, most of the Orthodox declaration was leveled against Elias. The Orthodox Minutes for that date mention nothing of "an old superannuated stale report" about which, the *Memoirs* give the details. A dozen years earlier a Newtown lawyer, whose coach he had failed to finish on time, took a dislike to him and led the prosecution in a libel suit against him for calling the local Baptist minister a "hireling priest." The lawyer, a Deist, doubly welcomed the chance to

[14] *Memoirs,* pp. 130-31.

[15] Archives of Friends Meeting (Orthodox), Arch St., Philadelphia: Minutes of Yearly Meeting, p. 34, 1828.

brand him as a liar because of his violent attacks on his sect's doctrines.

That Edward's talent for invective, perhaps even vituperation, was almost as marked as that for painting scenes of heavenly tranquility, is obvious from all these anecdotes. He himself, looking backward years later, confessed to possible exaggeration of the Orthodox intent to defame him, from their "dark stronghold." He regretted having "indulged too much a secret joy" whenever he saw them losing ground. Only when he drew near to his death was he again to feel love for those who had condemned him.

None of these embattled Friends, it appears, saw the wider implications of the Separation, or regarded it as due to "the clash of forces after the Revolutionary war," to borrow the words of Elbert Russell, scholar of Quaker history. We have seen, however, that Edward Hicks's enmity had some such basis which he himself came close to phrasing as Russell describes it, but not, of course, with scholarly objectivity, or with anything like true historical perspective. The reader may wonder whether today the essentials of Quakerism remain unchanged; the answer would seem to be that they do. Invisible or intangible values, diametrically opposed to outward sacraments as the ideal communication between God and man; frequent aloofness from civic office and the mainstream of public life; silent worship without ceremony or ritual, to be broken only by spontaneous vocal ministry from those moved to speak and to pray aloud; and the belief that all life is a sacrament, to be so lived—these remain the simple doctrines of all members, Orthodox and Hicksite, of the Religious Society of Friends.

The Knowledge of the Lord

MUCH as he longed at intervals to abandon his shop and turn to preaching, Edward Hicks kept up a steady flow of work. His ledger indicates that in 1828 he was painting coaches and signs for local persons, one of the most interesting of whom was Joseph Archambault. Behind the brief entry, "Painted tavern sign for Joseph Archambault, 1828, 10 mo. 10," lies one of Newtown's intriguing human interest stories.

Major and Madame Joseph O. Archambault, after three years in New York and Philadelphia, moved to the village in 1819. Trained in Napoleon Bonaparte's Cavalry School at St. Cloud, where he also received a gentleman's education, he became an officer of Napoleon's army. After serving for a year, Archambault, then seventeen, went to St. Helena in 1815 in the exiled ruler's suite of selected officers. He supervised the care of the horses, breaking four for Napoleon's use, and became well acquainted with the deposed hero. The expense connected with the large stable and suite caused the group to be disbanded and shipped to the Cape of Good Hope, where the officers sailed for Britain in an English warship. Archambault decided to settle in America.

In Newtown the Major built a handsome house, still one of the town's finest, three blocks from the home of the painter. He became the village postmaster, and also owned the historic Brick Hotel. For twenty years Archambault captained the Bucks County Cavalry; and his children, one of whom he named for Bonaparte, married local sons and daughters. Edward Hicks must have known him well and perhaps have taken pride in being entrusted with the tavern sign painting, for which the charge was six dollars.

Our awareness of such personalities in Hicks's workaday orbit lends breadth to perspective on his life. He may well have seen and perhaps met the Major's friend Joseph Bonaparte, living close by in Bordentown, New Jersey. Many tales have been handed down by the community about the former Emperor of Spain, Napoleon's brother. Again we are indebted to Fanny Wright for an account of a visit to him between her electrifying lectures against slavery. She and her party drove over to Jersey in a Dearborn wagon to call on Joseph, whose pretty white villa with fine views was set among "magnolias and kalmias" on a sweep of lawn, but with ugly statues all about—"gods and goddesses in naked—I cannot say—*majesty*."[1] General Moreau was responsible for the atrocious pagan deities and dogs and lions which he left behind on Robert Morris'

[1] *Travels* . . . pp. 136-42.

grounds after living there for three years in exile. After the Morris mansion burned, the neighborhood helped themselves, and Joseph received his quota of the stone menagerie, which the children of the town treated as so many hobby horses. In Joseph's house were busts of the Bonapartes and David's portrait of Napoleon crossing the Alps.

The Count Survillier, as the nobleman called himself, appeared in an old coat dusty with mortar, for which he made no apology. "His face is fine," wrote Miss Wright, "and bears . . . a resemblance to that of his more distinguished brother." Speaking in French they discussed poetry. Joseph picked a wild flower and gave it to her, with the wish that she should be "as much pleased with America" as he was, this man so kind to French emigrants and to his neighbors that he was said to have been imposed upon for his goodness.

It has already been mentioned, in connection with the detail of a beribboned child in one variant of Edward's "Kingdoms," that he seemed influenced by a similar figure in a Rigaud print that hung in his bedroom. Where, one cannot but wonder, did he he come by such a picture? Late eighteenth-century art would seem likely to have offended him. Certainly it is not the kind of gift Quakers exchanged in those austere days versus art and music. Might the pair of Rigaud prints have come from Major Archambault, by chance, before he left Newtown?

Edward's family was growing up. Sarah, the youngest, was twelve. Mary, the eldest, twenty-four, seemed doomed to spinsterhood of a drudging kind and to chronic illness. Her only known vice was one for which, had her stern parent been aware of it, she might have paid dearly—the taking of an occasional pinch of snuff from one of the two monogrammed boxes eventually found among her effects. Susan, twenty-two, enjoyed making the social rounds at Yearly Meeting and others. Her brother Isaac,

serious and mild, slightly built, was busily employed now, at nineteen, in his father's paint shop. His temperament was mild, like his mother's. Elizabeth, seventeen, was showing signs of becoming the most religious, and also the most erudite and serious of all. Her almost psychotic earnestness was to lead to a serious but temporary breakdown later in her life, a chapter with no rightful place in the present story.

Sarah, wife of Samuel Hicks of New York, had been urging Edward to bring Susan to Yearly Meeting, no doubt in a match-making spirit. In the late spring of 1829 he drove her almost to New Brunswick, where she continued on her way alone on the boat bound for New York. Edward himself drove on to Salem, New Jersey, to a meeting.

Glib, mercurial, worldly, a butterfly with the dark flights of a moon moth, Susan enters these pages, bent on commanding attention. This she does by means of a series of amazingly graphic and interesting letters. On reaching Jericho, Long Island, her destination, she let the family know how she was faring: "I am again within the walls of Jericho. John Carle came on in place of Cousin Valentine Hicks to meet me. We dined on board the steamer at New Brunswick, and I received every attention. John was very polite." She added that upon reaching New York Harbor, they were driven in a gig to the Island: "After a delightful ride, it being very pleasant and moonlight, we reached here between ten and eleven. I did not feel near so much fatigued as I expected after riding ninety-eight miles from Newtown."[2] Before long she paid a second visit to New York. This time, perhaps sensing that fate had great changes in store, she wrote Mary a homesick letter, ending wistfully: "Get the sweet briers from L. Leedom's that she promised me. . . . This month she said was the time to take them up. . . . She said I might have as many as I wanted . . . it

2 Hicks Coll.

will be too late to move them when I get home." Those sweetbriers—bittersweet—were Newtown, though Susan scarcely knew it.

Living more and more in the past, Edward's eighty-year-old father urged him to sit down for a chat one day. He wished to pass along some advice which his own father, the fugitive, gave him before leaving New York for exile. Gilbert Hicks had said to Isaac that he would be exposed to frequent temptations, but he was never to ignore his conscience, never to disobey his soul's "voice" as he himself had done. "Sacrifice property, personal liberty, and even life itself rather than be disobedient to a Heavenly vision," advised the remorseful Tory. "I disobeyed this inward monitor and am now suffering the due reward of my deeds." Gilbert was not referring to his dereliction toward the American cause but to an incident years before that, when he tried two Negro fugitive slaves and sentenced them to deportation to the West Indies and slavery for life, without any inner conviction as to their guilt. This act of injustice returned to haunt him when he himself was about to be cut off forever from his family. The real heart, however, of Gilbert Hicks is reflected in a letter to an official, dated "Attleborough, November 20, 1767," deploring vile prison conditions:

Dear Sir:

I was yesterday at Newtown, and understanding that the people in prison wanted to speak with me I considered as a Christian it was my Duty to visit them. . . . I heard their several complaints, among the rest the lamentations of your man Ned, expressed in such moving terms as to have melted the most obdurate heart.

He is almost naked, without anything to lay upon excepting a cold floor in a stenching jail, with a small allowance of a pound of bread a day, with the addition of Cold Water; and permit me to add that I am under apprehensions that unless he soon receives some relief, Death must inevitably be his portion very soon. Under these considerations I must beg leave to recommend him to you as a proper object of your compassion. . . .

Gilbert Hicks.[3]

This returns one's thoughts, quite naturally, to Edward's attitude toward the Negro and slavery, on which colorful light is shed by a story related in his *Memoirs*. About a generation earlier there had lived in Chester County another Edward Hicks of a different family. His English grandfather had willed his mother land and slaves in the West Indies. Before she moved to Pennsylvania, all but one of her slaves were auctioned. She kept the young widow of an African king, and brought her with her to Chester County. During the voyage north the young Negress was delivered of a boy child at sea; the slaveholder decided to name him after her native Cornwall in England.

County Cornwall, or "Corn," the slave girl's son who grew up in Pennsylvania, became a familiar figure throughout the eastern counties. His owner, a Mrs. Hicks, had a son named Edward, who, at length, sold the boy on the auction block. That Edward, then still a minor, was finishing his apprenticeship as a cooper, after which he turned Quaker, adopted Friends' principles and became the foe of slavery. He deeply regretted selling the slave; and so, taking the proceeds with him, he traveled to Bucks County to buy his freedom. But not even a generous amount of gold could persuade the Presbyterian minister who now owned "Corn" to part with that youth of high character and African princely bearing. When the case began to appear hopeless, the antislavery Friends of Wrightstown together raised funds in an acceptable amount. "Corn" was at once hired as a grist grinder at the mill of the Hulmes, whom the painter Edward lived with when he first moved to Milford. Indeed the ex-slave and the Edward Hicks of the "Peaceable Kingdom" became the best of friends, both being loved and respected members of Wrightstown Meeting which set him free.

[3] Hicks Coll.

63

In the winter of 1829 Edward decided to preach through Western Pennsylvania and eastern Ohio. This time Benjamin Price, a Chester County elder, joined him. The two were a study in contrasts, but their Hicksite sympathies drew them together. Price, thirteen years Edward's junior, had been educated at Westtown Friends School and Enoch Lewis Academy at New Garden. A well-known progressive farmer, he was the first to practice under-draining extensively in Chester, the first to plant Virginia thorn for hedges, and first to try the mowing machine in the year 1820. He liked traveling about with ministers; indeed his wife, the brilliant, peripatetic Jane Paxson, a Quaker minister, was chaperoned by him for many years. Perhaps the sharpest contrast between Edward and Benjamin was in their approach to the issue of slavery, the latter having helped many a fugitive to escape, while allowing his home to be a link in the underground railway.

Though they did not wait until Christmas Day was past, there is no reason to suppose that they timed their departure with sentimental thought of that event, Yuletide not being observed among Friends as festively as by most Christians. Edward reached Chester the middle of the month, stayed overnight at the Price's, and was off with Benjamin in the snowy daybreak for Lampeter. They rode on to York to hold meetings, then to Booth's Tavern where Edward, coughing miserably, was glad of a warm breakfast by candlelight beside an open fire. He was determined to move on to Hagerstown, a ride of forty miles. After crossing South Mountain and loping down through a rough valley until dusk, the travelers were more than ready for Newcomer's Tavern. Unwell and racked with coughing, Edward took a tablet in molasses, went to bed, and hoped to be feeling better by morning. Next day the redoubtable pair traveled forty miles through the "stupendous ridges" of the Alleghenies.

At a fine tavern in Cumberland they lingered for "a little refreshment for man and horse." From there they took the National Turnpike to "Hursttown" where, by dark, they reached a tavern spoiled for them by the presence of some "talkative Methodist" young men and women. Edward managed, he said, to put a pall of quiet upon them by "secretly engaging in prayer and supplication." Three times on Christmas Eve they stopped at smithies to have the worn shoes of their horses repaired, going but thirty miles to Smithfield on the Potomac. The Yuletide spirit found many of the citizens "under the influence," to Edward's distress. "Superstition" was what he termed such Christmas cheer. Early Christmas morning he and Benjamin were off for Brownsville, thirty-five miles onward, stopping for noonday dinner at Uniontown, an occasion recalled not for its festivity but for the lady innkeeper's sorrow over the news of the death of her son who had lately joined the Western movement.

To reach Westland Meeting they had to leave their horses and travel in an open boat with other Friends to a point a hundred feet below their destination, then climb the steep and frozen bluff on foot. Edward could sense what inroads the Orthodox had made, but by the time he and Benjamin returned up the river they felt he had undone some of the damage.

An old cooper shop at Pike Run served for the next meeting. Its very simplicity helped create a successful service.

Wheeling was twenty miles yonder. Then St. Clairsville, Ohio, was reached after New Year's. Finding no mail awaiting him, Edward began a long chronicle of his travels for Sarah, in which he admitted to feeling discouraged and homesick:

No letters, no tidings from my dear wife and children. Waited till afternoon for the Eastern Mail . . . but none for poor me. I felt almost out of patience. I am sure if you only knew the great satisfaction it is to a poor lonely traveller in a strange land to get news, if it is only a few lines from their

dearest friends, you would certainly write every week, and I do sincerely hope you will not omit giving me a little narrative, how you are getting along from day to day, as I shall endeavour to give you.[4]

This letter was six days on its way; when it reached Newtown, Mary wrote that they were overjoyed, and did not want him to worry about them. "We are getting along very well indeed, and have everything to render us comfortable. Our friends do not forget us." She grieved that he should have been called forth "in this inclement season, upon the Master's business," and wished that he would not "take two meetings a day" in his delicate health. She reported some family and local news—Elias had been "much affected with a cold." She closed with an item typical of the era: "Jacob Knowles has buried another daughter in the short space of six weeks. He has consigned four lovely daughters to the silent tomb."[5]

Edward, who could frighten Sarah with even gentle hints about his frailty, wrote a letter on January 24, 1830, which must have made him seem a martyr to her: "I cast many a sorrowful look towards home, and time seems to move more slow, but I have a lively hope that I shall see thee again. And, if not, I trust we shall meet again in that blessed state where the wicked cease from troubling and the weary soul forever is at rest."[6] He reported on Ohio meetings in Flushing, Gurnsey, Freeport, "Brushyport," West Grove, Harrisville, Smithfield, New Lisbon, Carmel, and Concord, ruffled by Orthodox attempts here and there to hobble his progress. Cold and snow were compensated for by Quaker hospitality, most memorably that of Benjamin Hanna, whose "splendid and hospitable mansion on the heights above New Lisbon" brought some relief from his cough, and from the rigors

of winter travel on horseback "pretty much on the Western shore of the Ohio river."

Benjamin proved the ideal companion, giving mostly favorable appraisal of Edward's meetings, a function of elders going along on such journeys. February found them very far from Newtown. Elizabeth wrote her father about the family welfare and the village's inquiries for him, then she closed with this well disguised advice: "We are pleased to hear there is good sleighing, for it will be pleasanter travelling, but we hope thee will not take two meetings a day. But thou knowest best, my beloved father."[7] She added greetings from all, including his apprentices, one of whom, Morris Croasdale, was directly descended from a follower of Penn.

From Claysville, on February 26, Edward wrote the family via Susan, saying that word of Elias' sick spell did not surprise him. But he could not have guessed the venerable Friend was near death as he wrote this letter.

The Plainfield meeting had not room enough for the many who gathered to hear Edward. He wrote that "some had to stand out in the rain." All this success notwithstanding he was relieved to announce:

I am now done with meeting till I get home (I trust), and shall travel steady on. I shall expect to meet mother [Sarah] in Philadelphia on the evening of the 10th of next month. . . . I want the boys to shell three or four bushels of corn and get it ground, and mix it with two bushels of wheat shoots for feed for my horses when I get home, and have some straw cut fine and nice. . . . I am now reasonably well, but some cold is evidently hanging about me. But I consider that I have been wonderfully favoured as to health, having not missed a meeting nor laid by a day. We are now at John Flemming's tavern, writing, and B. has just looked at his watch and says it is 10 o'clock. . . . I must therefore conclude. We intend to go ten miles to brakefast tomorrow morning. . . . In much love to you all. . . . Farewell my dear daughter, farewell. Edw. Hicks.[8]

4 Hicks Coll.: "St. Clearsville, Ohio, 1 moth 1st, 1830."
5 Ibid.
6 Ibid.
7 Hicks Coll.
8 Ibid.

By Their Fruits

BY MID-MARCH 1830, Edward was home again. But a great change had taken place in his world. No more guidance would emanate from that one to whom he had repeatedly turned for courage and guidance. On February 27, 1830, the eloquence of Elias Hicks, who to the last had clung to his convictions, was stilled in death, a little while after he had uttered this eloquent plea for peace:

Until the professors of Christianity agree to lay aside all their non-essentials of religion, wars and fightings, confusion and error will prevail. When all nations are made willing to make this inward law and light the rule and standard of all their faith and works, then we shall be brought to know and believe alike that there is one Lord, one faith.[1]

Before we take leave of Elias Hicks, certain similarities between him and Edward invite consideration, lest the vast differences make their harmony seem incongruous. These artisans and convinced Friends, though mostly unschooled, were well read in history. Edward's taste for poetry was a paradox. His library, much of which has been handed down to the present, indicates his interests and those of his son Isaac. The little collection also exposes his human weakness for borrowing but not always returning books. From the standpoint of his

[1] Letters of Elias Hicks, pp. 231-34, 1834.

66

painting, no book is more interesting than Goodrich's *Lives of the Signers of the Declaration of Independence*, 1829 edition, which shows much handling. Isaac had his own copy in a later, identical edition, but where his frontispiece is intact, Edward's is missing, suggesting that he may have removed it for use while copying Trumbull's "Declaration of Independence." There is no telling, however, whether he worked from the Illman & Pilbrow engraving in this book, after Trumbull, or from another print such as one by Durand. Opinion differs widely as to the success of this effort which he repeated on a few occasions, with slight variations. In no way does it compare with the "Kingdoms" or with his "Penn's Treaty," and it would not, alone, have secured his reputation, lacking as it does the "inner" or spiritual quality. Its chief interest lies in its being a part of his legacy.

Above the biography of Franklin in the Goodrich book Edward firmly scrawled "self-taught." He calculated the age of each of the signers and jotted the number beside their names. Above "Robert Morris" he wrote "Selfmade man, aged 43."

From the standpoint of Edward's preaching, one of the most interesting volumes in his library is Robert Barclay's *An Apology for the True Christian Divinity . . . Doctrines of the*

People Called Quakers, which provided him with such pet phrases as "like people, like priest." The sentiments in the chapter entitled "Of the Ministry" are ones he often repeated. (On the title-page he scribbled, "John Hulme, His Book, lent to Edward Hicks By his Wife, to be returned when well read and considered." "Well considered" beyond a doubt, but returned never!) Fox's *Journal,* Gough's Quaker history, Samuel Bownas' *Life and Travels* were other titles equally dear to Edward and Elias, and owned and much referred to by them.

The one book in his library which lends support to his alleged fondness for astrology is only incidentally astrological, Branagan's *An Intellectual Telescope, or a Compendious Display of the Goodness, Glory and Power of God, in the Starry Heavens and the Great Deep.*

Edward was not alone in his fondness for verse and for quoting it on all occasions. This was a pastime of the age. The fashion among young people in the 1830's and '40's, as with Elizabeth and Mary Hicks, was to copy off long seraphic effusions by some current versifier and enclose them in letters, as a subtle token of rapport between friends. Their quality varied, but they were consistently soulful, mournful, meditative, nostalgic, and well-nigh unendurably sentimental. Edward himself wrote doggerel on at least one memorable occasion, as shall be seen.

The Hicks daughters' enclosures of poetry in letters are far less indicative of their tastes and times than the letters themselves. Some of these illumine Newtown, New York, and Philadelphia, and remove the discouraging lacunae created by the failure of Edward and other ancient Friends to write of current happenings—the Separation, abolition, and temperance excepted.

Most stimulating among scores in the Hicks family collection were the letters from Edward Hicks Kennedy, youngest son of the drowned Eliza Violetta. Addressed to Elizabeth, to whom he was devoted, they extend over a decade and

mirror much of what this brilliant young medico saw and thought. Named for his Uncle Edward, reared by two stepmothers in rapid succession, he was a wilful and spoiled intellectual. Although a Presbyterian by upbringing, he mingled constantly with his Quaker cousins. His accounts must have been read to, or read by, Edward Hicks, who shared his own mail with all the family, once the waxed seals were broken. The garrulous nephew, whose Irish strain on the Kennedy side helps account for his love of lengthy disquisitions, had a Belfast-born great-grandmother who arrived in America with a Bible dated 1599 beneath her arm. But the reader of Edward Hicks's *Memoirs* will readily perceive that prolixity was not only a Kennedy family characteristic. Young Kennedy enters the scene in his twentieth year, writing an excited report to Elizabeth of the "western" city of St. Louis and his journey. His half-facetious reference to his uncle's fame in a place so remote must have astonished Edward Hicks:

St. Louis, June 20, 1830.
I write to you, Dear Coz, as I lie in bed, being somewhat sick. . . . This abominable ague makes one extremely indisposed to exertion. . . . I am here in St. Louis, the chief city of Missouri—about 1,535 miles from my excellent friends in Bucks County. The people here are really civilized (though they do occasionally burn niggers) . . . and like good folks all the world over. The ladies are passably handsome. Some folks are rich, some poor. . . . I arrived here about four days ago after a ride of seven days in a blowup steamboat—which, however, did not blow up. . . . The journey was pleasant for the most part. . . . The scenery along the Juniata river is the most magnificent I ever saw, surpasses the Hudson far, which you know is not to be sneezed at. Passage across the Alleghany Mountain is a distance of thirty-six miles. The steep ascents are overcome by a stationary engine at the top which draws the cars up by a rope. Of these "inclined planes" there are ten. . . .
One great deficiency here . . . is that the mails are so extremely tardy. We left Philadelphia on June 4th, and after lodging a night in the canal (not in the water exactly) from being detained. Stayed

two days in Pittsburgh, and lazed up more than the half of one or two nights on the Ohio because of fog, then running about Louisville a couple of days. I have not since been able to get sight of an Eastern paper of late date.

I calculate to settle in St. Louis—not as a Doctor, for they are thick as bees, but in the drug business or the like. The people here all grow rich. You have no idea at all what cities there are out here. Louisville, with 20,000, has all the bustle of an Eastern city. And so far as paved streets and substantial three-story houses combine to give a city appearance you have it here. In St. Louis 'tis even busier than Louisville. It has a population of 10,000 and is constantly growing. In serious earnest, it is not without a fair deduction—that in fifty years or less this city will rival New York in population, will be the centre from which railroads will diverge to the Atlantic and Pacific. It will moreover be the seat of government for the United States. You will live a good while—mark this prophecy.

Last evening an old lady who is very intelligent and extremely talkative was speaking of some church faction, the one party being in favor of pulling down a neat church that they now have and of erecting one more fashionable. "What would *Mr. Hicks* say to such manoeuvres?" says she. I asked her, "What Mr. Hicks?" and she said *"Why the famous Quaker preacher in Pennsylvania!"* So you see Uncle Edward's name has spread itself beyond the Mississippi.

I am boarding in a very pleasant family. (Being comprised of a dozen or so ladies, how could it be otherwise?)

If I had time I should now write you a longer letter, but Mr. Oakford will go faster than the mail, and he starts this morning. . . . I think to go up the river four or five hundred miles in a few days. Meanwhile, Dear Coz, remember me occasionally.

E. H. K.[2]

Edward Kennedy's prophecies were, like himself, erratic and charming.

Spring, 1831, found the minister in Edward's nature darkly brooding. A movement was afoot among the Hicksites to "revise the Discipline," or Quaker rules of conduct. Edward was not so distraught, however, that he lost sight of certain

2 Hicks Coll.

practical matters. On March 26, 1831, he bought four more acres adjoining his homestead, paying the coach driver Jacob Sunderland $143 and assuming a mortgage encumbrance of $207 at five per cent ("six, if in arrears").[3] The "usurer" was that excellent Newtown Quaker Thomas Janney—of the Janney family in whose midst Mrs. Twining had found Edward Hicks in infancy.

The family members had their own preoccupations. In June, Susan went to Jericho to be bridesmaid at a wedding. John Carle saw her home to Newtown, and before the year was up they were married, with Susan breaking from the family circle and establishing her own home in New York City in an atmosphere of prosperity and ever-growing wealth and comfort.

In January 1832, Thomas Goslin, Newtown job painter, in Hicks's employ off and on for years, cast aspersions which to this day endure on a small but damning piece of paper. The inference appears to be that the tireless critic of "usurers" and their infamous tribe was not, himself, irreproachable as to punctual payments horrified though he must have been at the suggestion:

Whereas having had dealings with Edward Hicks for upwards of twenty years, and it appearing likely through his negligence that there would be some difficulty of making a statement of our account to full satisfaction, we have mutually agreed to pass receipts as follows. Rec'd, 1st mo., 23 day, 1832, of Edward Hicks, the sum of Ten Dollars, in full of all demands whatever up to this date. I say received by me, Thomas Goslin.[4]

Possibly Edward was feeling too pressed to dwell for long on Goslin's reproach. He had in mind such matters, for instance, as the completion of a carriage just ordered by Benjamin Price, which, he promised, would have springs adequate to carry all the Prices to Birmingham and back without the vehicle being a cumbersome "load of wood."[5] Another concern may well

3 Deed Bk., Doylestown Court House.
4 and 5 Hicks Coll.

have begun to trouble Edward through Susan's nervously swift succession of accounts of the approach of a wave of cholera from the north. Followed by others of increasing agitation, the first dated June 20, 1832, was one of anxious warning:

. . . You have doubtless heard that the fatal malady, that scourge of Europe which thee so much and so long has dreaded, but contemplated in all its violence as raging in a strange land, has made its appearance in Canada and has produced great alarm. From the reports last evening it was raging with great violence at Montreal and Quebec but as yet has not crossed the Lake. . . . When the intelligence first reached this city it produced great excitement. . . . Albany, Troy and indeed every town and village between here and Canada are all alive to it, and using all their powers to prevent its advancing. All communication is under examination—not a boat or vehicle of any kind is permitted to approach the city without a strict examination. . . . The city corporation are indefatigable in their exertions. A thorough cleaning of the city has commenced. Men are appointed to examine every house, yard and storehouse in the city, and they are going through every street spreading the chloric of lime all through every gutter, in all the cellars and yards and stores. The streets were literally white on Monday afternoon when I went to see Cary. . . . Our city will be well prepared. . . . As yet I feel no alarm.[6]

If the excitement continues, business will be bad except for the drug business, and it is astonishing what a run they have. The store is crowded constantly, and John has scarcely time to eat. Preventatives are in great demand, such as camphor and chloric of lime. I think you had best buy some as camphor will be very scarce. . . . The people being so alarmed is a great thing for the city, as they must now keep it clean. . . . I have filled my paper with cholera as if I thought of nothing else. . . . I know dear Mother will be alarmed but she must not be. Should the cholera be here, I would not think of your coming, but if it does not come I cannot think of anything else . . . Susan.[7]

By July 6 the outlook was still darker. Susan wrote to Mary:

6, 7, 8 and 9 Hicks Coll.

I knew you would hear through the public prints that the cholera was actually here. . . . Thee, my sister, has always felt such an awful dread of that fatal malady, but be not alarmed I entreat thee, precious sister. Suffer not thy imagination to picture dangers that cannot be avoided. Neither, my dear, believe the exaggerated reports thee may hear.[8]

[Here Susan proceeded to terrify with details, forgetting her advice.]

It is taking some of the finest citizens, [she concluded] but as yet it is mostly confined to the lower class and to the intemperate ones. The doctors do not think it contagious—neither is it confined to any particular place, but to a particular class only. . . . Should it attack the temperate, we should undoubtedly leave the city.[9]

Early in July the Carles closed their house in Manhattan, going to Brooklyn to stay with Elias Hicks's granddaughter Caroline, whose husband, Dr. Seaman, a consulting physician at the main city hospital, was on constant call.

On July 10 Susan wrote without much enthusiasm that her John was "busy as can be, selling medicines" to individuals, doctors, and the hospital. She was rapidly becoming versed in the current cures and prevention of the scourge. Worried lest it spread to Bucks County, she cautioned her family against "exertion, fruit, cucumbers, cabbage, green apple pies or fruit pies, peas, beans, new potatoes and beets," as well as the night air and the morning's rural exertions without a good breakfast. After prescribing this starvation diet, she added: "There is something in the air now that makes it very dangerous to indulge or even touch anything of the kind." A fine Wilmington doctor, she said, was prescribing "spirits of camphor in cold water" for fits of vomiting, and also "calomel and powdered opium every three hours in a little brown sugar, and about a teaspoonful of strong coffee to wash it down." After this nostrum she recommended "strong mustard plasters all over the bowels, and to the feet and ankles,

and to the wrists," and rubbing the patient when he grew cold.[10]

Soon after, she and John were in Westbury, Long Island, whither they had traveled by gig, glad to put the city's gloom behind them.

Stores are shut up in every direction [she wrote Mary on July 26] and houses are closed. The streets are deserted to what they have been. Frequently we see the litter belonging to the Hospital conveying some poor subject; and occasionally the poor-house hearse casts deeper gloom over all around us. This is a season, my precious sister, that never, never will be forgotten.[11]

The stage mail was carrying John's mail between him and his faithful employees in New York City who elected to keep his shop open for business.

Meanwhile the excitable Susan, homesick and worried, decided that the family was not sufficiently responsive to her reports and warnings. Their indifference and her uneasiness lest the cholera arrive in Newtown was, she assured them, making her half ill. If Edward's skepticism concerning doctors was increased by Susan's account of the current nostrums, his antagonism must have mounted as he read one of Edward Hicks Kennedy's letters to Elizabeth from Philadelphia. (The painter, oddly enough, had approved of his nephew's decision to study medicine.) The interne's picture of the Alms House, Blockley, dated August 9, 1832, may well have shocked his Uncle Edward:

My dear Cousin,

Last evening I arrived in the city. . . . Behold me here, a new tenant of a new and elegant poor house . . . think, my Dear Coz, what I have already come to, only twenty-one and a tenant of a building designed for the gleanings of the earth—the old and poor, the most miserable of all classes.

A young physician here has already given me employment—at cholera. I am sort of a Sovereign Lord. I order what I please, as far as I can yet observe, and have under my charge some three or four or half a dozen women. One has a feeble pulse

10 and 11 Hicks Coll.

and cold extremities; though she has no cramp yet, I think I shall go down and have mustard plasters put on. They are all old women of shattered constitutions, and little can be expected to be done for them. However, we must try. . . .

This building is more like a Windsor palace than a receptacle for filth, a large and beautiful house covering perhaps twelve acres, with long galleries, folding doors and high ceilings.

'Tis one o'clock. A half dozen old women called me away and I have been busy ever since, giving pills, plasters, or bleeding or cupping others. It is a glorious place—I am called *Doctor* and everyone consults me for an *oracle*. Dr. Mickle and I have supreme sway over them all. The matron, a nice, clever old woman with *a cap on,* has two daughters, one a very pretty girl who dresses her hair all so tastily. She trotted off and got me some crackers and wine. It has relieved me wonderfully to see a silk dress. I have given an old man who has premonitory symptoms some calomel and opium. . . . The apothecary, whilst I am writing, is all the time talking to me in his half French, half English style. I do not, however, pay any attention to him. He says he "vas one of de victim of de Frencha revolution," one of the proscribed. . . . Truly dear Coz,
Yours, E. H. Kennedy.
WRITE, WRITE, WRITE, WRITE.

Within two weeks came another account of the doings at Blockley, with a noticeable increase of mischievous details for Elizabeth's edification as usual:

As I am now a night errand runner (not knight errant) it becomes me to apologize for the barbarism of having written you a scrawl on dirty foolscap. . . . I do not know why I feel such an eternal itching for letter writing. . . .

After dinner today Dr. Mickle and I went to a temporary hospital close by and saw some patients. One old woman, a rum drinker and opium eater, had some days ago some symptoms of cholera which were stopped. Typhus fever has supervened and she will die, but to do all possible for her I went and made a blister, had her head shaved, put it on, made her a stimulating julep, and left her comfortable indeed. . . .

Of all the lamenting, eye-damping letters that ever a poor fellow received, this last one of yours caps the climax!! Why, my dear, considerate friends,

do you still continue your anxiety on my account? I have stood the brunt of cholera, but think you that the danger has passed when the city of near 200,000 inhabitants reports but twenty-five cases and five deaths or so a day? . . .

Yesterday I was pretty busy until dinner, cupping three women, etc., but what was worse was listening to the complaints of a dozen others. This place has its pleasantries, but it vexes my spirit. Our "family" here are the most worthless dregs of creation. They all *lie*, and with few exceptions *drink* and *steal*. This morning two women had to be put in cells for being drunk and noisy. One, a young woman, who when sober is industrious and clever . . . this morning abused me for permitting her to be so punished. Human nature is everywhere the same. "Man, clothed in a little brief authority," will assume much and raise himself in his own estimation. . . . This is my case and it will be much, I fear, to my detriment against my better judgment.

Breakfast's over, prescribing's over, and attendance on the pauper is over, too, thank perseverance. . . . An old fat woman sent for me, and she had a wonderful catalogue of complaints . . . a full pulse, headache, etc., so I determined on bleeding her. I bound up her arm, as big as a stove-pipe, found what I thought was a vein, and cracked away with a lancer: no *blood*, but a little fat exuded. . . . I gave another cut into darkness and uncertainty. Out sprung the blood, and 'twas milk and honey to me. It bled bad, however, after some six or eight ounces had been drawn, and it struck me that I had cut an *Artery!* My heart sank, as the saying goes. Oh, how I felt! But it turned out to the contrary:—no matter, 'twas only an old woman. . . .

The moral obligation due the patient, however poor and worthless, enforce the attention which would otherwise lag. Dictates of conscience . . . prevent laziness. . . . I am very much pleased with my situation . . . having plenty to do and plenty to think about, and hundreds to talk to. . . . You cannot imagine the pleasure your letter gave me. . . . Ned.[12]

Epidemic or no, Edward Hicks was too busy to indulge his fears, if he had them. Willet Hicks's carriage had to be repaired after the New Yorker had sent it over with most explicit instructions. The wheels were to be hooped,

and a wheelwright was to set the springs and replace worn irons, before the painting could be done.

By 1833, Newtown was as safe as if Susan's weird suggestions had not been found wanting. But her warnings continued: "Tell dear Mother not to eat any blackberries—I know she is fond of them. And tell dear Father not to drink much milk, particularly at night." Cholera flare-ups in New York kept her apprehensive. Faithfully John Carle sent the New York papers and news "Extras." The bride came often to Newtown; she and John made their journeys a lark, stopping with Quaker friends along the way, and pausing for a fruit lemonade at Baker's tavern before taking the New Brunswick boat, where they led their horse aboard with the hope that it would behave quietly. Gabriel, their Negro servant, always met them at the New York pier.

What of Edward's son Isaac by this time? He was a charter member of the Bucks County Society for the Promotion of Temperance, and had never known any oat-sowing days like those of his father's youth. Furthermore, he was hopelessly in love. The progress and eventual end of this romance—the reasons for its failure—remain a tantalizing mystery.

I was particularly interested [Susan wrote] in what thee whispered in my ear about brother and his *gals*, dear sister. How dearly I should love to have been at home to see the whole of them, but more particularly Sarah Speakman. Is she interesting, and does thee think brother is seriously pleased with her? I am very glad thee told me, for I ought to hear and know all such things respecting you, and I know it is doing as thee would wish to be done by. Thee must not fail to tell me if anything more transpires in this. . . . I do want to know. Also, say, my dear sister, if *Tom* (not a Tom Cat but Tom Janney) continues to come to see you *all all* as often as ever.[13]

Susan could write with such sophistication because by now she was a seasoned New Yorker

12 Hicks Coll.

13 Hicks Coll.

71

and traveler. On July 30, 1833, she sent this charming view of the wider world of the upper Hudson to the folks in Newtown:

You will be surprised when I tell you that I have actually travelled in a few days upwards of three hundred miles. I thought perhaps a little trip out of town would be good for me, and so we fixed off on board the steamboat for Albany. The sail was most grand—impossible to describe. . . . The celebrated Black Hawk and six of his Indian tribesmen were on board, attracting great attention in their extravagant costumes. Our room in "The American" at Albany had a bell in it and servants to attend to all our wants. . . . My John had an excellent carriage before a pair of horses with a good careful driver, and we started off to see the Shakers at Neskayuna. We got there in time to attend their meeting, about nine miles from Albany. They are indeed the most singular people, and their manner of worship appears to me like a complete burlesque upon religion. . . . After that we saw the Lahore falls, one of the most sublime sights . . . then the great canal and the boats passing through the locks. The road from Troy to Albany exceeds anything I have ever travelled—it has been macadamized.[14]

She began one of her almost fatuous pleas for Mary to pay the Carles an early visit: "Come when Cousin Willet's wagon comes, if it is only for a day or two."

By the end of the year she was nearing her first confinement. Elizabeth was delegated to be present. Susan would scarcely let her out of her sight, even hating to let her go to tea in Brooklyn with their cousins, the Seamans. Terrified, insecure, the presence of servants in her big comfortable house by no means appeased her. She had Elizabeth bake her some Newtown specialties, such as a plum cake calling for twenty eggs at the exorbitant cost of "12½¢ for 5." But then it was not so extravagant as she feared, when she pondered that her eggs came from her father's Newtown henyard in a basket.[15]

Elizabeth's letters home were always enlight-

ening. Often they contained their share of comic relief:

Poor dear sister Sarah, now she has to milk *Splatterdash* all herself. It is too bad. I do not intend to say anything more about wanting to see you, but I do think I shall love you all better than ever. I shall expect a letter from my dear Father soon.

After sympathizing with Mary's having to rise so early to pick chickens, she closed with one of her typical effusions: "Farewell, dear sister. You must love me just as well when I return, for I cannot bear the idea of your getting used to doing without me and not caring how long I stay."[16]

Two days later before Susan's child was born, Edward wrote to his absent Elizabeth, never dreaming what power the new infant would exert over his unpredictable affections. The letter "could come without expense," he said, because a friend was bound for the city and could take it. After telling of recent meetings, about his severe cough, and a local wedding, he described the home scene around him in minute detail worthy of a painter:

Isaac and the boys are in the shop. Mother is setting with her back to the stove, with her spectacles on, sewing at a skirt. Mary is setting on the other side of the stove on a little chair, sewing likewise, but her principal business is boiling cider to make apple butter. Sarah is setting eating an apple and looking out at the window next the sink closet. . . . I have just been informed that a stout, fine-looking young man that wears *Spectacles* called yesterday to know when we heard from New York. [This was to tease Elizabeth.] We want thee at home again, feeling a great void in the domestic circle. Yet if it's a comfort and encouragement to thy dear sister, we are willing thee should stay a little longer.

Speaking of Susan's confinement, he said to give her his love.

"Tell her to put her trust and confidence in her Heavenly Father who is able to strengthen her and bring her through every difficulty."

14 Hicks Coll.
15, 16 *Ibid.*

Mary added a postscript saying she was enclosing some dress "pattrens" for Elizabeth from "Aunt Ann."[17]

Elizabeth's stay with the Carles did not cause any interruption in the flow of Edward Hicks Kennedy's letters. The twenty-two-year-old delighted in passing along his impressions. Only a few months before, in June, he had broached the subject of her possible attitude toward marriage —not, of course, to him, but marriage generally.

How could you be otherwise than happy, in the bosom of a family whom you so love and by whom you are so beloved. This last, alone, gives felicity. To be loved calls forth all the warmest feelings of the soul. What a conflict it must be in a young female's mind, who is comfortably fixed like yourself. Whether to *marry* or *not to marry*, 'tis a question—to leave the enjoyments of a home for uncertain happiness and certain trouble. Then again, parents cannot live as long as their children; and when convenience would bid them leave that home, fate may not throw such beneficial offers in the way. Altogether, the age of eighteen and twenty-five in a young lady is an age of quandary. The prospect of an old maid's annuity!—and add lap dogs and pet cats. It's dreadful!

Here Kennedy turned to a less problematical topic:

Odds, blossoms and primroses, my father and Mrs. K. are having their portraits taken by Mr. Moon of Easton who is here with his pencils all so

fine. He intends making a superb face of pa's, a real sneezer—on the Napoleonic order. And Mrs. K.'s face—odds blooms—how it will shine! I kind o' hinted to pa about a vacant niche in the parlor, while I stroked my own face with my hand. "I don't like to see *boy's* portraits hung about!" said he. See what it is to have a beardless chin, If none I had but beard upon my face, To miss the good we otherwise might win, My portrait would perhaps our parlor grace.

Have you heard of the great paintings of Adam and Eve that are being exhibited here? I go to see them every day. They are so superb as to be beyond my meager praise. Mr. Moon and I went the other afternoon to see the Panorama of Mexico, another great painting, but we could only catch a glimpse occasionally of a chimney top, and that between ladies' bonnets. . . . I'm very tired, having been with Mr. Moon to the Academy of Natural Sciences, looking over a great number of splendid ancient engravings. Next Monday we are invited to come back and see Audubon's great book of Birds.[18]

By November he was telling Elizabeth, who was then in New York, about his visit to the Academy of Fine Arts, news of undoubted interest to Edward Hicks also. "There are some splendid paintings there by the old painters," he told her, "Rembrandt, Guido, Van Dyck, Rubens, Sir J. Reynolds, West, etc. They are interesting, some being three centuries old. I shall write to Mr. Moon and this news will set him afire and bring him at once, I know."[19]

17 Hicks Coll.

18 Hicks Coll.
19 *Ibid.*

Bubbles Deviled O'er by Sense

ON DECEMBER 27, 1833, Edward Hicks's first grandchild was born. Ten days later Elizabeth, who had gone to help at the Carles', found time to let the family know how everything was going. She also sought an opinion as to what the new baby should be named:

I thought I must just write thee a few lines to let you know how finely our dear Sue and her babe is getting along, for I know how anxious you feel and what pleasure it will give you to hear Sister is now sitting up with the babe in her arms, and has quite a motherly appearance; she is very smart indeed, has had no pull back at all. Her little girl grows finely, gets prettier every day, fat and healthy as can be. . . . They have not fixed on any name yet. Susan and John like Sarah Ann, after Mother and Aunt Ann. They cannot bear the name of Phebe Ann, but I think Aunt Phebe would be much pleased to have it so, and I try to persuade them to call it that. They have been talking of Ann Eliza—what does thee think of that?—for Aunt Eliza Violetta. . . . I tell them I know it would be your wish to have it after John's family instead of ours, and I am sure dear Mother would much rather have it named for Aunt Phebe than for herself. . . . Write, dear sister Mary, and say, then I can tell them. . . . I want to come home too bad for anything. I was too sorry to find you had killed hogs, for I felt so anxious to return before that. How hard you must have had to work. Has thee not made thyself sick? I feel very uneasy about

thee—and dear father, has he got well? And will he and Mother come, or will thee come?[1]

It fell to Edward's lot to answer, and he did so with no visible awareness that the small soul whom he must help to name would very soon win him over completely. His *Memoirs* make poignantly clear the depth of this attachment, in a career of either loving or abhorring all who came within his sensitive orbit. Calmly he replied to Elizabeth, but with no reference to the infant:

First month. Ninth Day.
My very dear Elizabeth,
It falls to the lot of thy poor father again to write to thee, and of course thee may expect a trifling letter. We are pretty well except Mother, and Isaac has a little cold. We're all about in the old way. It is now about six o'clock, and Mary and Sarah are clearing the table, and talking about Mother spraining her foot. Cousin Betsey Walmsby is setting near the stairdoor with her knitting in her hand. Mother is setting between the stove and kitchen door, talking continually and saying I must not mention her spraining her foot for fear it will alarm thee. It is the old sprain she has been talking about. The boys are all at work in the shop and I am setting at the stand behind the stove writing.
Today has been our monthly meeting in the good old way. . . .
Dear Elizabeth, we want to see thee and have

[1] Hicks Coll.

74

thee at home again, and as thee has stayed more than two months with thy dear sister, and seen her through her difficulty, and she is so comfortable and surrounded by such valuable friends and, above all, has such a precious husband, that she can now spare thee. So in thy next letter thee will name the time thee would wish to come home and Isaac will come for thee. But as for Mother or Sister coming on this winter, dear Susan will, I believe, have to excuse them. The weather is too cold and their health too delicate, but as soon as the weather will permit we will some of us come on, for we want to see dear Susan and John and the little Stranger as well as many other precious friends. . . .

Poor dear Elizabeth Parrish, Delwin Parrish's wife, is gone into the Eternal World. [Here Edward quoted the "beautiful views of Doctor Young," a lachrymose poet, on death. He listed names, too, of the new, youthful dead.]

I did not expect to be so serious. I will try to return to my little chit-chat. Some changes and overturnings are likely to take place this spring in our neighbourhood. . . . There is prospect of Cyrus Betts coming to Newtown and joining Ann Buckman in a boarding school. Doctor Jenks is trying to set up a temperance house, and Isaac has just come in and says that Fromburgher is agoing to set up a temperance house in the spring, so that we are likely to be very temperate the coming year. . . . Isaac has just got the carpenters for making his house, so if that gets done there will be another one to let, for I believe he will be a young bachelor another year.

Once again, as in a previous letter, he teased Elizabeth about "Spectacles," disclosing his identity:

Oh, I have got something to tell thee. Jonathan Schofield talks hard of going with his cousin Jo Schofield to Ohio—Spectacles and all. So thee and Mary Briggs will quit quarreling about him. Oliver, I believe, is much taken with Mary Jackson, but I expect Sister Mary has told thee all about it. Isaac and Sister Mary have been to Philadelphia and Darby. Mary went no further than the city, and suffered so much with the cold that she thinks she will not be willing to venture forth this winter. They went as far as John Comly's on seventh day and stayed all night. . . .

I have just had a coffing spell and Mary says I

must quit. I think so too . . . tho' I intended to fill the letter or paper. Dear child, thee will say in the next when thee will be ready to come home, and Isaac will come after thee, as he wants to see thee worse than he ever did (he says). Indeed we all want to see thee as bad as him. Give my dear love to John and Susan, sister Phebe and her children, and accept a large share thyself. Mother, brother, sister and cousin Betsey joins in the concern with thy affectionate father. Farewell,

Edward Hicks.

Almost as an afterthought Mary penciled this postscript:

Answering Elizabeth's urgent question: I expect little baby is named by this time. I think Phebe Ann is the name we all like best. It is much prettier than either of the others. And Aunt Phebe has been such a dear kind mother to Sister that she ought to call her something about this name. I think Sarah Ann quite a homely name. I told father I wanted to write something about the name, and he said, "Tell her to call it after her mother-in-law by all means—it ought to be that." We are all unanimous in favor of having it called after Aunt Phebe, so send me word—whether it is named—and what it is.[2]

What with fresh orders from his Quaker acquaintances, Edward's coach-painting business gained momentum by springtime. Roads were open, snows were thawing, folks again began to stir about.

On March 28, Benjamin Ferris, whose name stands out in the Separation, wrote a facetious and engaging letter. As a letter-writer Ferris won fame a decade earlier, when he debated Friends doctrines in the press, handily disposing of the bigoted attacks of a Presbyterian minister, the Reverend Eliphalet W. Gilbert, who remained anonymous.[3] During the two years of their orderly hostilities, Ferris signed himself "Amicus."

Now, in his beautiful hand, he was writing to Edward on divers matters—a carriage and harness, Quaker doctrine, and the late annoying tension:

[2] Hicks Coll.
[3] Mr. Gilbert's first attack appeared in the *Christian Repository*. The debate ended in Feb., 1823.

75

Wilmington, 3 mo. 28, 1834.

My beloved friend Edward Hicks,

. . . With respect to the harness for our coaches, John Clark expects thee to furnish the harness. He says that Edward Hicks told him that the carriage and harness would, he thought, cost $130. . . . But if this price is too low he is not disposed to claim the carriage and harness at that sum, but to pay what may be further justly demanded. And he further says that Edward Hicks undertook to deliver them in Wilmington, which I was very glad to hear, as then we might catch a glimpse of thee, brought here *by contract,* since neither friendship, love nor duty have been sufficiently powerful to impel thee to visit us for a while!

. . . With respect to my part in the carriage "concern" . . . I fully intended to see thee at Newtown before it was finished, in order to consult with thee further on the kind of body the carriage should have. Thou mayst remember I told thee that I did not like the common Dearborn bodies with the *"ribs" outside of the flesh.* The appearance is unnatural, and odious to me. I don't like the ribs to show at all, even in a horse. It looks too much like starvation, and I would much rather pay for a covering to their bony parts than have them exposed to the action of Sun and Air. However, make thyself easy as to this matter, so far as it may easily be remedied, for experience has taught me to submit with cheerfulness and resignation to circumstances which may not be altered. . . .

Benjamin Ferris turned to Quakerly subjects, sketching, inadvertently, a small and diverting vignette of Edward:

Now to matters of another character, I sincerely sympathize with thee in thy tribulations before the Yearly Meeting committee on *schools.* For though I do not aspire to any resemblance to thee in the strong and excellent parts of thy character, yet in the weaker parts I think we are very much alike— first, in our scheming propensities. We get hold of some theory or favorite notion for the good of mankind, and having dandled and nursed our bantling, until it begins to exhibit signs of great merit, we introduce it into *public company,* and then if our lame and perhaps deformed Child does not obtain the admiration and praise of the *spectators,* we are apt to think *they* are either very dull or very perverse. . . .

Again, we are apt to consider *our particular* views, "as connected with the fundamental doctrines of the Christian religion," when perhaps they have no relation to them—one whit more than the views of our beloved friends who differ from us on these points! And thirdly, when we fail in carrying conviction into the bosom of our dear friends, we are apt to be "discouraged," and to say, "I will speak no more in thy name to a crooked and perverse generation. . . .

Ferris pitied Edward that he had "been plunged into the same bitter waters," but added that they both must "meet the well-intended but mistaken view of the Younger or more ardent Brethren with Charity," while opposing innovation except where it was good.[4]

Edward's brooding over Quaker troubles was fed by other such letters and the troubles themselves. Except for his sentiments on abolition, what he thought of the Jacksonian era can only be surmised. That no amount of shop work or feuding could entirely shut out the national scene is proved by the presence of Edward Hicks Kennedy's reports, sent to the intellectual Elizabeth to be shared.

In late April the young doctor posted this picture, which brings a segment of yesterday to life:

Last Saturday I saw that "God-like Man" Daniel Webster. He was at the Exchange and there gave a short speech, merely by way of giving the people a sample of his roaring. He certainly is a great looking man . . . carries more intellect in his face than any man I ever saw. His face is as stern as an iron post, nor did all the applause he received give him the least emotion, or induce him to relax one atom of his ice coldness. He bowed when he had to and that was all, otherwise he did not seem to notice it. His speaking is wholly argumentative, at times energetic, but usually calm and decisive. His voice is clear, and sufficiently powerful. He was on his way to Washington, where, by the way, he was much wanted.

The latest of Jackson's encroachments has been,

4 Hicks Coll.

as you know, his "protest" sent in at the moment when seven of the opposition senators were absent, among them Clay, Webster and Preston. We are indeed coming to a pretty pass. The President protests against the right of the senator to scrutinize his measures, and scolds them individually for their opposition to him. I know not what next he will do—perhaps, like his progenitor, Cromwell, come into the Senate, sword in hand to drive them out. 'Tis reported that he will preside in the Senate, when they are to legislate upon his appointments, to awe them into compliance. Fortunate it is for the country and its best interests that we have such a Senate in this crisis, that we have there—such men as Clay, as Webster, as Leigh or Calhoun, as Preston, as Poindexter, as Southard, or Frelinghuysen, as Sprague and others. Were it not for their manly resistance, where would be the end of these outrageous usurpations!

Turning from politics, he described a charitable occasion:

The Festival, on Tuesday, was a great affair . . . more than fifty thousand were present. I never saw such a mass of mankind. As for the provisions, such never were seen. How otherwise could it be, when the invitation was so general. Every wharf rat and starveling in the city and surrounding country were there. Hams disappeared almost before they reached the table, and in a minute were entirely devoured, every fellow tugging, pulling, cutting and chewing as if for life. From the enclosure they threw small loaves of bread, the size of a double fist, to the multitude. For two hours it literally rained bread, fifteen thousand loaves being thus distributed. You will see an account of it in the papers.

Again the young man's increasing urbanity and sophistication were shown frankly to the Hicks family:

Coming up Chestnut Street the other day with brother Fred, and we stopped at a window with a picture of Ann Boleyn in it. . . . Without saying a word more I asked Fred who it looked like. . . . He answered, "Elizabeth Hicks." I hope tho', Coz, there are no Henry the Eighths for you. You'll recollect that he cut her head off three years after their marriage. . . .[5]

[5] Hicks Coll.

By the autumn of 1834 John Carle was so angered by Elizabeth's "neglect" that he felt he should split a cord of wood before trusting himself to write her calmly. Phebe Ann, though mischievous, was a "beautiful babe," he reported; he and Susan delighted in her precocity. Unmindful of the countless duties which Mary and Elizabeth always faced at home, Susan bitterly complained of her own exhaustion, hinting that one of them must drop her chores and come to her assistance. She had the thoughtfulness, however, to advise treatment for her mother's chronically rheumatic arm. What she recommended was a poultice of bread and milk with flax seed several times daily, and a "wash of one dram of powdered opium in a pint of hot water" to be poured on the area. Gradually Edward began to scan her letters for news of Phebe Ann, whom he regarded as a family addition worth watching, after making her acquaintance in the city. He wished she might pay them a visit soon. But Susan, after enclosing swatches of goods to give the aunts an idea of the child's new dresses, added that Phebe was "too tender a little plant to expose to so long a journey." She offered this glimpse for consolation:

Little Sis does dearly love to go visiting and riding. She is actually so troublesome that she requires constant attention—creeps into all mischief and gets up by the chair and walks around holding on by one hand. Let her see a lamp and she blows whether it is lit or not—claps her hands for her father to come home, and, if she hears him opening the door about the usual time it is impossible to hold her she is so delighted. Her sixth tooth is nearly through. . . . We have a little girl thirteen years old that can help quite smart and tends Sis, who is very fond of her—indeed the blacker the better, for her. How I do wish you could see our dear little girl . . . no longer a baby. She has taken several steps and stands like a little woman. . . . I do wish, Mary, you would tell me all thee knows about Brother Isaac and Sarah Speakman. He took her to a wedding, I heard. Tell him I think he ought to write me all about it.[6]

[6] Hicks Coll.

Susan might well inquire about Isaac because, the previous spring, his handsome mansion opposite the Hicks paternal homestead was completed. There was still no certainty that he would live there, this young introvert whose poetic countenance was to be painted by his talented cousin Tom Hicks for his fiancée.

Letters about Phebe Ann, though they commanded rapt attention, were probably read with no less interest than the lengthy, erudite reports from Edward Hicks Kennedy. This letter of December 16, 1834, commenting on the currently popular travel books in lively, personal vein, shows what other ideas managed to penetrate the thick, close curtain of Hicks family preoccupation with Quaker matters:

When Cadmus first introduced the almost divine attribute of writing (and of all human discoveries this has been of the highest and most lasting importance), a reed, sharpened, sufficed him for a pen and a vegetable juice for ink. The bark of a tree was his papyrus. . . . Rob us of books, and what would we be . . . ? I say *we*, for we differ materially from generations who have preceded us. It is only within the last hundred years or so that education has become so universally diffused, and that the love of literature has so grown into us. . . .

At the library this evening I spent a most pleasant pair of hours with "Letters to a friend in Germany," on the subject of America. English travellers such as Mrs. Trollope, Fiddler, Hall, Hamilton and the cart load of *"Illustri"* who whisk through the country with a "flourish of trumpets," give no idea of us. Their several books are mere personal journals of their own vexations and adventures. If, as the stagecoach whirls through a village, they chance to see a fellow drunk, they gravely set this down as the character of the people. If it should chance to be Meeting Day, forthwith all the goodly inhabitants are enrolled among the saints. They know nothing at all about us, and are forced to judge of our exteriors merely, in their flying tour, with as little chance of speaking correctly of us, really as we are, as the Star Gazer has of knowing what the dinner hour is on the planet Jupiter. And any incident that they note is distorted through preconceived bias, founded in jealousy and ill nature.

Major Hamilton was terribly shocked because at a beautiful table in New York they eat eggs with a spoon!—and because the forks had only *two prongs*. The political and moral relations of society he said not a word about. He scolds because the Galleries of Congress are gala places, where all the fashion of Washington "do most congregate." He says a poor gentleman has no chance of hearing or seeing anything, on extraordinary occasions, that ladies fill up every nook—and every glimpse that can be caught of The House is through a vista of blonde, worked lace, and filigree ribbons. He recommends that a law be passed to exclude all under the age of *twenty-five*. He talks a great deal about the ladies of this country, and is highly disposed in favour of their sweetness and beauty, their modesty yet self-confidence, their general cleverness and small feet—smaller than those of the Dutch and even the English. But still he does complain about their frequenting the Halls of Legislation. He also complains about the sudden sinking of the bride into the household wife, who drops like a *Cactus Grandiflora* after a twenty-four-hour bloom, and is at once registered among the stately dames and ancients. This, as you know, is true—it is a glaring evil. Not that a young lady should continue the airs of a belle after marriage, but that she should not rank with the grand-dames as we know she too much does.

Here Edward Kennedy interjected his own ideas:

I think ladies all marry too young. With trifling exceptions, twenty-eight or twenty-six at the earliest is time enough for such enveilment. She even then becomes a grandmother quite early enough. But as it is, they are terribly afflicted if at twenty or so they have no immediate prospect of being "made happy." Poor ignorant things, for wishing to shake off their present reign of glory for the, at most, uncertain joys in anticipation.

He quoted Lord Byron and Washington Irving on marriage to strengthen his own disapproval of "helter skelter" or immature youth. All such wisdom was gleaned, apparently, from "two or three evenings weekly at the Library, among all manner of sweet flowers and gentle perfumes of literature." Urging Elizabeth to

read "The New Yorker" newspaper regularly, he said he was mailing it to her each Thursday from Philadelphia.[7]

Spring found Elizabeth back in New York again with the Carles. She was devouring a book not of young Kennedy's choice but her own, the *Journal of Fanny Kemble*, when Susan's temporarily bedfast direction of housecleaning and whitewashing permitted. One of her remarks in a letter to Mary sheds warmth on her aloof personality: "Cousin Peter is more homely than ever and does not seem any more sociable—tell Grandmother Worstall she need not feel the least uneasy about me, for I don't see as many of the male sex as when at home."[8]

Before long Elizabeth was home again, but the ever yearning and petulant Susan was soon pining for Newtown visitors, or to be at home during the butchering in December in order to sample her father's "sausages, fine chickens and turkeys"—somehow better, at least in her mind, than the fancy ones that her John's prosperity afforded.[9]

Suddenly, a year hence, Susan Hicks Carle had something real to complain about when, in December 1835, catastrophe befell the city of New York. The great fire of Wall Street shook and devastated much of the lower island. Susan's remarkable account, a rare eyewitness report, brings back the historic scene:

Peck Slip, New York, 12 mo. 17, 1835.
. . . We were fearful you would hear of the awful conflagration that we have had and feel anxious on our account, and I have hastened to write a few lines to inform you of our preservation. We are well, in health, and safe as regards our property, but never before have the citizens of New York been called upon to witness such an awful sight as they were last night.

The alarm of fire was given at nine o'clock last evening. It broke out in a street in the rear of the

Exchange, and it spread with such astonishing rapidity that in less than one hour the whole block was not only in flames, but it extended to Pearl Street, and so across the street through to Water Street, and so on to Front and South Streets, to the river. Not a building is left through all those blocks up as high as Wall Street. The wind blew and the night was so extremely cold that what little water they could get froze, and, to add to the difficulty, the tide was down, so that they could not get a supply from the river. Indeed it raged with such astonishing fury that the firemen were obliged to give up, as they could not in the least arrest its progress.

Oh it was, my dear Sister, the most awful time I ever witnessed, although I was some distance from it. But the brightness all around us was so great that our house was completely lighted, and as far as we could see all was illuminated with a sheet of fire that nothing could arrest. . . . We never thought of going to bed, and even at this moment I have not slept any. My John and the boys were out all night, only occasionally coming to let me know they were safe and how it was going on. The fire raged without the least abatement, crossing streets and leveling the largest buildings—until about nine or ten o'clock this morning when they had recourse to blowing up the buildings to arrest its progress.

At this moment it is burning with great fury, and now, while I write, I hear the explosions. . . . The scene is beyond description or imagination. The merchant buildings were all from four to six stories high, filled with goods. The exchange, too, is level with the ground. The Post Office is gone, and now whilst I write I know not how we will send this. The morning papers were not out, as the publishers were among the sufferers. Adonijah Underhill's store is entirely gone, but for his books. Cousin Peter and William and Henry and Titus's are entirely destroyed, but they saved their books and some goods. Many others removed their goods from the stores as they thought to a place of safety, but it was all consumed in the general destruction. The sun of yesterday which set upon those larger and noble buildings, filled to overflowing and surrounded by bustling industry, are rich, smouldering ruins. There has not been such a scene since the conflagration of Moscow or the great fire of London. It is thought that upwards of five hundred buildings were destroyed. The best and most enterprising part of our city is a heap of ruins, and property to

[7] Hicks Coll.
[8], [9] *Ibid.*

the amount of thirty millions is lost. It is thought that the insurance companies will be utterly ruined. We who thought ourselves safe in our insurance will have nothing to depend upon.

The watchers are to be stationed tonight to prevent the progress of the fire, still raging like a volcano.

Next day Susan added a dramatic note:

My Dear Sister, we rested last night without any trouble. My John had a private watch all night to guard the store; this will be continued. The fire is under control but will no doubt continue to burn for weeks. . . . I do want to see you more than ever, since such scenes brought home nearer than ever. My John does not feel very well this morning, having taken some cold, being up all these nights and exerting himself to help others save what they could. . . . My John will send you a paper containing a particular account as soon as one is published. It is now high time this was in the post office. . . . I hope you will come, for I feel now as though I could not do without you. Do please! Oh that it would be tomorrow. In great haste and with much love from both to all, all, thy

Sister Sue.[10]

About a week later Edward Hicks himself saw the ruins. Friends meetings took him over to New York and Brooklyn, as well as the wish to see Phebe Ann. "Little Pet," as he called her, was now quite equal to sitting entranced on a Rose Street Meeting bench while her grandfather preached salvation. On Christmas Eve he was so disturbed by the awful spectacle of the ruined streets near the Carle home on Peck Slip that he warned the family at home to have a care:

This awful fire has revived my apprehensions about home. Do take care of the fire, particularly in the cellar. I want George [the hired hand] to take care of the cows, particularly the milk cow. She ought to be fed twice a day. I want Tommy [Hicks] to attend to the fire in the Meeting House, if Isaac will please see to that. . . . In haste, Farewell, Edw. Hicks.[11]

10, 11 Hicks Coll.

80

The year ahead, facing the painter as he started homeward, was one of the most unremitting hardship. In mid-February came word of Phebe's illness; despite devastating coughing spells, she managed, John Carle wrote, to be a "great talker, lively and full of chat"—"very literary" at the age of three. Her father, to please Edward, added:

Phebe Ann has not forgotten her grandfather. She frequently speaks of him, and says he was sick. She can say anything and everything and has a most excellent memory. She knows the alphabet and is particularly fond of Books. Several different ones she uses constantly, and she has her mother nearly exhausted with reading to her by the hour—wanting more, more, more.

The busy John could seldom take time for such reports, as his closing remarks indicate: "I cannot hardly think of anything but Physic and Money; if I do, I should have to down some of the former and of course lose the latter."[12]

Soon Susan would be confined again.

In February Elizabeth was summoned by the Carles. By March 2, Edward Hicks, sorely missing his favorite daughter, wrote her to return: "I should be very happy if thy brother and sister could spare thee to come home, as we want to see thee very much. Mother at times appears very unhappy about thee, she says she wants to see thee so bad." He said that his father, old Squire Hicks, eighty-nine, was fast wearing away; Mrs. Hicks and Mary had just been down to see him. He told of an epidemic that had struck the village: "That awful messenger that rides the pale horse has appeared." He regretted that Elizabeth's "very excellent letter" to him had been marred by her mention of having enjoyed a lecture by a visiting English Friend who, to him, was but a "mercenary hireling." He closed with the wish that Elias' daughter Abigail and her husband would pay them an early visit: "I have kept a turkey for them, and if they don't come soon it will lay."[13]

12, 13 Hicks Coll.

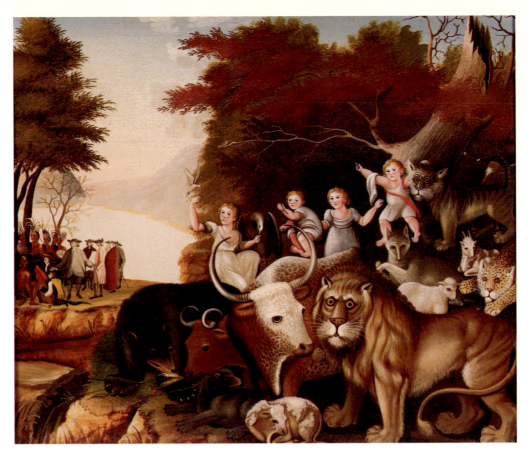

THE PEACEABLE KINGDOM. Oil on canvas. 30″ × 34½″. c. 1840–45. *Courtesy New York State Historical Association, Cooperstown. Photo by Richard Walker*

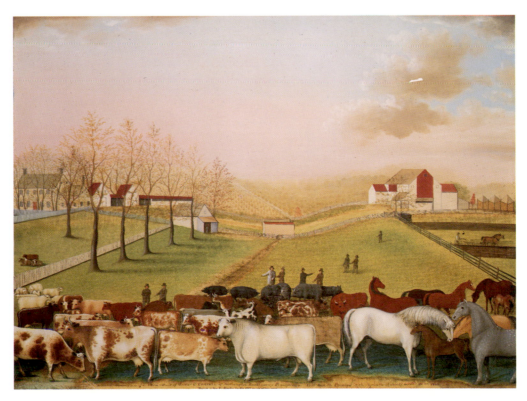

THE CORNELL FARM. Oil on canvas. 37″ × 49″. 1848. *Courtesy National Gallery of Art, Washington, © 1997 Board of Trustees: Gift of Edgar William and Bernice Chrysler Garbisch*

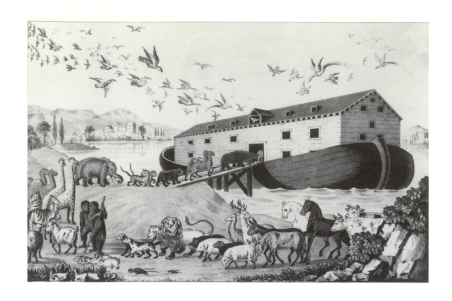

NOAH'S ARK. N. Currier Lithograph. *Courtesy Philadelphia Museum of Art: Bequest of Lisa Norris Elkins*

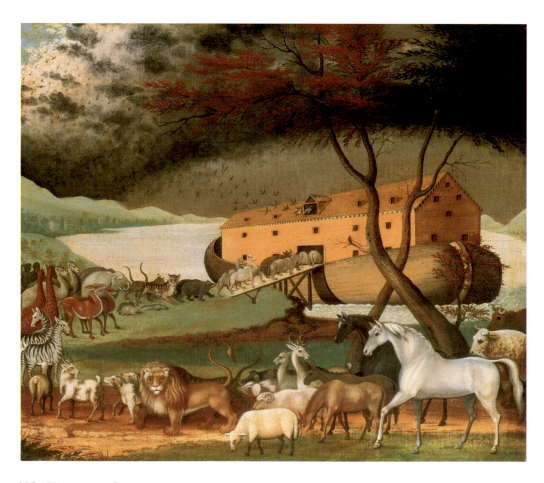

NOAH'S ARK. Oil on canvas. 26½″ × 30½″. Signed and dated: 1846. *Courtesy Philadelphia Museum of Art: Bequest of Lisa Norris Elkins*

The following autumn, 1836, old Squire Hicks died. That his aged father's small estate was in disorder must have come as a shock to Edward. One wonders whether this ennobling obituary was sent by him to the *Bucks County Intelligencer & General Adviser*, and the *Long Island Star*, before he had examined his father's ledgers:

He was becoming a stranger in the midst of a new succession of men that had risen up about him, and that knew him not. . . . In the exercise of his office as a magistrate . . . he was a peacemaker and a consummator of the most important covenants among mankind, having joined in the bonds of matrimony no less than twelve hundred and forty souls.[14]

Uniting souls was an ironical sideline for this man whose own family life had been all too brief and bitter. His will, never probated, showed debts of $2,827.14 and credits $927.40, leaving a deficit for Edward to adjust, if ever he was able.[15] The painter renounced administration of the estate in favor of his son.

With the word, soon after, that his brother Dr. Gilbert Hicks had died in Catawissa, Edward reflected that he alone remained of the pathetic little circle whom his mother Catherine had left behind on that day, so long ago, of her death and Cornwallis' surrender. Thomas Kennedy, Eliza Violetta's husband, died about this time. Edward's aged mother-in-law also passed away. Death must be done, it seemed, for a time, with the Hickses and their kin. Then Mary was suddenly seized with a dire illness, from which the others were suffering in less degree, leading Sarah to send for Dr. Joseph Parrish, noted Philadelphia physician and dedicated Quaker, who was being summoned by the epidemic from all directions. Not the least impressive bidder for his services was Joseph Bonaparte of Bordentown. Edward told in his *Memoirs*, a shade boastfully, how the good

Doctor advised "the rich potentate" to come to the city and be treated, though he drove thirty miles to tend to the Hickses, fully aware of the slight chance of any payment. Later, when Edward offered to pay him for saving Mary's life, he declined: " 'I cannot take thy money. . . . Not money induced me to come but sympathy and love for thee and thy afflicted family.' "[16] Did Hicks present the Niagara fireboard to Dr. Parrish after this? His gratitude to the Parrish family had not subsided when, not so many years later, he gave to the son of the kindly physician, also a doctor, Joseph, Jr., of Mount Holly, one of his masterpieces, "Noah's Ark," now in the Lisa Norris Elkins Collection of the Philadelphia Museum of Art.

Through sickness, health and every kind of fortune Hicks kept on painting. On February 20—ostensibly 1836—he wrote in his ledger: "Two landscape paintings." *Which two? Where are they?* One longs to be enlightened, but no titles or recipients were specified. Compared with the personal facts to be gleaned from the memoirs, letters, accounts, and ledger of Hicks, information as to his art activities is today regrettably sparse. However, available hints are of the most absorbing interest—take the dispirited letter he wrote to "Luis Jones" who, one judges, was a Quaker artisan or former apprentice living between Doylestown and Newtown:

Newtown, 6 mo[th] 14th, 1836.
Beloved friend Luis Jones:
An opportunity offering to send thee a line, I thought I would say that I have been uneasy about giving thee the trouble of selling my paintings. I have been very much discouraged about them and indeed everything else. If I can get rid of them at almost any rate, I think I will never paint any more. I thought verily that it was right for me to paint them in order to raise the money to have my expenses in my journey, having no work, scarcely, to do, but alas; I fear the whole concern will come to naught and the poor old good-for-nothing painter sink down to his proper place, the gulf of oblivion.

14 Bucks County Hist. Soc.
15 Recorder's Office, Doylestown, Pa.

16 *Memoirs*, 119-20.

Dear Luis, I don't want to give thee trouble. The friend proposed for them would not give me as much profit as plain painting, but thee may sell them for anything or nothing, or give them away, or burn them; don't give thyself any more trouble. My family continues poorly and myself quite so. In much love to thee & thine.

<div align="right">

farewell

Edw. Hicks.[17]

</div>

Further evidence of hard times is a long over-due bill, finally paid to Amos H. Taylor, for a "coat, pants and vest" for one of his boy apprentices, Morris Croasdale. The bill also shows a coat for "G. Gold"—another apprentice, perhaps. Morris, descended from a Penn follower, as has been said, is remembered for a lovely little wooden trinket box he made for Edward's wife, whose initials are set in a delicately painted garland.

An apprentice of exceptional promise was now working in the Hicks shop. Thomas Hicks, a cousin, even at fourteen bore watching. This son of Joseph Hicks, a brother of the Tory Gilbert, showed a talent so promising that Edward, ordinarily opposed to taking the fine arts too seriously, agreed that Tom should receive formal training. Edward was to live to see Tom Hicks rise to eminence in New York, though he was never to view his cousin's portrait of Abraham Lincoln, which was painted when the rising Whig was beardless. Edward's writings include no reference at all to Lincoln. Although Tom was to serve for twelve years as president of the Artists Fund Society, and become Academician of the National Academy of Design in New York, he has not the fame, today, of his venerable coach-painting cousin and first master, who, while Thomas himself was enjoying much personal glory, was almost unknown outside Bucks County as an artist.

Signs still kept Edward busy. Major Archambault had taken over the old Red Lion Inn which was now known by the prosaic name of the Brick Hotel, in 1836, enlarged it for a Post Office, and encouraged Edward to turn out a sign which, though it has long since disappeared, was famous in eastern Pennsylvania. Within a decade it bade for immortality in Sherman Day's *Historical Recollections of Pennsylvania,* published in 1843, after the historian had become personally acquainted with both sign and painter:

A specimen of his self-acquired skill in the fine arts, as well as of his high-souled patriotism, may be seen on the tavern sign in the village. It is no ordinary specimen of village art, but is really the spirited production of a skilful artist. On one side is represented the crossing of the Delaware, after Sully's design; but, with true historical accuracy, the general is represented as mounted upon a chestnut-sorrel horse, and not upon a white horse, as is usual in painting that scene. It seems that the distinguished white charger, so well known to all, was a great favorite with the commander-in-chief; and being somewhat in years, the general selected for the arduous service of that night a younger and more vigorous animal. On the other side of the sign is the declaration of independence, after Trumbull's design. Mr. Hicks relates that General Washington left Newtown the same night that he crossed the Delaware. He also says that the night preceding, General Mercer told Mrs. Keith that he had dreamed of being attacked and overpowered by a huge black bear. A few days afterward he was indeed attacked and killed at Princeton by the British and Hessians. . . .

Newtown's own historian, Josiah Smith, also described the popular sign, saying it attracted "a great deal of admiration."[18] Like the "Penn's Treaty" sign for Sam Willett's tavern, it was mounted atop a pole near the entrance where it stood for years. The swinging sign by Hicks for the Delaware House in New Hope may have been the same pictorial type.

The most diverting and perhaps best-known Hicks sign-painting story was also published by Sherman Day in 1843, six years before the artist's death. Day had this anecdote on the au-

[18] Bucks C. H. S.: J. B. Smith, Ms. Bk. I, 43; II, 171.

thority of "a highly respectable Quaker of Delaware County":

An aged painter . . . was once called on to paint a sign for a stage proprietor and tavern-keeper, living somewhere in Bucks County. The device was to be a fine coach-and-four, driven by the proprietor himself, who remarked that occasionally he had driven his own stages. The work was done admirably—the proprietor called in to take a preliminary look, and gave his approval. *The likeness of the driver's face was perfect,* but he appeared to be lolling over as if half inclined to drop from his box. His whip hung slouchingly down—the reins were loosely held; and still he did not appear to be asleep, but had a remarkably good-humored expression all over his ruddy countenance. "But who is this?" said the proprietor. "That is not the way for a driver to sit." "Doesn't thee get a little so sometimes?" shrewdly inquired the old Quaker. The man burst into a foaming passion; but the painter cooled him down, and agreed that if he would promise to quit his cups forever he would rub out the driver and paint him as he should be, and the affair should be hushed up. It appeared that the habit of the man was not generally suspected, and was known only to the painter and a few other friends. The reformation is said to have been prompt and permanent. The Washingtonians could not have done it more gently.[19]

This story, while pointing up Edward Hicks's sense of humor and his ingenious approach to temperance, also raises an interesting question. If the likeness of the bibulous driver, probably Jacob Sunderland, was "perfect," why did Hicks turn out little (if any) known portraiture—*none* in the sense of "head-taking," as primitive limners often called their art. At least three of his landscapes contain figures said to resemble the subjects logical to them. But this is not portraiture by the usual standards. The portrait of Jackson, found in his shop after his death, is a copy of a print, after a Ralph E. Earl painting of the hero made from life. Like the print, one engraved by T. Illman, Hicks's copy is reversed in pose. It was executed on carriage curtain cloth which, in recent years, was mounted on board for preservation. The Illman engraving

[19] Day, p. 171.

was copied by Hoppner Meyer, and in all probability by other printers as well, a fact which removes the Hicks version from the purer category of primitive portraiture. Rather is it of interest in being the only such work definitely attributable to Hicks. Found in his shop at his death, it is undoubtedly from his hand. The likeness of Robert Morris on the signboard in the Bucks County Historical Society cannot be accepted as by Hicks without question, there being a Philadelphia sign company's name at the base, and the attribution having been made many years ago, more or less on hearsay.

The important and memorable Bucks County Bi-Centennial Celebration held at Doylestown, Pennsylvania, from August 31 to September 2, 1882, exhibited several Hicks oils, including a portrait of Edward Hicks Kennedy, then owned by "Mrs. Blaker" who said it was "one of Edward Hicks's first paintings." The location of this picture is unknown, but doubts of its authenticity must be raised. First of all, Kennedy was not born until 1811, and would not have been a likely subject for a portrait until he reached the age of twenty or more, by which time, as we have noted, Samuel Moon of Easton was painting the Kennedy family portraits. More important still, Hicks had done many oils by 1830—so that the portrait, if it is by him, could not be one of his first works, as Mrs. Blaker supposed. The suspicion arises that Thomas Hicks may have painted it before he left for art school, among his rather numerous likenesses of localites. As for Edward Hicks's distinctly inferior copy of Thomas' portrait of himself (Edward) such a copy does not entitle him to the classification of portraitist in any proper sense of the term, obviously. But should the Kennedy portrait ever turn up, and be attributable to Edward Hicks beyond doubt—by signature—and also pass muster as good work, this may alter the present deduction that he was, first and last, and with very minor exceptions, a landscape painter.

Perhaps Hicks borrowed a portrait of a Quaker of Alexandria, Virginia, named Stabler, executed by an artist named "Bownian" [*sic*]—and there is a letter to prove that he did so—in order to interest Tommy Hicks in this branch of painting. On December 3, 1836, Richard Price (a prosperous Philadelphia merchant whose influence was so wide that Edward sometimes asked favors) relayed word from William and Edward H. Stabler concerning the loan to him of the portrait of their father, secretly painted by "Bownian" after the latter had studied the subject in Quaker meeting. The Stablers had informed Price by letter: "Edward Hicks wishes to have the use of it for a while. Wilt thou be kind enough to take care of it when it gets to hand, and let Edward Hicks know of its arrival?"[20] Revelation of this letter in these pages can accomplish more harm than good, unless it be emphatically pointed out that it cannot be used, with impunity, to prove that Edward Hicks painted portraits, or to make a case for wholly dubious attributions. The fact worth noting in connection with the loan is that it occurred a short time before Thomas Hicks enrolled in the Academy of Fine Arts, Philadelphia.

The Hicks descendants own a ledger in which literally dozens of inexpensive, indubitably amateur portraits by Thomas are listed. Already he had a penchant for this branch. Moreover, there is a letter in the Hicks family collection to show that Edward allowed Thomas to take the portrait by "Bownian" to Philadelphia to show it to a friend—perhaps an instructor. There were other portraits in Newtown, of course, for the young student to consider—a few by Samuel Moon of Easton, for instance. But the "Bownian" work, seen by Edward on a visit to Alexandria, must have impressed him forcibly as of a type for the boy to emulate, leading him to borrow it for such inspiration. A further sign

of Edward's interest in spurring Tom's talents in this art branch is the portrait, a full-length study, for which he posed. This early work by Thomas Hicks is a skilfully painted and by no means primitive glimpse of the minister and painter, fascinating as a character study, and showing the iconographical details of his teacher's "Peaceable Kingdom," brushed into the left middle ground. It is difficult to imagine Hicks submitting to the trials, and the temptation to vanity, of the sitter, but judging from his expression he enjoyed it and had full confidence in the limner, who in 1837 left his tutelage. This portrait was exhibited in 1838 and again in 1842 by the National Academy of Design in New York City, a fact to be pondered by all who have been inclined to think of Edward Hicks as an entirely obscure figure in his time.

Did he feel wistfulness over Tom's opportunity for formal training? Despite his repeated belittling of art and artists, the strongest suspicion arises that he may well have felt envious. The growing assurance and maturity of his own output indicates aspirations and rising standards. Other and differing opinion to the contrary, his lack of opportunity is our own good fortune, for the well-spring of his genius was his spirit, which might have dried up in the academies of his day. His inventiveness and freshness, so apparent even in paintings based on others' inspiration, might have been drilled away by instruction. Certainly his exquisite and affectionate approach to others' themes would have been lost by the wayside. Such a loss would have cost us the primitive master as we know him. Who places a value so high on acquired or educated style that he really believes Hicks's genius, if developed in formal channels, would have produced works more pleasing than those which, without such training, make him great among the primitives? His genius was destined in the way and degree in which, gratefully, we find it.

[20] Hicks Coll.

84

Faith That Works by Love

AT GOOSE CREEK MEETING in Loudon, Virginia, in February 1837, Edward delivered a "discourse" which is the perfect elucidation of his "Kingdoms." Once this sermon is read and thoroughly comprehended, all doubt as to the significance of his famous allegory, iconographically and subjectively, or as to his creative intent—treated in perhaps a hundred versions—is at an end. Every subtlety and nuance of this superbly tender yet powerful exposition on canvas fades before the literalness of his message.

The sermon, based on Isaiah, was recorded by a stenographer among his listeners, unbeknownst to him. Afterward, when he was convinced the recorder was not mercenarily trafficking in gospel truth, he himself had it printed as a "treatise." (After his death it was also printed with his *Memoirs* and diary and another sermon.) He gave the pamphlet the title, "A Little Present for Friends and Friendly People; in the form of a Miscellaneous Discourse, By a Poor Illiterate Mechanic." It sheds light on his "Noah's Ark" as well, an important work which had its genesis in N. Currier's delightful lithograph which, in turn, may well have been a copy or a synthesis of some European work or works yet to be discovered. The print, still in the Hicks family, is the worse for wear because

of having been glued to glass and later broken. J. Baillie, another American printer, also lithographed an identical version. Hicks appropriated the model but made fascinating alterations, removing the apes and putting in men, adding llamas, and changing the color scheme and many details with subtle sensitivity.

He knew precisely what he wished to say on canvas, in a century when, but for printing, brushes and oils were the only means of communication more enduring than the human voice, holding at least the faint promise of immortality to one's cherished ideas. Though he has been belittled by certain art historians and critics for copying freely from the masters, through prints, he did so with good reason, just as other artists have done from time immemorial in such media as music and the drama. He stated his rich message in his own manner and style which cannot ever be mistaken for the painting of any other artist. His critics should not forget a significant fact. As recently as 1805, the year of the first organized association of the young and growing Pennsylvania Academy of the Fine Arts, copying had actually been advocated. The association met in Independence Hall "to promote the cultivation of the Fine Arts in the United States of America by introducing *correct* and *elegant copies* from works of the

85

first masters in sculpture and painting, and by thus facilitating the access to such Standards." Edward's ultimate disdain for straight copying is shown by his improvisation, to say nothing of this couplet from one of his long poems:

Inferior folks with only munkeys' art
May immitate but never life impart . . .

Few will argue that Hicks failed to impart life to a degree surpassing many formal masters, whose eclecticism is often more chilling than inspiring.

Before he began to preach that day at Goose Creek Meeting he asked all present to join him in the prayer that he would speak to the Creator's honor and glory. Then he turned vigorously to the theme of Adam's fall, in which "the animal man became a slave to that cruel, selfish nature emblematically described by the wolf, the leopard, the bear and the lion." Adam, shorn of the "innocent, angelic covering of God's righteousness," tried in vain to hide his nakedness with fig leaves, until he had no choice but to wear the "skins of beasts." To Edward, as to Isaiah, "the lamb, the kid, the cow, and the ox are emblems of good men and women, while the wolf, the leopard, the bear and the lion are figures of the wicked." These fierce ones "would cruelly destroy each other, while the four innocent animals . . . would dwell harmoniously together."[1]

Taking the Scriptures as "the most important history, the purest morality, and the finest strains of poetry and eloquence that can be found in any book, in whatever age or language," Edward reminded his listeners firmly that in Abel was the lamb, in Cain the wolf. Man—God's final creation—was "compounded of the four principal elements: Earth, Air, Water and Fire," which determined the character of Adam's sons and daughters, and the race of man, a character *melancholy, sanguine, phlegmatic* and *choleric*. Superior to all other animals, man

possesses the traits of the lower beings. He is "a little lower than the angels," though he was given "dominion over the work" of the Creator, as told in Genesis.

The first class, or the *melancholy*, have, for their predominating element, Earth. Their symbol, unregenerate, is the Wolf. They are "the money-mongers," the "usurers," the despairing who turn to suicide, as Edward said he himself once nearly did (referring to that fateful day in Philadelphia in 1817, when he had spoken out of turn at Yearly Meeting). The melancholy would not learn "to dwell with the lamb," but foolishly vaunted "education, fame and speculation," letting the wolf triumph. John the Disciple, George Fox, John Woolman, and distinguished Friends, had put on the lamblike "garments of primitive Christianity," and lost their melancholy leanings.

The second class, the *sanguine*, have the element of Air, above all. Theirs is the nature of the leopard, "the most subtle, cruel, restless creature, the most beautiful of all the carnivorous animals of the cat kind." Unless they conquer their inner or animal nature they are not to be relied on. They are overfond of "company, gaiety, music and dancing, taverns and places of diversion." The male leopards, "beautiful monsters," rob "the poor negatively innocent females of their virtue" and "leave them in a state of desperation, afraid to meet the tears of their parents." They then fly to "sinks of pollution" and "come to a miserable end." Here Edward admitted that he had known such places in his wayward youth! Such people are susceptible to the "narrow writings" of the "sophistical Paine" (who had Quaker antecedents), as well as to "tippling houses, gambling tables, houses of ill-fame, tremendous quarrellings and fightings." Their blasphemous tendencies would put to shame the "howling of the wolf, the screaming of the leopard, the growling of the bear, or the roaring of the lion." They are "too often seen staggering along the high-

[1] *A Little Treatise* (in *Memoirs*), p. 270.

way with their black jug and corncob stopper . . . purchased from some Judas that would sell his Saviour for money."

Edward used a figure of speech which explains a mysterious detail in some of his "Kingdoms," a leopard struggling to emerge from a hole in the earth: "Oh! that the Shepherd would extend his crook and snatch these poor creatures from the horrible pit." His own feet, he confessed, had years ago been "plucked out of a horrible pit and placed upon rock." The leopard appears in both its struggling and redeemed state, with pit and rock. Leopard-like persons were naturally inclined to be spotty. They favored "singing meetings, temperance lectures, abolition and colonization lectures." Catlike, they tore their friends to pieces; many happened to be female. To ease the humiliation of the leopards who were present, he observed that Peter had possessed that very beast in his nature, which later assumed the gentleness of a kid. The leopard is beautifully represented in some of the "Kingdoms," sometimes handsomely mobile, oftener reclining, and frequently dominating the entire composition. There are about four stock leopard figures, varying from one picture composition to the next, all of them ostensibly copies of animals in books and prints.

The third class of humans, the *phlegmatic*, with the element of Water dominant within them, have the Bear for their symbol. "Cold, unfeeling, dull, inert and beastly," they are readily aroused by "cruel and voracious" passions. "The bear will seldom prey upon other animals, if it can find plenty of nuts, fruit, grain, or even roots; it will then, especially in autumn, become very fat and retire to its den, curl up in its bed of leaves, and live by sleeping and sucking its paws. . . . Woe unto the man who would presume to take away one of its leaves." Edward rhetorically asked: "Could the prophet have found, in the whole chain of carnivorous animals, one link that would so completely describe a phlegmatic worldly-minded man,

wholly intent on the acquisition of wealth?" He repeated an old Dutch proverb, "My son, get money—get it honestly if you can, but be sure to get it." If trade be dull such a man will "shave some poor, weak, straitened brother's notes or paper" to make "a comfortable dry bed" for the bear in him to "retire to" and "grow fat."

He told a cruel anecdote about foreign missions, for he set no store by them. A certain man was asked to subscribe a sum for the Hottentots, so the story ran. He demanded to know why the solicitors went so far from home to give charity when the poor Negro in their midst needed befriending. To this the elderly lady collector replied, " 'La, Sir, nobody thinks of things so near home, and, besides, the Missionary Magazine never mentions them.' " The man thereupon took out a subscription, but with the promise from the lady that he would see his name printed in the missionary magazine as a donor. Edward was trying, without much finesse, to discourage any but the most sincere and heartfelt concern for the Indian and Negro. He continued with other tales of the evils of greed and of vanity, none of them more merciful.

Amazingly, in the light of his own miserable agrarian failure, he urged young Friends to go to farming and pay for its incomparable joys "with the labor of their hands." They could thus avoid the "grizzly-bear-like creditor." Matthew, the Apostle, had been a business man, but he remained "steady and sober," the only Apostle who was rich. His own personal bear never bested him, as may be seen in the benign animal in the peaceable painting, feeding beside the cow, quite as Isaiah recommended.

The final or fourth class, the *choleric*, having the element of Fire and the body of the lion, know pride and arrogance, Edward said, as their besetting sins. Many Orthodox Quakers seemed to him to be lions—choleric, intellectual, proud would-be leaders and "professors," unmindful that "the lion shall eat straw like the ox." It was a spirit he had from time to time

detected in himself when others differed with his opinions. "This self-will, when brought back to its original state, is clearly embraced in the figure of the ox," he explained, "—strong and powerful, but perfectly docile and submissive." Iniquitous tongues are touched with the element of fire, entirely heedless that, as "God is love," so also "the devil is hatred." His personal ideal among the Apostles, Paul, had this choleric bent. Paul was "one of the most malignant, bitter persecutors that ever lived." "The voracious, cruel lion ruled in him," but gave way before its opposite, the ox, after a "heavenly vision."

Commending "innocence, liberality and patience, like the lamb, the kid, the cow and the ox," he urged them to foresake their lower natures which, like "the wolves, leopards, bears and lions," are forever "devouring, tearing, oppressing and killing one another." He likened the transformation from fierce to gentle as a miracle of God's love. The miraculous quality, the mystical sweetness of his paintings, are thus to be explained. It is his own vivid, tender impression of creatures at peace with one another in the best, most beautiful of all worlds. It is the fulfillment of the aspiring, ever frustrate dream of this preaching painter.

Edward Hicks then took leave of his listeners with these words:

Finally, my friends, farewell! May the melancholy be encouraged and the sanguine quieted; may the phlegmatic be tendered and the choleric humbled. May self be denied and the cross of Christ worn as a daily garment. May his peaceable kingdom for ever be established in the rational, immortal soul. Then will be fulfilled the prophetic declaration . . . "The wolf also shall dwell with the lamb, and the leopard shall lie down with the kid, the calf, and the young lion, and the fatling together, and a little child shall lead them; the cow and the bear shall feed, their young shall lie down together, and the lion shall eat straw like the ox. The sucking child shall play upon the hole of an asp, and the weaned child shall put its hand on the cockatrice's den. Nothing shall hurt or destroy in all my holy

mountain, for the earth shall be full of the knowledge of the Lord, as the waters cover the sea."[2]

American history ran amok in 1837, a year of crisis for the nation, which was plunged into depression at the outset of Van Buren's administration. Indeed it is surprising that Edward did not seize on these "wild-cat money" days to speak or paint with his characteristic feeling about the vagaries of man and beast. The times must have affected his own affairs. Those persons who might have had the means for luxuries such as paintings would seem, if the following letter be any indication, to have hesitated to invest in his productions. Dated March 12, 1838, it is addressed to Samuel Hart who lived near Doylestown:

If thee should come to Newtown I would be glad thee would give me a call, and further if thee feels a freedom and should see my friend Abraham Chapman, ask him if anybody has taken any of them paintings I took the liberty to send to his care, and, if they are still there, apologize for the liberty I took of troubling him, and if he is willing to take them. I think there is two. One I presented to him as a small compensation for many favors, and if thou can dispose of them for any price from five dollars to twenty, do so, but keep them out of sight, hung up in some upper room till some suitable person should be at thy house that thou might think would like to have one. Thou then might show them. However, I don't care much about them. The object of my painting them was to try to raise money to bear my expenses in my late journey. It is all now done and settled. Therefore, they are of but little consequences.

The painter also expressed worry over an old debt of sixty dollars:

As but one of the five carriages is sold that we had on hand when I borrowed said money, and no money obtained, I should esteem it a favour to be indulged a little longer, until we can dispose of some of the work in which our funds now lay . . . In much love to thee, thy dear wife and children, and my dear friend A. Chapman when thou sees

2 *Memoirs.*

88

him, for I am like a good woman—if I love a man, I always love him. Farewell, Edw. Hicks.[3]

Bucks County's favorite local bard, Samuel Johnson of Buckingham, was a close friend of Edward Hicks. At one time he lived in Cooperstown, New York, and the painter visited him there during one of his preaching journeys. They agreed to disagree in a perfectly amiable way about abolition, "the cause of Afric's children," as Samuel's verse put it in an unpublished 180-line poem which he sent in long-hand to Edward. The engraving at the head of the first sheet showed a "Colored Young Man of the City of New York 1835" on bended knee at an auction block. Johnson inscribed the verse: "To Edward Hicks on his proposition for painting an Historical piece commemorative of the progress of religious Liberty." It began:

Dear Brother,
A brother's hand now sweeps the speaking string!
Imagination takes the Muses wing.

Edward executed no such painting, at least to the best of anyone's knowledge. But he did trouble to compose a reply in verse of 169 lines, the manuscript of which is owned by Edward R. Barnsley of Newtown. In some passages of this poem dated "Newtown, 10th mo 8th, 1839," the author was a "dogmatical disputant," as he once said; in others, the doggerel, full of fanciful spelling and grammar, is arch, and over-confident of its philosophies and poetic mastery. As in his painting, his milder mood became him best; these lines will satisfy curiosity as to his skill:

From Thomas Elwood down to old friend Weeks
The muse has mourned to see such blundering freaks
Made in her name by men of scanty brains
Whose verse may jingle but like rusty chains,
Unlike my friend's melodious solemn lyre,
Breathing in every line poettick fire.
His lovely letter sacred music graced
Like well-chimed bells in regular order placed,
While Afric's cause emply'd life's evening ray,

[3] Bucks County Historical Society Coll.

Like Venus lingering in the rear of day.
Inferior folks with only munkey's art
May immitate but never life impart,
Torture invention, tax their little brains,
And have at last their labour for their pains,
While my dear friend with grave sarcastic scan
Says in the prophet's words, 'Thou art the man.'
A *Saviour* came, a heavenly cause to plead.
A *Saviour* for the falling soul did bleed. . . .
And if by *truth* their souls from sin is freed,
Christ says such souls are truly free indeed. . . .
Deny yourselves, take up your daily cross.
Esteem the friendship of the world as dross.
Keep his greate precept ever in your sight
And with his humble *fishermen* unite.
In this straight path our early Friends did walk. . . .
When brotherly love rules in its wide domanes,
Celestial charity triumphant reigns. . . .
Liberty both civil and divine
Plays on our rocks and o'er our mountains shine.
The illustrious Penn this seed of freedom sowed.
A Franklin watered and the plant soon grow'd.
Its spreading top resplendent with its fruit,
Its just perportions and its vigerous root
Was seen afar when Thousands to its shade
Repared for shelter and pertection's aid,
When lo, a sad disease was soon descried.
In Southern limbs the very fruit was dyed. . . .
Much might be said on this delightful theme.
It is deep instruction and no idol dream,
Oft-times dealt out in particles to one
Whose sands of life on earth are nearly run,
Who hopes to die at the *bless'd Saviour's* feet
In self-abasement and repentence meet.
Oh may my precious brother meet me there
And join in fervent and effectual prayer.
　　　　　　　　　　Farewell,
　　　　　　　　　　　Edw. Hicks

The chief value of this long verse, for the student of primitive art, occurs about mid-way, where the following lines clarify an iconographical mystery of several "Kingdoms":

The starlike radiance shone with steady ray.
Those milder, light labors soon pointed out the way
By telling Friends they must the example set
And cleanse those branches that near their dwelling
　　met.
With due submition Friends their counsel heard,
And free'd these slaves obedient to the word.

Sweet peace, the Saviour's legacy of love
Descended on them from the Heaven above.
Then mercy smiled and justice sat surrene,
While Heavenly glory filled the space between.
High on the mount, conspicuous to the sight,
Friends stood alone, environed round with light.

Then let them stand there, let the people know
They cannot mingle with the world below.

The Carle Collection, Swarthmore, and several other private owners have oils containing a vignette of the scene on the mount.

Of Such is the Kingdom

IN THE year 1840 Edward, with prescience of the end, entered his final decade. Sometimes such foreknowledge brings fruition. So it was with the painter of the "Peaceable Kingdom." Like those whose powers reach their zenith late, he began to bring forth his loveliest creations. Pity it is that he could not see how time, like a wave, was bringing him not only near to the God and the Heaven he aspired to, but the full sum of his hard-earned gifts, that he might deploy them maturely in all their richness. Not that this by-turns bitter, vitriolic, mellow, loving, penitent, and righteous man turned saint at the last. But a change, a resignation, a progression, a new command is seen in his later paintings.

He began to speak for the first time of approaching death. To Rachel Hunt, a poet[1] and leading Pennsylvania elder, he wrote: "I should love to see thee once more, face to face, but time is uncertain and eternity is at hand."[2]

By spring he was sending his popular paintings to points as far away as Virginia. Word from a gentleman who had just received one of his "Kingdoms" must have pleased him:

Chantilly, Virginia, June 25, 1841.
My Dear Mr. Hicks,

I write to make my thanks for the painting you

sent me at Alexandria. I am highly gratified with it. My friends regard the subject as well chosen, and its performance as highly creditable to your untaught pencil.

The side grouping, representing Penn's Treaty with the Indians, and the peaceable establishment of a kingdom, seems happily associated with the millennium, or reign of our blessed Saviour upon Earth.

Your historical paintings are useful. They are like an open book from which all read and imbibe the right sort of national feeling. . . . I am, my dear friend, very truly yours

S. P. Lee.[3]

Ever more eagerly looked for by the painter were his granddaughter's captivating messages from New York. Phebe Ann was sufficiently grown up to frame her budding ideas beguilingly in a neat and precise little hand. Just before she reached nine she sent off this letter, which alone is sufficient to explain the conquest she made of Edward and all who knew her:

New York 12 mo., 4th, 1842.
My dear Aunt E—I have been wanting to write to thee for a long time, but have been waiting to improve in my writing. . . . I often think of the pleasant times I spent at Newtown. I am afraid sometimes that I was so much trouble to you that you will never want me to come and stay any more, but I will be older another summer, and I hope can

[1] See Notes.
[2] Friends Hist. Library, Swarthmore.

[3] Hicks Coll.

be a better girl. We have heard that thee was coming on to Yearly Meeting. I do hope you are, and then I can return home with you, if thee will be willing to have me. I wish thee would have me.

Brother and sister are playing and Catherine and I are minding them, and father and mother are down cellar cutting up a pig which has just come from the country. Tell grandfather and grandmother if they will come on to see us we will give them plenty of the Croton water, for we have it in the house now. . . .

I am learning Geography at school and read in the first class and spell in the first class too, and have been head most all the time, only when I stay at home. Father has bought me a beautiful New Testament which I can read to mother.

I have been to the Museum to see the Dwarf.[4] He is not as big as brother and drest just like a man. He only weighs fifteen pounds and is eleven years old, they say.[5]

Hicks's ability to render Caslon lettering in low relief as well as on the borders of his canvases when he so desired apparently led to the launching of a small side industry. In his own Bible are large capital letters cut from papers or books and preserved for use as stencils. Now came "Hicks Alphabet Blocks" for children, possibly begun as a fireside pastime for his children and grandchildren, but finally the germ of a serious but none too thriving business with many ups and downs. In April 1843, an Attleborough merchant named J. Ely advertised in the *Newtown Journal & Workingmen's Advocate:* "Constantly on hand Hicks' alphabet neatly painted on square blocks by Edward Hicks, put up in neat boxes."[6] A few weeks later that paper carried an ad put in by Edward Hicks, who, as it shows, was also keeping his eye on a road-marking project:

Edward Hicks wishes to inform the Supervisors and all others interested in putting up the Directors, on our public highways, according to law, that if they will paint the boards white, to suit themselves, and bring them to his shop in Newtown, he will letter them and ornament them with Hands &c. on

[4] P. T. Barnum Museum's famous Tom Thumb.
[5] Hicks Coll.
[6] Bucks County Hist. Soc.

92

both sides, completely, for forty-five cents per board. Or should he receive orders for forty or fifty in a place, he will deliver the boards, finished, ready to put up, at any distance not exceeding fifty miles, for sixty-five cents per board.

In this, his sixty-fourth year, he was not only making alphabet sets and keeping up his artisan and other painting, but on April 4, 1843, he drew up a chair to begin his *Memoirs*, a task which would engage him for a year and longer. "I am, this day, sixty-three years of age," he began, "and I have thought right to attempt, at least, to write a short narrative of my life, by way of testimony to the mercy and goodness of a gracious God."

It must have been gratifying to the old painter to read in the *Journal* on May 2 that his blocks were vastly superior "to the toys commonly used to amuse children, such as whirligigs, tops, miniature men and dogs, &c." He may even have seen to it that this gentle observation found its way into the local news sheet.

Newtown's late summer and early autumn epidemic which afflicted so many families, particularly among the children, brought grievous anxiety to the Hickses. Susan's "little Silas," who had been visiting his grandparents in the village, was stricken, but they bundled him off to New York in his grandmother's care. Edward's anxiety was such that he wrote his wife a bewildered chronicle about the dead and the dying:

> Newtown. 6th day eve, near sundown. 9 mo'th, 15th. [1844]

My dear Sally,

About an hour ago while Jane Price and Mary Johnson was with us, Jesse Leedom Jr. drove up in the carriage and came in the house weeping and said his grandmother was a-dieing. Elizabeth went immediately, and as soon as the company went I geared up the waggon and called for Joseph Briggs and we started over, but meeting Edward, and her sister Mary, on the hill, who said she was better, we turned back. We have just had supper, and Isaac and Sarah is going over to see how she is, and I will then tell thee.

We received Phebe Ann's letter and were glad to find you were encouraged about little Silas. Indeed I still think that except it is the divine will that he should die, his being removed from our infected atmosphere here will save him. Stephen Twining's child is not expected to live till morning. James Johnson's child was buried this afternoon and Edward Ridge's about 12 o'clock. Thomas Goslin called on me about noon to invite me to the burial of Joshua Headly near the Falls. Elizabeth intended to have written to thee for thy Judgment with respect to her coming on to New York. She says thee knows how much there is to do, and the disadvantage it will be for her to leave home at this time. Nevertheless, if it is thy will, she will come. Thee has left a void, my dear, in our little circle that can't be filled till thee returns, which we hope will be as soon as Susan can possibly spare thee. I have spent some lonely hours by myself, my cough keeping me awake.

Half after seven: Isaac and Sarah have just returned. Cousin Polly is still alive and appears to lay entirely easy and is perfectly sensible, but they think she can hardly last till morning. I have just told the children that I intend, if able, to get up early tomorrow morning and make a fire and put on the kittle, and then gear the horse to the waggon, and then call Isaac to go right over to Cousin Jesse's while I am shaving and getting dressed. When he returns I can finish this.

Nine o'clock. I have just returned from Stephen Twining's. Their poor little boy is gone. He died about eight o'clock. They bear their affliction with great dignity and firmness, but what is their affliction compared, or indeed what would Susan's affliction be, if she was to lose her dear little Silas—compared, I say, to Joshua Hedly's wife, her husband a corpse in the house, and five of her children very sick at the same time, and herself a poor helpless destitute widow? She has sent a particular request for me to come, but if Cousin Polly dies tonight I hardly know how I can go to the funeral of Joshua Headly which is at ten o'clock tomorrow morning.

He closed his letter at seven next morning, on Isaac's return from the Leedoms' with the news:

Cousin Polly is still living and considerably revived. She may live several days. Tommy Goslin is taken sick this morning. Sarah says, give my love to dear mother and tell her how bad I want to see her. Indeed we may all say the same, how bad we want to see thee, and send our love most affectionately. Mary seems very anxious that little Silas should take that syrup. Most affectionately thine, our love to all—all,

Edw. Hicks.[7]

The pall of sickness and tragedy in his township helps to explain the increasing tenderness, power, and spirituality of his "Kingdoms." In this year he painted a version for Joseph Brey, Middletown Friend. He declared it one of his best up to that time. A letter about it is still in the Brey family. The oil hung for many years in Bristol. The letter, written a week after Edward's anxious communication to his wife, has added interest because of its reference to a framer:

9 mo., 23rd, 1844.

Dear Joseph

I send thee by my son one of the best paintings I ever done (and it may be my last). The price as agreed upon is twenty dollars, with the additional sum of one dollar 75 cents which I give Edward Trego for the fraim. I thought it a great deal cheaper than thee would be likely to get a fraim with ten coats of varnish anywhere else. Thee can pay the money to Isaac who can give thee a receipt if necessary but—I have no account against thee. With gratitude and thankfulness for thy kind patronage of the poor painter and a grateful remembrance of many favours from thy kind parents, I bid thee, dear child, an affectionate farewell,

Edw. Hicks.

In this handsome canvas are a loping leopard of great beauty, and a lion and ox of unusual majesty and presence. A very similar example is owned in Trenton. A third example, similar but with an elaboration of details which makes it an even more compelling work, is the Martin Grossman Collection's "Kingdom," illustrated on page 154. The latter, the handsomest of the three, may be presumed to be slightly later than the others. Hicks, ill and deeply in need of such expression as his declining vocal ministry denied him, perhaps fearful of having to abandon painting too, was striving to excel his best before too late.

[7] Hicks Coll.

Tongues of Men and Angels

EDWARD HICKS asked Richard Price, the Philadelphia Friend who had recently relayed to him the message about borrowing the Stabler portrait, to help him market his Hicks Alphabet Blocks in Philadelphia. But the request elicited only a coolly cautious reply, its one note of warmth being congratulations on the engagement of Sarah, Edward's youngest, to Isaac Parry, Jr., the son of his first traveling companion on the journey into Canada.[1]

A year later, September 2, 1845, Price wrote a still more disconcerting letter in answer to another of Edward's requests—this one having to do with the final preparations for the printing of his *Memoirs* and a sermon or two, while he had the strength for such projects. Edward had informed Richard Price that the ever dependable Henry Hicks, his wealthy kinsman, had agreed to finance the project. Price replied succinctly that he did not care to handle Henry's money or anybody else's:

Thee asks me to receive money from H. W. Hicks and appropriate it for thee, in the fulfillment of a religious duty. I would much prefer being excused from doing so. It could be done equally well by Oliver Hough [son-in-law of Newtown's hatter, Joseph Briggs, a dear Quaker friend of Edward]. . . . A rich harvest would not be gained from these publications [in the religious sense]. I must therefore solicit thee to excuse me from attention to thy wishes. Feel assured it is no want of affection or friendship for thee. . . . I do not feel at liberty to undertake additional matters.[2]

Clearly, Edward was seeking to interest Green Street Meeting in the publications by involving Price.

It must have been as obvious to Hicks as to Price that the scrivener or copyist who was to correct the spelling, punctuation, and English, and copy the manuscript in a hand legibile enough for the printer, was the logical man to make arrangements. Oliver Hough agreed ten days later to take on the job, and for little or nothing, in a dedicated spirit, because he felt that the "publication ought not to be postponed."[3] Delay, however, was to prevent Edward's ever seeing the *Memoirs* in print. He continued to expand the manuscript and to interrupt its progress in favor of his smaller tracts.

In 1845, as a "last effort to restore that peace and unity for which Friends were once so remarkable," he had a tract especially printed for young Quakers, before his "feeble hold on life" should prevent his contributing his mite toward

[1] Hicks Coll.

[2] Hicks Coll.
[3] *Ibid.*

healing Society's ills. Eventually republished with the *Memoirs,* along with his Goose Creek Meeting sermon on man's animal nature, he called it "A Word of Exhortation to Young Friends, Presented to Them Without Money and Without Price, By a Poor Illiterate Mechanic."[4] A series of partly outrageous tirades against all the detested classes and kinds of evil, it nonetheless meant so much to Edward Hicks that it demands at least passing notice. The color, the whimsey and humor which emerge despite his solemnity offset his fanaticism. He had lost hope, the sermon said, of seeing Friends reunited, unless the rising generation would labor for union. He was not remorseful for his share in opposing policies which he held to be anti-Christian. The young were advised to turn their backs on the rich and on the professional classes and to take up farming, though, like all else, the life of the soil had its perils:

It is too often in the kitchen of the large farmer or tradesman that the poor bound girl is exposed to the wiles of the seducer, that too often leads to the ruin of her character forever. I have, in my childhood, seen the most shameful and licentious conduct under the roof of the respectable farmer, in the absence of the heads of the family.

Down, he urged, with rival religions as well as the Orthodox strayers! But he led up to this righteous counsel with the docile if paradoxical admission: "My soul feels a sweet union with all God's children in their devotional exercise, whether it is performed in a Protestant meeting house, a Roman cathedral, a Jewish synagogue, an Hindoo temple, an Indian wigwam, or by the wild Arab of the great desert with his face turned towards Mecca." Back he went to castigating indifferent Friends; Presbyterians who "massacred the Indians of the eastern shores of America"; Catholics who, he said, crusaded against Palestine at the holy sepulchre; Jewish

4 *Memoirs,* pp. 337-65.

priests of the Crucifixion; "the murdering Indian"; and the "Arabian robber."

With a show of erudition surprising for "an illiterate mechanic," he lashed out against such formidable figures as Genghis Khan, Frederick the Great, Voltaire, Paine, and Spinoza, all of whom were to him but "Gog and Magog." The allegedly elegant and empty learning of the ordained ministry he summarily dismissed, along with "aristocracy, priest-craft and king-craft," as "dross and dung"—vanities opposed to Christ's teaching. Here he intruded a strange contradiction in his frenzy, demanding that missionary travels be regarded with suspicion. He contended that they led to too much pampering and lionizing of preachers. Only if the minister could ply his trade and pay for lodgings en route was such travel justifiable. Jesus, he stressed, "never travelled in the work of the ministry further than one hundred miles in a direct line. Hicks deprecated his own "conceit" and his jealousy of other and better preachers. And he seemed to be speaking from experience when he inveighed against ministers' "sitting in idleness in rich Friends' rocking chairs, cracking jokes, telling anecdotes, backbiting brethren and sisters, or nursing fanatical melancholy." These lines are proof positive, as has been said, that he did no painting while on his travels, either artisan work or oils on canvas.

Turning to another paradoxical theme, he spoke at some length about his hero, George Washington:

"I do not present Washington as an example I wish Quakers to follow throughout," he apologized, "far from it, or, as a pattern of Christian perfection. I produce him in favor of my important concern that American youth should make the strongest sinews of civil government." A farmer and a widow's son, Washington was a man whom "no academy ever welcomed to its shade, no college ever granted a diploma"; his formal education was but to "read, write and cypher." Yet he headed a "band of the most

95

illustrious patriots the world ever saw." Strange sentiments for a pacifist Quaker! Carried away by the grandeur of his theme, Edward continued:

Such then was George Washington, that distinguished instrument in the hand of the infinitely wise Jehovah for establishing the American Republic, a system of government the most healthy and happy, the most successful and generous now under heaven. . . . While virtue, liberty and independence continue to be esteemed among the children of men, the name of Washington will be pronounced with veneration and respect by millions of intelligent beings.

Yet, two years later, Hicks wrote in his diary that the celebration of the hero's birthday with parades was no more than "a high day" for "political companies." "Forty-seven years ago," he continued, "I too participated in this festival and marched in the ranks as a soldier. Alas! where are my comrades and fellow-soldiers?"

Concerning so-called "progress," he conceded that the nineteenth century was an improvement over the seventeenth, and had brought admirable practical advances in "government, law, agriculture, engineering, machinery, and mathematics." But these he dismissed as "things of man."

He upbraided those Orthodox Friends who hinted that primitive Christianity was infantile, and who agreed among themselves that there was a man working for temperance reforms whose campaign was accomplishing "greater works than ever Jesus done." Father Theobald Mathew of Tipperary, Ireland, who had thus impressed Friends in Britain, was his target. All but unknown in our own times, the priest impressed Hicks as a hateful menace. Incensed by Mathew's influence, which had spread to these shores, Edward and his wrath invite a backward glance at the bizarre wave of local color which Father Mathew inspired in such cities as Cincinnati. The priest had signed a temperance pledge in 1838 and begun a crusade

which, by the 1840's, had taken a firm grip even toward the edge of our frontier lands.

In his *American Notes*, Dickens described a Cincinnati "Temperance Convention" conducted under the spell of Father Mathew. Thousands of members of the "Washington Auxiliary Temperance Societies" marched or rode on horseback, their "scarves and ribbons fluttering behind them" to the gay music of many bands. The Irish marched together, bearing high above the crowd their prized portrait of Father Mathew and their "National Harp," and wearing "green scarves" for Ireland. Their "well painted" banners illustrated the "smiting of the rock and gushing forth of the waters," and also showed a sober man about to annihilate a serpent coiled on top of a barrel of whiskey. "A huge allegorical device, borne among the ship-carpenters, [showed] the steamboat *Alcohol* bursting her boiler and exploding with a great crash, while upon the other, the good ship *Temperance* sailed away with a fair wind. . . ."[5]

In closing this sermon Hicks asked young Friends to seek "that state called the kingdom of heaven." His "Peaceable Kingdom" is the fulfillment of that wish, and it is his personal release from the despair he felt for its elusiveness on earth. His peace symbols—wild and domestic animals—appeared not only on canvas; he had many a small china and pottery figurine on his shop shelves, as well as newspaper, book, and Bible illustrations to guide him in the task of materializing with his brush a universe at peace that expressed the incessant longings of his heart. His parting words were those of the unshakable idealist: "Dear Friends, farewell. Be perfect, be of good comfort, be of one mind—live in peace—and the God of mercy and peace will be with you."

Edward cared immensely that such printed messages should reach those for whom they were intended. He ordered editions of a thousand at a time, at about forty dollars the run,

[5] *American Notes*, pp. 112-13.

from his printer. On November 16, 1845, he wrote Isaac, who was absent in New York on business, that he should attend to some small corrections in the text of this sermon. His amiable letter shows his mind full of a wide variety of personal concerns:

I tell thee what, dear Son, I have been thinking of. We shall kill our hogs before long. They are so very fat, and we shall have plenty of wood and coal and three or four stoves and sausage and mince pie and all that kind of thing, and shall really want a little help. Just put Susan and Sally and dear little Ned into the Cars and only let us know, and some of us will meet you at Trenton. I mentioned the above to Phebe Ann and she seemed wonderfully pleased, but wished me to not say anything about her going home. We just had supper, Mother, Aunt Molly, Aunt Mary, Phebe and myself. Phebe is now setting by me, mending a pen. . . . In much love from all to all, farewell, thy affectionate father. . . .[6]

This time his signature, with its butterfly flourish beneath it, was more than ordinarily forceful.

One of Hicks's fine farmscapes, the "Hillborn Farm," illustrated on page 147, was painted in the year 1845. Similar to the "Twining Farm," the original is considerably less brilliant than the "Cornell Farm," on page 108. Nevertheless, it is a primitive masterpiece. Thomas Hillborn is seen guiding a hand plow behind a fine team, with fat cattle beside him. A fence divides the Pennsylvania barn, shed, and house, and various human figures and livestock, from the lower half of the picture. The picture is inscribed with these words: "The Residence of Thomas Hillborn in Newtown Township, Bucks County, Pennsylvania, in the year of 1821. Purchased by his son Cyrus Hillborn in 1845, when this picture was painted by Edward Hicks in his 66th Year."

What shopwork was Edward doing at the time of these publications? The *Doylestown*

Democrat of October 12, 1845, gives us some idea:

An elegant sign, painted by Edward Hicks for Brown & Eyre, was exhibited, and attracted much attention. It presented the variety of stoves and implements of husbandry which they are engaged in manufacturing, truly and beautifully, also a rural scene, including farm buildings, groves, landscape, and all the operations of the farmer, handsomely arranged and true to nature.[7]

Somewhere along the way, between that year and the end of the century, this outstanding sign was lost, perhaps through ravages of fire or weather. It must have been in the tradition of his handsome farm scenes—or their forerunner: the "Cornell Farm," "Hillborn Farm," "Leedom Farm," and the three or more versions of the "Twining Farm," with other farmscapes perhaps yet to be discovered. In the opinion of Virgil Barker, author of *American Painting*, published in 1950, Hicks may have seen the Pennsylvania farm scenes of the painter Woodside, his contemporary, specifically the oil in the Harry T. Peters Collection. That possibility strongly occurred to this writer also, when it was shown during the Sesqui-Centennial at the Corcoran Gallery in Washington, D. C., in 1950. But may not the similarity be due more to the actual scene, in the last analysis? To repeat, Edward Hicks did not visit exhibitions. There is not a hint, documentarily, that he ever knew or heard of Woodside. The brilliant clarity of their color could be pure coincidence. Comparison is certainly unavoidable, even though Woodside's technique is more nearly formal. When Hicks painted neighbors' farms he was not doing so via Woodside's manner or that of any other artist. He was simply painting familiar scenes in his independent style, and very brilliantly, if one judges them among primitive works.

No interval in his career brought more tribulation than the year 1846. None sent him more

[6] Hicks Coll.

[7] Bucks County Hist. Soc. Coll.

swiftly and irrevocably into decline. Scenes of sickness and death constantly around him were a reminder that his own last ordeal lay not far ahead. The slow realization weakened him, broke his resistance.

The first shadow of the evil at hand was cast by—of all innocent means—word from Phebe Ann Carle to Elizabeth. The letter, dated January 9, 1846, written in genuine and no longer experimental Spencerian penmanship by the twelve-year-old, told of her small brother's illness:

Dear Aunt,

We are all well excepting Bub, and he has just had a fit. He had a cold at first but was taken worse today. We are very anxious about him. Grandmother was coming home to Newtown . . . but she will have to wait until he is better. Grandmother sends her love to all, in which I unite. Please excuse the writing, for thee can imagine my hurry. This is very unexpected. I must close. Bub is rather better, if there is any change since I began. Thy aff. niece, P.A.C.

P.S. Bub lays quietly at present. He seems rather more comfortable just now. He had another fit last night about 12 o'clock. The doctor stayed a part of the night with him. He ordered leeches on one arm and a blister on his breast, which relieved him for a while. His fever continues, and we are fearful of more fits. We have very little hope. All the rest well.[8]

Without anyone's quite knowing what took him off, "little Silas" died.

The event made Edward sense his own time closing in about him. On February 12, 1846, two months before his sixty-sixth birthday, he began a diary, which he kept spasmodically until April 1, 1847, the last date of entry. He began with this explanation: "I have thought it right this day to commence a little diary, or memorandum of passing events." The journal that he had kept seventeen years earlier has disappeared. The final one, published with the *Memoirs*, darts like most personal records from observations about the weather and from repe-

titious doings to reminiscence, philosophy, and fits of exceptionally morbid brooding. During that winter he also began a period of intensive painting, groping for inner peace when ministerial duties taxed his stamina almost beyond endurance.

News came on February 27 which moved him to pen an uneasy entry: "This day a messenger arrived from New York to inform us of the illness of my very dear granddaughter, Phebe Ann Carle, which brought my mind under a close exercise in sorrow and anxiety." Next day he wrote: "A day of sorrow on account of my dear grandchild. Towards evening I got relief in a sweet exercise of prayer and supplication."

Four bleak days, blanketed in snow, passed without further word of Phebe. Then, on March 3, he recorded the most recent news:

Intelligence from New York respecting my dear little granddaughter is of a very discouraging character, which produced heart-rending sorrow, for I certainly loved her, if possible, too much. Notwithstanding, I would rather she would die in her present innocence than live to be proud and wicked, for I could now hope that in heaven her angel could behold the face of the eternal Father.

A day later he mused sadly: "I am so little disposed to take my own advice, when sorrow and trouble come to my own door."

Two days of more encouraging word were followed by a discouraging letter from Isaac, who had gone to the Carles to help. He said the first diagnosis of "dropsy" had been changed to "brain congestion," and that the child might die at any moment.[9]

Edward Hicks, utterly distraught, experienced a psychic manifestation. At a funeral in Newtown, gazing down upon the "lovely corpse" of a little girl just Phebe's age, he suddenly saw in the still features "the very image" of his beloved grandchild. So affecting was the illusion that he retired to a back window to fight his tears. He was not entirely surprised, therefore,

8 Hicks Coll.

9 Hicks Coll.

when the news came next day, March 9, that his "precious little Phebe Ann" had died at about the moment when he seemed to have seen her in the other child's coffin. She was interred beside the fresh grave of her brother, "little Silas," after the horse-drawn cortege had traversed the long way from her father's house in Manhattan to Westbury, Long Island. Edward, at home in Newtown, prayed and wept despairingly: "I have never known what such sorrow was before."

He tried to ease his grief by writing out his feelings, as in this entry for March 13: "A day of gloom and sorrow. Oh! that I had more faith that works by love, which is that charity that suffereth long, and is kind. And oh! that I had more hope that would be an anchor to my poor soul, which seems tossed upon the tempestuous billows, without sun, moon or stars."

After Isaac returned with assurance that Susan and John were bearing their loss bravely, the old painter tried to become resigned: "My poor soul feels relieved from the most intense suffering for ten days I have ever experienced." His extraordinary love for the child had been mixed with a real belief that she exemplified the best of the "rising generation." A letter to Elizabeth Hicks, written by Phebe Ann almost a year to the day before her death, is given here in deference to her rare and unique place in Hicks's affections:

New York 3rd mo. 10th, 1845.
Dear Aunt,

I did not intend such a long time should have elapsed before answering thy affectionate letter. But my time has been so taken up with brother, and lately I have been engaged learning to knit purses. Brother is very interesting. He says da-da and calls Sarah "Say" plainly. He has two teeth. He got one of his side ones first. Mother wishes thee to ask Grandmother if she ever heard of such a thing? And now he has one of the front under ones through. He feels them very much, and it makes him very uneasy. He does not creep yet, but gets over on his stomach as soon as we set him on the floor, and tries very hard. Mother thinks he is very awkward about it. He loves to stand up by a chair.

Mrs. Stewart that lives across the street very kindly learned me to knit the purses and went with me to get the silk. I knit one and presented it to Adonijah. [Adonijah Kennedy, son of Dr. Edward Hicks Kennedy, who had settled in New York to practice medicine, having abandoned newspaper ambitions in Western Tennessee.]

Sister and I have quit going to school. Mother thought it was running such a risk of bringing diseases home to Bub. . . . I feel very anxious to come on to Newtown and commence school, but if thee will only come on I will wait and go home with thee. . . . Father is very anxious for Mother to have her teeth fixed. She has lost nearly all her front ones, and it injures her speech very much. She says if thee will come on and keep Bub she will be induced. . . . She says she cannot think of having it done unless thee is here. . . .

Please ask Eliza Woolston the name of a rosebush she was so kind as to send Mother. It grows beautifully.

Tom Hicks is preparing to leave for Europe. He expects to sail the forepart of Fifth Month.

Mrs. Stewart invited us to spend the evening with her last week to eat some of her own make of Ice Cream. There was to be no one there but us. They have the most books I ever saw in one house, and one is eight hundred years old. It is a great curiosity. It was written with a pen before the invention of printing. The ink looks as black as if it had been done a few days since. They have several from two hundred to six hundred years old, and five or six of the most beautiful drawings I ever looked upon.

Please write soon, for I do like to receive a long letter from Newtown. When thee does write please mention how cousin Jesse is, as L. Loines wishes to know. Please give my love to Grandfather and Grandmother . . . with a share for thyself. Please excuse the bad writing. Thy affectionate niece, Phebe Ann Carle.[10]

The writing was not "bad." It was beautiful, altogether worthy of the grandchild of an accomplished primitive painter, of a child precociously attracted to the beauty of old books.

Nine days after this loss, Edward became

10 Hicks Coll.

"quite unwell," but he was trying again to be "diligent in business," and praying "that the Comforter might bind up an almost broken heart."

Elizabeth's delay in returning home impelled him to write her plaintively on March 31:

My very dear Elizabeth,

I waited with impatience for the mail, fully expecting a letter from thee, but got nothing but a paper. . . . If my dear child can possibly leave her dear afflicted sister, I really want her to come home, for I have been quite unwell for a week or ten days, with something like an inflammation of the breast. Last seventh day I was taken with a chill and had to have the bed warmed and go into it about the middle of the afternoon, and take medision, which gave me some relief, but I did not get out on first day. Set up part of the day yesterday but took more medision last night, and I think I am better, though very weak. Indeed I never wanted to see thee worse than at this sorrowful season, though my sorrow respecting the loss of my precious little Phebe has almost been turned into joy from a prospect opened before me which I cannot find language, possessing force sufficient, adequately to describe. Suffice it to say there has been taken out of our limmited garden one of the most perfect plants that ever was planted in mutability, and it is now transplanted in the garden of the Paradise of *God*, there to bloom and flourish throughout the endless ages of eternity. Oh that her poor unworthy grandfather and dear afflicted mother may be prepared to join her in that city whose walls are Salvation—and whose gates are Eternal Praise.

[Gradually he was beginning to entertain thoughts of the happy reunion.]

I must be excused for wanting my dear Elizabeth to come home, and how rejoiced I would be if she could bring the deeply interesting family with her.

Deeply interesting, perhaps, but no substitute for Phebe, his favorite. He could not refrain from dwelling on the sad subject of her passing:

Emmor Kimber likewise said in his letter, when he read that part of Mary's letter that gave an account of our dear little Phebe that he wept aloud. And Isaac Parry told me that when he told John Comly of it, he never saw John so affected. Indeed I have been astonished at the extent of the circle in which that precious child was beloved.

We were a little alarmed just before noon at the driving up of a fine-looking young man with a gay horse and carriage from towards Trenton. But it was only Seth Davis's son, come to invite me to the funeral of David Longstreth.

Next day he closed this letter saying that he was feeling better, and showing that this was so by his spirited reminder: "Please write immediately on the receipt of this, and don't serve as thee has done. In much love from all to all, farewell, thy affectionate father."[11]

Two days after his sixty-sixth birthday he again wrote to Elizabeth:

I have just received John's very kind and affectionate letter, and can only say that Mother and myself want thee very much to come home. It is not thy services that we want but thy company, and those cannot be insensible that thou art to us a very *dear*—I had like to have said—*only* daughter. And it is not our feebleness of body that makes thy absence so painful, as our minds. We are old, and dear John must remember that the vacant place in the domestic circle is as deeply felt by me as it can be by him. For I am almost ready to conclude that I shall never get over the loss, and perhaps before the weary round of another year I shall be permitted to join the angelic spirit in the mansions of eternal bliss. Ah, had we our dear little Phebe with us, thy absence would not be so painful. Think then, my dear Elizabeth, of the obligations thou can feel towards thy aged parents. Compare them with the obligations that thou art under to a deeply afflicted sister (that I think ought to come with thee) and make thy decision as a free independent woman, and write to thy brother immediately on the receipt of this, who will send thy clothes or anything else thou mayst want. I have been trying to work a little today, feeling evidently stronger, but I continue to be exceedingly short breath[d]. . . .

In the morning he began to think that perhaps the friend who was to deliver the preceding in person might be delayed in Philadelphia en route. So he wrote another in the same tone, with signs of senescence:

11 Hicks Coll.

... I had a distressing night last night. Whether it was my dream, or what it is I know not, but indeed I meant thee very much to come home, and so does Mother. If thee would write immediately by the receipt of this, I soon would meet thee. I should love thee to be at home next first day when Sarah and Isaac comes. I appreciate the value of John's affectionate letter and feel the tenderest love and sympathy with him ... and his many memorials of a dear departed child, but he must remember that I participate largely in the same feelings, even weeping while I am writing, and I am old, and shall never get over it because I can't stay long enough in the world. Having an only dear daughter left with me as a peculiar blessing in my old age, I ought not to be improperly deprived of her company. Ah, had I that dear, precious little Phebe, who always anticipated my wants and appeared rejoiced to do anything I asked her to do, I should not feel the loss of my very dear Elizabeth, but oh my heart almost aches when I think of the contrast between my kind and affectionate granddaughter and her poor unfortunate Aunt Mary, who won't do a thing I ask her to do. But why need I be opening wounds that may be disposed to close, or continue to awaken those springs of painful sensibility. I therefore will try to suppress my sorrow and only add that I do want my dear Elizabeth to come home, and then perhaps she might go back next month, and it may be possible if I live I may come with her.

It is not, my dear E., services in the family that we want (tho' they are of great importance) but thy company, not only dear to us but to many others. . . .[12]

Was not this letter perhaps a message of genuine affliction rather than the petulant protesting of an old man? Isaac wrote Elizabeth he was sure she could not appreciate that her "father and mother were almost sick" from anxiety, and that Edward had walked "all the way to the Parrys' through the mud"—or several miles—in hopes of finding a letter from her the day before.[13]

April revived his spirits, and Quaker differences were a lively counter-irritant to grief. A friend's book on Friends' religious doctrine was being critcized by both Orthodox and Hicksites. "If I am not mistaken," Edward observed in his diary, "this redoubtable book, with my own little penny production alongside it, will soon sink with their own dead weight, undistinguished among the numerous productions of a quibbling, scribbling age."

On the fourth of the month, his birthday, he philosophized:

I am this day sixty-six, and I think it safe for me to say that few, and full of evil, have been the days of my pilgrimage. I do not know that I have done any good for my merciful Heavenly Father's cause, unless it was publishing that very little book that has given offense. I feel sorrowful, and I feel straitened, and hardly know what to do. I am not well enough to work, and I am not sick enough to be confined to my house or bed.

Three days later the *Newtown Journal and Dollar Weekly* carried his notice as to "having an assistant in the Painting business" and his message that he would "be thankful for a few carriages, wagons, &c., to paint," especially from "friends at a distance."[14] So as to "minister" to his "necessities," as he expressed it, he continued to go to his shop and work with his hands, but the "new ideas" rising up in his midst proved a distraction. The stuff of nightmares was the saying among some Friends that "the best way to kill the Devil is to love him to death." He would waken from his troubled sleep and take down Penn's sermons for comfort, seeking the feeling of unity which "that precious friend, dear William," always gave him.

Almost incredible it is that on the eighteenth date of that birthday month of 1846 he should have called himself "a poor old worthless insignificant painter." He wrote this on the very day when he was painting his superlative "Noah's Ark." Sarah Hicks Parry's letter to the absent Elizabeth proves this interesting co-incidence:

Thy rose bush is very pretty and thy geranium will be beautiful. It has just commenced blooming.

12 Hicks Coll.
13 *Ibid.*

14 Bucks County Hist. Soc.

101

Before I left, Father came in. He looks quite well again and is in good spirits. He is so much interested in his new painting. He says he thinks he is a much smarter workman than Noah, he has completed his ark in so much shorter time. . . . Father says I must add he is lost without thee.[15]

Hicks's primary inspiration for this masterpiece was Noah and his heterogeneous family, "in whom most of innocent nature reigned," and who were "saved to repeople the earth."[16] His masterful improvisation on the theme in an N. Currier print ranks with the finest of his works.

He was fast failing in physical strength, though his creative powers were on the increase. His family was apprehensive about Sarah, his wife, as well. He had been obliged to abandon most of his preaching activities. Indeed he was consciously striving to be "quiet." Now, however, his restraint was tragic, induced as it was in part by signs that his words had begun to pall on certain Quakers. One had risen at meeting, stamped rudely to the fire, and warmed his feet to disrupt the tedium of Edward's discourse. Painting and shopwork were his panacea, as he remarked again and again:

May 8th. Steadily engaged in my shop. My business, though too trifling and insignificant for a Christian to follow, affords me an honorable and I hope an honest living. Having to work with my own hands, for all the money I get, appears to me to be more in accordance with primitive Christianity than living on the work of other people's hands, especially on rent and usury. But my view on this subject appears too much out of fashion to be united with, even by Friends.

Crushed by imagined rejection by his fellows, he decided to shun Yearly Meeting: "I hope it is better for me to be at home, humble and industrious, weeping and praying, than in Philadelphia, idle, talking and laughing." Nor was he cheered by a visit from the Carles, the sight of whom again plunged him into sorrowful

longing for Phebe Ann. His general discouragement was scarcely lightened, either, by an incident at Quarterly Meeting in May in Newtown, when an outsider, an abolitionist lecturer from Philadelphia, divided the gathering by his presence, which some favored warmly and others sternly opposed. Those in favor withdrew to the near-by woods to listen to the visitor's words, while the rest, Edward among them, kept to their benches with bowed and disapproving heads.

Summer brought a slight improvement in his health, drove off the worst of his despair, and so revived his spirits that he requested his meeting to allow him to pay a religious visit to near-by Friends groups and families. This time he set out alone, going first to Middletown, three miles distant, where to his delight he found "dear John Comly," whose fine preaching provided a figurative "feast of fat things, with wine on the lees well refined." Leaving his wagon he took the stagecoach to Bristol, traveling on to Mount Holly for a visit with Dr. Joseph Parrish, Jr., who took him to call on Friends. Edward may well have presented the son of his late respected friend with the "Noah's Ark" on this occasion. It was inscribed to him, and he had been painting it but a few weeks earlier. This journey was one from which he willingly returned, after observing Orthodox leanings among the younger Hicksites. By mid-June he was back in his shop, that he might busy himself with his hands for "sweet peace," and "study to be quiet." But he could not seem to remain there, without stopping to pay restless and troubled visits to meetings in the general vicinity, or without interrupting his painting for long laborious sessions of writing which, despite his efforts, he feared only his truly devoted friends would bother to read when they were finished. These other distractions and concerns would then be halted by the dread that suddenly he might no longer be able to use his hands "to minister to necessities," and find him-

[15] Hicks Coll.
[16] *Memoirs*, 271.

self dependent on his children. The fear would drive him back to his shop.

On the last day of June, while "feeble in body and mind," he wrote: "I thought I felt something like the angel of God's holy presence, touching my soul about the time of the evening oblation." Actually, the feeling was a half-wishful, premature premonition of his "time of departure from this world," which was not yet at hand.

He painted through the hot sultry weeks of July, feeling his few ministerial duties too much for him, but trying nevertheless to carry on; worrying about the farmers' labors to harvest the hay and wheat hampered by the wet warm weather; then suddenly feeling a fresh "concern" to travel and preach in Delaware County. He was relieved, after he had decided to go forth all alone, when seventy-seven-year-old Joseph Briggs, the hatter, offered to go along. On July 17 the two old men drove off together, stopping overnight with Friends along the way. It troubled Edward to find that a chill had come between him and his old traveling companion Benjamin Price, with whom they stayed one night. Price's post as a boarding-school principal was the reason, Edward having expressed himself on many occasions as staunchly opposed to higher education. He was nervous and upset, and a spell of coughing at one of the meetings forced him to withdraw. After twelve days he willingly turned home, worn out.

August "dog days" caused him to close his shop, though there, alone, was "peace of mind." Controversial meetings which he conscientiously attended did his failing health no service; and, being somewhat deaf by this time, he found it hard to follow all that Friends were saying. The things he heard made him feel weary, such as the statement that Franklin's books were more beneficial than the Bible.

His abandonment of his customary visits to the sick, after many years, was not the only sign that the patriarch was giving out. With tearful-

ness and irritability among other omens, he fired a young apprentice, then recorded the act with what seems like a guilty conscience:

I have parted with A. P., an honest, industrious, smart young man near 19, who came to live with us to learn to be a painter and do the little farming on my lot of twelve acres, and he has learnt more at lettering in nine months than any boy I ever had has learnt in five years. But he was too much like myself; he would speak what he thought, and was not sufficiently guarded in his thoughts, and I found myself too poor to pay him for working on my lot and find him clothes to please him,—so we parted peaceably, and I hope I have done my duty towards the young man, for whose present and everlasting welfare I feel sincerely desirous. . . . August 30th. Steadily at work in my shop, having now to do all my little chores myself. It may be best for me to exert my little strength to wait upon myself, for I am verily a poor, weak old man, and ought not to be proud.

By September he was working night and day lest he "go behind hand": "Really I feel so weak, short-breath'd and miserable, I may soon die like my father, in the old arm-chair in the shop." His powers of recovery and apparent tenacity proved so great, however, that within a few days he was expressing an opinion shared today by many admirers of his art: "Did more work and better than I ever did, in the same time, for which I am thankful to my Heavenly Father, for the ability to work and the poverty that drives me to it."

New Year's Day, 1847, "warm and mild" as spring, was exactly like one of seventeen years before remembered by Edward. He would take his old journal off the shelf and compare the weather of the past, as old men will do, with the atmosphere of the moment. The rhythm of the seasons was soothing. But more than weather was recorded in the journal of this argus of Newtown. He spoke about services for worship where he spoke his mind forthrightly. He discoursed about the uncertainties of life, as emphasized by the Schofield's runaway horses

which bolted near the meetinghouse and dashed the carriage to pieces. The opinions on Quaker doctrine in books to which he took exception, his pen dashed to pieces quite as spiritedly as the Schofields' team had wrecked their carriage. Indeed his unsparing tongue had become not only a legend but a menace to his standing as a minister. It threatened his health and burned him out like a firebrand, even as it wore patience thin all around him. But he himself realized this danger:

January 24th, 1847. First Day; very unwell, hardly able to make fire and get the meeting house ready for the people, and then hardly able to attend; but I did, and that is not the worst of it, I spoke, and I fear hurt the meeting, as well as myself. . . . The meeting was very much hurt by a lifeless communication from a poor, ignorant negatively wicked old man in his dotage, who notwithstanding has too high a conceit of himself. Be that as it may, I felt myself I thought grow weaker and weaker, and went to bed crying and praying, that I might live one more day like a Christian.

As for his "making the fire," he smarted from sly insinuations that the money he received from Newtown Friends was "pay for preaching." The "usurers" and "hireling ministers" were seeking to have their day, after long abuse. Hicks wrote with outraged pride in his *Memoirs:*

I admit that I receive ten dollars a year . . . for taking care of the meeting house, making fires, sweeping, etc., out of which I pay from a dollar to two dollars towards the contingent expenses. And as to favors and presents, with the exception of the Leedom family, descendants of my adopted mother, I receive no presents or favors.

The Angel of God's Presence

BY 1847 Edward's artistic genius glowed with the brilliance of a dying candle. His powers reached their zenith.

A new subject which came to him from a certain "engraving," he mentioned enthusiastically in a letter to Richard Price:

Newtown. Second day morn.
Beloved friend Richard Price,

I am much obliged by thy great kindness in sending me two bottles of thy good wine. It came safe to hand on seventh day eve, and is more than enough. I do not refer to the painting business because I want purchasers for my work—for I have more bespoke already than I shall ever get done perhaps—but just mention to thy father-in-law, as he has a taste for farming and cattle, that there is a flock on the place I allude to with the likeness of a famous English Bull. In fact the English engraving is a picture of the handsomest English landscape I ever saw, and to enhance its value Joseph John Gurney's [shown] with his chariot. Friends is represented near the meeting house and in the graveyard. . . .[1]

He was referring to "The Grave of William Penn," a scene of the Quaker Meeting and grounds at Jordans, near Beaconsfield, Buckinghamshire, England. He had undoubtedly seen not an engraving, but an English lithograph after the Dutch painter H. F. de Cort's oil presented to the Historical Society of Pennsylvania by Granville Penn in a letter dated September 24, 1834: "This picture was painted several years ago for my late brother. To give it something of an historical character, it supposes Montesquieu visiting William Penn's graves; it is a very accurate representation of the locality."[2] The lithograph, drawn on stone by Paul Gauci and printed by Graf & Soret, follows the painting closely, and was unquestionably Hicks's immediate model. Careful comparison of the de Cort with the slightly varying Hicks versions leads to the unhesitating conclusion that he neither saw nor knew about the large de Cort painting. The differences in color are striking. In the original the meeting house is off-white, in that of Hicks it is brownish-yellow. In the copy the green-cropped hedge becomes a whitewashed wall. The beasts are fine Pennsylvania rather than English livestock. The charming detail of a suckling lamb is a Hicks innovation. The sky, instead of being blue, with some shadowy clouds, takes on typical Newtown evening neutral hues washed with soft rose and gold. The tones of the tree foliage differ. The poses of the shepherd are not identical. The dog is different in each Hicks canvas. The circle of figures around the grave receives Hicks's indi-

[1] Friends Hist. Lib., Swarthmore, Pa.

[2] Hist. Soc. of Penna.

vidual touch. Among the known versions are those inscribed in his "sixty-eighth year," 1847, for Elizabeth Cary, Job Roberts, Ann Drake, and William H. Macy, and the oil in the Garbisch Collection. The first of these, an extraordinarily well-preserved and beautiful example owned by Miss Cornelia Carle Hicks of Newtown, had the distinction of being exhibited among the masterpieces of Europe and America in 1926 at the Philadelphia Sesquicentennial, five years before Hicks's so-called "rediscovery" in Manhattan. This was more than a decade before New York's Museum of Modern Art sent his work to be shown in Paris with a representative American selection. It was twenty years before the Tate Gallery of London exhibited a Hicks oil with Copley, West, and other American masters.

The burial ground contains the graves of William Penn, his two wives and five children, and two other Friends. What caused Hicks to assume that it was John Joseph Gurney, instead of Montesquieu, who headed the circle in the picture? Whatever the answer, the conclusion is interesting because, much though he venerated the memory of Penn, he aired his scorn for Gurney with a vengeance. The English leader of the Orthodox had a "princely fortune," "scholastic education" and the advantages of a regal existence in Lord Bacon's manor house, the Newtown Quaker said. But he himself, who had been offered wealth and education and refused them, was a better Friend and preacher —that was the clear implication. And when he read of Gurney's death, about the time that he saw the print, he would have none of the current apotheosizing of the English Friend!

A far more interesting aspect of Hicks's belief that Gurney headed the circle is that it proves indisputably that he never looked on the de Cort painting, which was given to the Historical Society with full information as to Montesquieu's presence in the landscape, and was

doubtless labeled accordingly for the public benefit.[3]

An extremely interesting "Penn's Grave" in the Garbisch Collection, showing the cattle grouped close together and lying down, and the shepherd moving rather than seated, is illustrated on page 152. In view of the compositional difficulties and the confident draughtsmanship, this variant not only emphasizes Hicks's increasing assurance and command of his medium, but it demonstrates his ability to copy when to do so suited his purpose, and also his apparently effortless faculty for making the model over.

It is impossible at this date to be certain, but his diary suggests that his shop routine was becoming as heavy a drain on his constitution as were his constant bouts with Orthodox Quakerism. The former had often restored and steadied him after enervating sessions with the latter. But he was now returning to his work with strength spent beyond redemption, while permitting the campaign which so winnowed his reserves to rage on relentlessly. He felt obliged to attack Gurney's alleged schemes to "amalgamate his followers with the Episcopalians." Yet the thought of bills falling due on the first of April—the zero hour in Bucks County as elsewhere for old obligations—also nettled and disturbed him. He knew he must attempt "to earn something to be able to meet all demands" outstanding. His debts, he consoled himself, were less formidable in 1847 than in the past.

March was also difficult in that it was the first anniversary of the death of his beloved Phebe Ann. His grief sought refuge in a sweet vision of her "safe arrival among those blessed angels."

[3] Dr. Julius S. Held, writing in the *Art Quarterly* in 1951, was evidently unaware not only of this point but of the existence of the Hicks letter which proves it. Certainly he could not have known of the Society's own lithograph of the scene, illustrated in the present work, Hicks's inspiration, although whose impression he copied is unknown. After seeing one in the gallery of Robert Carlen of Philadelphia, which came from Bucks County, this writer came upon the one, here illustrated, which is in the Society's collection.

On April 4, his debts settled but his fatigue very much with him, he resolved to close his "writing concern," after jotting down some "sorrowful truths" about the subdivision of Friends and the unhappy condition of the Christian religions in general. This day was his sixty-seventh birthday. He was immuring himself with the gift of silence, and brought his diary to a standstill. Not until a month before his death would he open it again.

In 1848 he painted a scene, the "Cornell Farm," not only regarded by many as his masterpiece, but one which is the most eloquent answer to those critics who, disparaging him as a copyist, utter such pronouncements as this one by Julius Held in the *Art Quarterly* for summer 1951. ". . . despite the occasionally expressed opinion that Hicks derived his paintings from the study of nature (in addition to that of prints), not a single instance is known where he actually did so."

He also painted a lovely landscape for Joshua Longstreth, a version of his several times repeated "Grave of William Penn." Surely his "Peaceable Kingdom" with its detail of lioness and cubs, two variants of which are privately owned (one known to have been painted in 1848 and the other at apparently about the same time) is unsurpassed among his works in its power to evoke a powerfully sympathetic response. One of these oils was exhibited by the Philadelphia Museum of Art during the 1950 Golden Jubilee celebration.

In the spring he completed a sign for the hotel at Willow Grove which so far outshone his others that on May 31 the *Doylestown Democrat* printed words in its praise. Not hesitating to draw upon such adjectives as "beautiful" and "eminent," the article must have brought color to his pallid cheeks:

The new sign recently erected . . . was painted by Edward Hicks, an aged and much beloved minister in the Society of Friends, and is such a one as we would expect to emanate from this eminent artist. It is one of the best specimens of the skill of the painter now hanging between Philadelphia and Doylestown, or even Easton; and we do not doubt but that thousands will call, if for no other purpose than to take a leisurely view of this beautiful work of art.[4]

This flattering item is sufficient to disprove assertions that Hicks was ridiculed in his community for his painting. He was ridiculed on occasion for his preaching, and by only a small minority, but not until shortly before his death. The earlier opposition to his preaching cannot be fairly reckoned as derision. Once he was "eldered" for answering sharply to criticism—by Friends but not by the wider Bucks County community—for his exaggerated interest in art, the value of which he had intrepidly defended in a sermon.[5]

If Richard Price saw no market for Edward's alphabet blocks in Philadelphia, his old friend William O. Boku did. "Esteemed Friend," wrote Boku, "several of my friends are wanting some of those letter'd Blocks. If on hand, please send me three boxes of them—by someone who may be coming to the city, and I will pay them for the same. How does my dear old friend come on?"[6]

On September 29, 1848, Richard Price wrote Edward a letter which explains in part why the *Memoirs* had yet to be printed.[7] Oliver Hough still held the document on which, because of his own vicissitudes and worries, he had accomplished little. He had given up his own Walnut Street office in Philadelphia and was working at home on other orders. Probably the vague financial arrangements between them did little to increase the incentive of the good-natured but impecunious Hough to finish copying and correcting the manuscript, despite his expressed

[4] Bucks County Hist. Soc.
[5] See Notes.
[6] Hicks Coll.
[7] *Ibid.*

willingness. Aware that Henry Hicks, Edward's wealthy cousin and benefactor, would pay the costs, and that the painter was evidently inclined to accept his impulsive offer, Hough must have elected to take his time. Hence Edward failed ever to see the *Memoirs* in print, much as he longed to.

He was unwilling to submit his writings to a Friends committee for approval, with the excuse that he did not wish members having an overabundance of civic and worldly interests to judge his own dedicated testimony. He said that John Comly, Isaac Parry, and other close comrades would judge fairly, but beyond them he was not so sure. As it turned out, Comly, Parry, Ferris, Comfort, and other Hicksites expressed extreme apprehension in letters exchanged just after his death, lest his ideas and volatile tongue harm the cause of Friends' peace.

Comparison of the manuscript[8] with the printed book shows how little Hough changed it, beyond correcting the spelling and punctuation. The book is virtually identical with the original, written in longhand by Edward.

A fortnight after Price's letter, Hicks's attention was drawn to quite another matter. The Bucks County Agricultural Society's exhibit of fancy livestock gave him a rare opportunity to demonstrate, by means of more than a mere painted sign, his remarkable talent for farm scenes. In the month of October he undertook a very large landscape on canvas. It undoubtedly far and away transcends any farm scene executed by an American primitive painter. To not a few, the "Cornell Farm" is his outstanding work. Certainly it is his answer to those who would today call him a mere copyist. On the side of technique and surface painting this claim cannot be gainsaid, although other connoisseurs may well choose the "Kingdoms" as more impressive for their *inner* as well as visual content. Not a portraitist by aspiration, he could nonetheless turn out a fair likeness without pretending to anything like exact representation. Tradition relates that the corpulent farmer standing in the group in the center of the large meadow is James C. Cornell, several of whose animals won prizes at the Agricultural Society's show. He and his brothers William and Adrian, also said to appear in the painting, walked off with the best of the awards, according to the *Democrat*'s account of October 17, 1848.[9] Hicks lettered the following inscription beneath the brilliant scene:

An Indian summer view of the Farm Stock of James C. Cornell of Northampton, Bucks county, Pennsylvania. That took the Premium in the Agricultural Society. October the 12, 1848.

Except for the disappearance of some of the buildings, the scene is so little changed today that one can walk to the approximate spot where Hicks must have made the drawing for his painting. The large dimensions of the canvas would seem to preclude the possibility of his having painted it out-of-doors in the Cornell fields. Until a few years ago it hung in the Cornell farmhouse parlor, unexposed to extremes of heat or light, a fact accounting for its freshness, which is as marked today as if the work were new rather than a century old. Would that the same might be said of all his oils, some of which have been sadly neglected or else abused by inexpert "preservation" and "restoration."

Had his interest waned in "Peaceable Kingdoms?" Indeed not. One of the most admirable examples was executed in 1848. Its lion, as the illustration shows, has more command and nobility than, perhaps, any of his others; it appears in several of the "Kingdoms" as one type. The detail of a lioness and her cubs in the lower lefthand corner, to be seen in the Phillips Gallery, and also in the Carlen and Garbisch collections, is among the most engaging that he painted, proving again the appeal—for Hicks—

[8] Hicks Coll.

[9] Bucks County Hist. Soc. Coll.

108

of maternity as a theme. The Carlen example has the familiar "Treaty" scene at the left, this time showing an Indian infant at its mother's breast. Hicks also, as we have already noted, added a suckling lamb to his "Penn's Grave" painting, a detail possibly seen in a Bible engraving, as on page 148.

Before the month was over, the artist's name was again singled out for recognition by the press. On October 27 the *Democrat* announced that he had lettered the fine "wagon for carrying threshing machines" which the Agricultural Society had just exhibited with excitement.[10]

[10] Bucks County Hist. Soc.

Passport to Heaven

AN OLD colleague in Hicksite concerns, Mary Lippincott of Moorestown, New Jersey, heard that the failing Newtown preacher was at last abandoning his battle with the dragons. On a February day in 1849 she decided to try to rally him with this message:

My beloved Friend . . . Pleasant is the remembrance of thee and of the favored seasons we have had, when we have gone up to the house of the Lord together. Dear *Edward, don't* give out—don't despair! . . . Well do I remember the voice of encouragement from thy lips, nearly thirty years ago, the first time I ever heard thee, and the subject, words and *illustration* are yet *clear* before me, and *hundreds of times* have arisen fresh as when uttered. . . . Now this is not to flatter but to strengthen. I think brighter days will yet be seen, and the Lord will make himself manifest as setting his face against that disorderly spirit that would remove our ancient landmarks and break down the hedge of discipline.[1]

Though his heart may well have been warmed by Mary's words, Edward Hicks knew that others must bear the cause forward. Often in recent years he had dramatically presaged the nearness of his release. But now he was beginning to predict it quietly and with assurance. His family's protestations that he would regain his strength and health only caused him to shake his head gently, in denial.

On the threshold of his seventieth year Edward Hicks began to prepare for death. With much thought and self-examination, he decided that the time had arrived for him to set his house in final order.

In a fine clear hand (such as he seldom if ever took the time for) because he intended that what he wrote should not only endure but be understood, he addressed an apologetic "acknowledgment" to Makefield Monthly Meeting, which was read before, and accepted by, that body:

Having but little expectation of ever mingling with Friends in meeting any more, I think it right to offer the following acknowledgment. Being impressed at time with fearful apprehensions that some part of my conduct or discourse may have increased a spirit of disunity and unsettlement in this meeting, and if so I am really sorry, and now feel it my religious duty thus publicly to condemn all such conduct and discourse as may have caused disunity and scattering among Friends, sincerely desiring my dear Friends to forgive me and continue me an object of their care, their sympathy and prayers. Edward Hicks.[2]

[1] Hicks Coll.

[2] Dated June, 1849. Dreer Coll., Hist. Soc. of Pa.

As he felt the days closing in around him, he found it hard to have Elizabeth away. After she went to the Carles in New York that spring to help nurse his new and desperately ailing young namesake, Ned Carle, it was not long before he begged her to return. Her reply sheds fascinating light on both father and daughter:

New York, 6th mo. 7th, 1849.

Dear Father,

. . . I do want to come home very much, but don't feel as though I could leave. . . .

Every year of my life, my beloved father, adds strength to the gratitude that I feel to thee, for the pure Christian faith that the prayers and exercises of thy spirit has desired for thy children; and although I am well aware that nothing but my own faithfulness and dedication can give me a permanent possession of this treasure, yet I feel a daily conviction that I owe much to thee.

And oh, how grateful I am that instead of spending the energies of thy unmolested spirit in accumulating the perishing riches of this world for thy children, thereby increasing the *snares* and *difficulties* in their path through life—that thou hast only been concerned to obtain for them that *"treasure"* that fadeth not away, but increases in value as the sorrows and disappointments of this life press the most heavily upon us. I feel, dear Father, that instead of giving a *dagger* to thy children that would pierce the soul and rob it of the true life, as too many fathers do, thou has provided us a *shield*, that as we prize and use it will protect from all the arrows of the enemy, all the trials of life.

I know, dear Father, that thee often feels discouraged, that thy faithful labours have yielded so little fruit, but I have a firm faith that thy dedication to the candle of Truth will not and cannot be lost. I believe thou has been an instrument, to sow seeds, that has taken root in different parts of the vineyard, and will bear a rich Harvest to the honor of the great *Husbandman*. . . .

There was some friends here yesterday inquiring after thee. They said I must give their loves to thee, and tell thee that thee was held in affectionate remembrance by a great many friends. . . .[3]

Edward's reply may well have been the last from his feeble hand:

[3] Hicks Coll.

Newtown. First day morn. 8 o'clock
6 mo[th] 10th, 1849.

My very dear Elizabeth,

Thy truly acceptable letter was a relief to our anxiety, but not to our sorrow for dear little Edward's continued indisposition, and the consequent sufferings of his over-indulgent parents. But I was more especially thankful for the comfort and encouragement my precious daughter was prepared to pour, as the oil and wine of the kingdom, into her poor father's exerzised and sometimes really sorrowful soul. . . .

Few men that has been exposed to the degrading vices and temptations of a wicked world have witnessed such a preservation from grave evil as I have. Indeed it appears the Lord's doings, and marvelous in my eyes, that I can now say at the full age of a man that if all my immoral conduct was exposed on the housetop it would not leave a stain upon my moral character in the sight of men. I therefore came upon the stage of active life almost peculiarly calculated to be happy.—Happy in myself—Happy in my family—Happy in my friends— and consequently Happy in the world. It is almost astonishing, the many valuable, yea I may say precious friends I have had, and, I trust, still have. Thus I have been descending too smoothly down the tide of time, too little intent on time, too much amused while unconscious of the gliding wave, or, in a better figure of speech, I have drunk too little of the cup of suffering that the Saviour drank of. . . .

The prospect of death made him lonely, and he hoped the family might join him in paradise, a "precious wish" which Elizabeth's reply made clear that she had sensed. Indeed her answer brought tears to his eyes and a feeling of thanksgiving.

But to return to Edward's letter, he spoke of the little boy's illness:

I still think he would have stood a better chance in Newtown and regret that he was not brought, agreeable to my wish. It may be that my feelings for children have become too callous, for I confess, since the death of my precious Phebe Ann, in writing whose name my eyes are filled with tears, I cannot feel the like for any other.

Next morning he added a mite of news to what he had written:

Mother was up by sunrise, but, I thought, looked drooping, but she thought she would feel better after stirring about. Indeed I feel afraid she will give out. We are sorrowfully disappointed, for we had anticipated a pleasant visit this month from dear John and Susan with their children. But could not Sarah come with thee? Poor Mother keeps repeating over and over, "Oh that I could see Susan." . . . I saw Eliza Leedom last night. She don't want thee to take the trouble, but says if thee gets her a dress, dark gingham of thy own choice is best. . . .[4]

Little Ned lived, and Susan returned, and the weeks moved along to midsummer. In July Edward opened his diary to make a final entry, revealing the heaven already in his heart:

Newtown, 7th mo. 13th, 1849.

I feel as if I ought to try to write a few lines more before I die, which some of the doctors think will be this summer. Indeed I feel scarcely able to walk up and down stairs, such is the weakness of my body, though, I humbly hope, I am favored with sound mind and memory, and want simply to say, in as few words as possible, something by way of encouragement to such precious visited minds as may come after me and read this.

Dear, precious children, believe me, an establishment in the ever blessed *truth*, as it is in Jesus, is infinitely—infinitely superior to everything of this world. Press after it, lay fast hold of it, in this your day of visitation, remembering that by "grace ye are saved, through faith, and that not of yourselves, it is the gift of God." Put no confidence in your own strength, your own resolutions or resolves, for should you thus attain to a religious standing among men, it may terminate in self-righteousness, or, at best, that of the elder brother, which was not the Christian state.

I now feel that it was a great blessing when I came to see my lost state about the twenty-first year of my age, that I lost all confidence in myself, and felt the need of a Saviour to save my sinful soul, for I knew without such a Saviour I must fall; and this fear of falling, which has been the companion of my mind for nearly fifty years, I now see has been an additional blessing to me, for it led to care and concern, and this concern, in the day of my espousal, when I first began to attend Friends' meetings, led to fervent prayer, which was effec-

tual, and hence my preservation as a monument of the mercy and goodness of God. I say monument of mercy, for I certainly have no merit, and am always astonished that such a poor creature as I have always been should have ever attained to such a standing in Society, and had so many good friends.

I now have a lively recollection that in those days of temptation and tremendous tossings . . . how I begged for preservation. . . . This prayer has been graciously answered . . . and my poor soul has become established in the eternal *Truth* . . . with that faith that works by love. For oh! the love I feel for my dear Redeemer is inexpressible, and the increase of love I feel for all his dear children the world over, let their name and profession be what it may. This faith in Christ, and love for him, furnishes the precious hope that I shall be saved . . . I therefore humbly hope that death to me will have no terrors, nor will the grave have any victory, but through that faith that works by love, my soul will triumph over death, hell and the grave.

I write this seriously, and awfully, and thoughtfully, being under no excitement from preparations of opium, or any other medicine. But in a short time I fear I shall not be able to say so, for unless I can get relief some other way, I shall have to have recourse to some kind of anodyne. And in that case, whatever expressions I may use will be more or less incoherent, in proportion to the irritability of the nervous system, the exquisite connection of soul and body.

. . . Paul felt himself, in the presence of Infinite purity, the chief of sinners. . . . With much more propriety than Paul . . . I view myself not only the chief of sinners, but a wretched sinner, a fool, a worm of the dust, a nothing. . . .

But I am writing too much and saying too little, and had better mind my own business, which, if I am not mistaken, is to bear a simple, childlike testimony to this mercy and goodness of my blessed *Saviour*, which will subject me to be pitied by the wise and prudent of this world, as a fool or ridiculed as an enthusiast; my doctrine considered madness, and my end without honor. Yet I would not part with this child-like belief in Jesus Christ, for ten thousand times ten thousand worlds. . . . Oh that I may have that precious life that is hid with Christ in God, as a passport from this world to the Heaven of Heavens.[5]

[4] Hicks Coll.

[5] Diary *(Memoirs),* pp. 258-61.

Another task, a heavy one, he could not put off any longer. On August 3 he called Isaac to help him make his will. Jesse Leedom, Mary Twining's husband, came in from his farm with his young son Edward to witness the proceedings.

Edward Hicks, with Isaac seated at the table to record his words as he spoke them, prepared a document[6] which is more like a testament of love than a transfer of possessions:

I, Edward Hicks . . . being considerably advanced in life, and after having enjoyed my share of happiness, and as many of the blessings and comforts of this world as most individuals, (graciously meted out to me by a kind Providence) think it right to endeavour to make the family I leave behind (who are very near and dear to me) as comfortable as the nature of the case, and my little estate, will admit of. I therefore make and publish this my Last Will and Testament, annulling all other and former wills by me at any time made.

In the First place, I direct all my debts, funeral expenses and will charges, fully paid out of my Estate by my Executor. . . .

2nd, I then give and devise to my dearly beloved wife Sarah W. Hicks (for the purpose of keeping my dear family together) all my remaining estate, real, personal and mixed of every kind whatsoever, during her natural life. And upon her decease, whatever may remain of said estate I order and direct to be divided into Three Equal Shares, in such manner as may be thought just and equitable, by the arbitrators.

One of which *Shares* I give and bequeath to my son Isaac W. Hicks, and to his heirs and assigns. *One Other* . . . to my daughter Elizabeth . . . and the remaining *Share* . . . to my said son . . . in Trust Nevertheless for my dear afflicted daughter Mary, the interest or income of which, and such parts of the principal as my said son shall think necessary, shall from time to time be expended for her comfort and support, during her natural life. It is then my will that such remainder shall be equally divided between *all* my children . . . share and share alike.

My reason for not giving my dear daughters Susan and Sarah an equal share . . . is not because

I do not love them equally well—very far from it. My children feel, and are, all equally near and dear to me: but it is because they are well provided for, and more comfortably situated than it is in my power to make my *other* children.

3rd . . . Should my daughter Elizabeth marry during the lifetime of her mother, my Executor, or dear wife shall pay her the sum of Three Hundred Dollars, for an out-set, in goods or money, out of my estate. And if they cannot conveniently raise that sum out of my personal property they are hereby authorized to borrow what part of it may be necessary, on the credit of my Real Estate, which . . . shall be considered a part of [her] share of my estate without interest.

4th I hereby appoint my friends Thomas Janney, Joseph Paul, M. H. Jenks, Edward Worstall, William Stapler and Jesse Leedom, Arbitrators. . . . And I appoint my son Isaac W. Hicks, Executor . . . enjoining upon him to make *no charge* for executing the trust reposed in him.

In Testimony Whereof, I have hereunto set my hand and seal this third day of the eighth month in the year of Our Lord, One thousand eight hundred and forty-nine.[7]

With a trembling hand he signed his name, penning the familiar butterfly flourish beneath it.

Two weeks later he was painting in his shop in an effort to finish his last "Peaceable Kingdom." This one was to be Elizabeth's. The news that he was failing fast had spread among his friends. John Watson dropped in from Burlington to see him, but found his "much esteemed friend very feeble in body, though lively, and in a sweet disposition of mind."[8] Lest he tire him he did not stay long, but as Watson rose to depart, the old painter "kept hold" of his hand and murmured:

I am thankful for this visit, it has done me good— I am very feeble, but don't see the issue. I know I am liable to drop off suddenly and before long, but it is possible a change may take place, and I may yet live some years. There is a blessed Saviour— that I have believed in and loved from early life. He has heard my prayers, He has blessed me, and

6 Recorder's Office, Doylestown Court House, Pa.

7 Recorder's Office, Doylestown, Pa.
8 E. R. Barnsley Coll., Newtown, Pa.

113

I now am favoured with a clear evidence that if I continue steadfast unto the end he will love and bless me forever.

Benjamin Ferris traveled up from Wilmington. When Samuel Walton of Harford County, son of Edward's friend James, who long ago helped convince him of Quaker truth, came, Edward said to him: "I feel like a man who has had a task given to him to perform in the morning, and who has got it all finished a little before sundown, and is now taking a little rest from the labors of the day."[9] To another caller he confided: "My impression is that I shall go suddenly, without much pain or suffering, and with very little warning to my family."[10]

On Wednesday, August 22, though he was feeling quite unequal to the effort, Edward again went to work on Elizabeth's "Kingdom." In the landscape of this moving picture is a lovely child so like a miniature of his Phebe Ann that one wonders whether he worked from the gold locket which contains her picture. All of the human and animal figures are this time brought down into the immediate foreground, in a kind of final, tender procession, with the promising sky and landscape dominating the creatures, the whole effect creating complete and subtle harmony between them and nature.

His painting was interrupted by the arrival of a letter. He paused to read it. Henry Hicks, concerned for the publications, had written that he was arriving the following Saturday to talk them over. Edward, putting the letter down, quietly told the family that he was grateful for Henry's solicitude but that all of his lifework was done—his writings included. He assured them that he no longer felt anxiety for anything, but only peace and love for all about him. Then he startled them with the clairvoyant announcement that although Henry would not arrive soon enough to see him, he would be there in time to attend the funeral service.[11]

[9] Memoirs.
[10] Memoirs. See also Notes.
[11, 12] Memoirs.

That evening at supper he said that he believed he had paid his last visit to the shop. Isaac, he added, could put the finishing touches to the "Kingdom" on his easel. They tried to treat this shattering valedictory as a passing mood, but he repeated that he was very soon to die. His place on the facing bench was left vacant in case he should turn up that night once more for midweek meeting. But his strength would no longer carry him from his back door over the winding, well-worn footpath to join his friends a final time for worship.

The next day's forecast in the Agricultural Almanac—and surely a worn copy must have hung in the Hicks kitchen as in all rural Pennsylvania homes—showed the sun entering the sign of Virgo, rising "fiery and dry" after five in the morning. It would set after half-past six that evening. The moon would rise at ten, and at half-past four disappear again before sunup.

Edward Hicks had spoken in all truth. At nine, before moonrise, August 23, 1849, that "mercy" which had spied him "when a great way off," came to meet him at the portal of his "Heaven of Heavens." He died peacefully, speaking to all who came to his bedside to see him. A little while before, he had recited calmly, with some of his old spirit:

Oh 'tis a glorious boon to die,
That favor can't be prized too high.[12]

A brief notice appeared in the county papers, without any mention of his art. One obituary reported succinctly: "In Newtown, on the 23d inst., Edward Hicks, aged about 70 years. The deceased was an eminent member and minister of the Society of Friends."[13] The other was no more informative: "In Newtown Borough, on Thursday Eve last, Edward Hicks, aged about 70 years, for many years a highly esteemed and popular Preacher of the Society of Friends."[14] The appraisal of his estate the following October lent no little pathos to his will, with its

[13, 14] Bucks County Hist. Soc.

illusion of more assets than he actually possessed.[15] His personal property, including unfinished paintings in his shop—reckoned as worth but $67 in all—was assigned the niggardly valuation of $422, excluding his house and twelve acres.

Were it not for a letter lately resurrected, no fuller apostrophe could be written to his passing. A member of the family of Edward's scrivener, Oliver Hough, received a letter after the funeral meeting. Hough's descendants preserved its brief but illuminating message:[16]

Edward Hicks's funeral was the largest ever known in Bucks County. It was estimated that there were three to four thousand people attended, not more than one fourth of whom could get in the Meeting House. We had communications from Mary Lippincott, Joseph Foulke, John Hunt, John D. Wright, Eliza Newport and Daniel Comly, all of them excellent, and expressive of their great unity with Edward's service in the ministry of the gospel during his life.

One voice spoke out from the throng that had foregathered in final tribute: "Know ye not that there is a prince, and a great man fallen this day in Israel?"[17] Already Edward rested in a freshly filled grave by the gate of the burial acres.

The Friends who had gathered together filled the meetinghouse. The crowd overflowed to the veranda and across the spacious grounds. There came the moment when Elizabeth's soft voice was heard within, in supplication.[18] The fear

15 Notes.
16 Hist. Soc. Pa.: Hough Coll.: 880.
17, 18 Notes.

that her father may have lost standing among the Hicksites was intensified by the rapt attention of the listeners seated on the benches.

Weeks later, troubled and distraught, Elizabeth wrote to Benjamin Ferris for consolation. That ancient Friend eloquently reassured her:[19]

. . . That thy dear father was on the right foundation, and a true disciple of Jesus Christ is not to be doubted. If thou has observed anything to cause thee to suppose "he did not meet with the full unity of the body," I would rather conclude that it was in appearance only. I have lived long enough to discover that among Friends who dearly love each other, a difference of sentiment on subjects of a speculative nature may exist where the unity of the body remains perfect and entire. The *Oneness* in the Christian relationship does not depend on Oneness of opinion, even on *important* subjects. It depends upon our Oneness with the Spiritual Head. . . .

The truth appears to be that thy father, seeing clearly into the nature of the Gospel, was willing to submit to its simplicity both in doctrine *and practice* further than many members of Society were prepared to follow him. Now if this is true, it neither proves him to be in error nor the Society to be wrong. All may be following in the same way to the Kingdom, but be in different degrees of advancement on the Road. . . .

Edward, could he have comforted Elizabeth, might have repeated that prophecy of his refuge, one transmitted by him, untold times, to canvas: "The wolf also shall dwell with the lamb. . . . The weaned child shall put its hand on the cockatrice's den. Nothing shall hurt or destroy in all my holy mountain. . . ."

19 Hicks Coll.

Notes

Chapter I

1. After the painter's death two eighteenth-century letters, not dated but apparently written late in 1771 or the winter of 1772 by Catherine Hicks to her husband Isaac, were found among his effects, now in the Hicks Collection in Newtown. They are tied with faded brown string, and bear this note in his handwriting: "I wish these letters of my dear Mother to be preserved." They appear to have been carried on his person and read and re-read. On the back of one is a pencil sketch of oak leaves and acorns, identical with the design painted on a wood frame for an oil on canvas, "Washington Crossing the Delaware," one of at least four versions, not counting those on tavern signs. The first letter follows:

I can't say with truth that I have had one moment's ease since you left me . . . I would rather live in Low Circumstances with you, my Life, than in the greatest affluence with any man. I long to come home. My brother William says we are welcome to his hospitality till we can provide for ourselves. I am surprised at your father's taking no notice of our difficulties, but Brother says he can't believe your father knows of them—that if he *does*, he can never forgive him. But it was I who opposed your father, rather than the other way about, when it comes to that. The first night my brother came he would not see me here. Then the next day I saw him and the tears were in his eyes, and he told me that though he looked on me as a child, and had willed me a child's portion at his death, I had now forfeited that right. He could no longer look on me in the light he had, and said that if anyone else had served him the way you have he could not forgive him. But he said he knows the goodness of your Heart and your Love for me, and can, for this, forgive us sooner. He would never see me want, he told me. Believe me, I am never afraid of that! But when all this trouble is made up, once more, I shall be the Happiest Woman in the world. My paper puts me in mind it is time to conclude, with assuring you, my dear Isaac, I am and ever will be—affectionately, C. Hicks.

This letter, written a short time later, shows Catherine's brother as near his death, with no real reconciliation between them:

Believe me, my dear Isaac, nothing could have given me greater pleasure than your letter. I had begun to feel very Gloomy about you. I exist only in your Dear Company. I never knew till now how Essential you were to my Happiness. You, my Soul, know how well I love you, but, much as my Loss is, I thought I could be happy a few days without you. But I find I am mistaken. I long to see you and lie in your Dear Arms. I miss you much in the Day but a Vast Deal more at Night—I can't sleep at all! You tell me you propose coming tomorrow Night. I think you had better not, as I shall not let you go without me. And my friends are unwilling to part with me so soon. Come Saturday, and on Sunday we will set off. My Brother is as Ill as he can be. God knows if he ever will get the better of it. Four doctors attend him. They think it is a gathering in his side, but for my part I believe they don't know what it is. What pain he suffers!—and he can have no one moment's ease unless under the force of an anodyne. Every time I see him I suffer a vast deal. I've a vast deal more to say to you, but my pen is so very Bad that I don't believe you will be able to understand half this . . . I long to see you, to assure you, my dear Life, that I am your affectionate C. Hicks.

2. In the Register of Wills, City Hall, Phila., is that of William Hicks (who died in the spring of 1772) with John Dickinson (a notable), Philemon Dickinson of N. J., and Gilbert Hicks as executors. An extremely interesting document in the period sense, indicating close friendship with Richard Penn, descendant of William Penn, it contains the following passage: "As I have ever treated my sister as one of my children, I would in this last solemn act of my life consider her as such, and I hereby recommend her to my executors, desiring that in the distribution of my little property they will regard her as one of my family, till she may by some means obtain such a settlement in life as may secure her from want and distress." The codicil of

October 8, 1771 reads: ". . . I do altogether revoke . . . every Clause . . . which relates to my Sister Catherine."

CHAPTER IV

1. Ballad on the drowning of Eliza Violetta Hicks Kennedy, the painter's sister:

"LINES"

"Written on the death of Violetta Kennedy (late consort of *Thomas G. Kennedy*, Esq. Sheriff of Bucks County) who was drowned on the 28th of July, 1817, in the stream that runs through Newtown, while endeavoring to rescue her little son, who had fallen into the water from a board, on which he was amusing himself.

"Oh! Newtown, wrapt in sorrow's shade,
Renounce your grandeur and parade,
And mourn for Violetta's fall—
That blooming flow'r torn from your wall:

"Cut off when her meridian sun
Had scarce its western race begun;
And now ennrapt in death's dark shade,
She in the silent tomb is laid.

"A mother fond, a virtuous wife,
Her mind serene, and free from strife;
A pattern of domestic peace—
She too must die, her labors cease.

"Her fond attempts her son to save,
Did plunge her in a watery grave:
'And launch'd from life's ambiguous shore,
Ingulf'd in death t'appear no more.'

"Where this sad tale of earth is told,
There stand appall'd, ye young and old;
And the sad scene in tears deplore,
Since Violetta is no more.

"Ye virgin throng, in vestal pride,
Come lay your costly robes aside,
In weed of woe lament her fate,
Her sudden death and transient date.

"Her dear companion left to mourn,
His greatest treasure from him torn,
His hopes of earthly joy are fled,
Since she is numbered with the dead.

"He views the solitary room,
Which only points him to her tomb,
To contemplate her dear remains
That lie involv'd in death's cold chains:

"There to remain till time shall cease,
When death his pris'ner shall release,
The grave her body will refine,
That she in brightest robes may shine.

"Then cease to grieve—Oh! mourn no more,
Your Violetta's gone before,
To join the blissful throng above,
And dwell in everlasting love,

"Her sudden death, her early fall,
Let this a warning be to all:
Oh! for the solemn hour prepare,
For death to us is ever near!

"Our fleeting lives soon pass away,
Nor will our short-liv'd minutes stay;
We soon must pass the vale of death,
And in his arms resign our breath.

"Then let us all prepare to go.
To realms where endless blessings flow—
Though bleak misfortune clouds our sky
Perpetual pleasures dwell on high!"

Printed for the Author by Simeon Siegfried. (Both Siegfried and Samuel Johnson, the bard who probably wrote these "Lines," lived in Newtown and were friends of Edward Hicks.)

2. Letter from Susan Hicks, Edward's daughter, to Eliza Hicks of Catawissa, daughter of Edward's brother Dr. Gilbert Hicks. In the Hicks collection:

Newtown 1st 19th 1818.
My dear Cousin
. . . I expect thou hast heard of the decease of our dear Aunt Violetta. It was a verry sorrowful conclusion indeed. She was drownd in Newtown Creek as she was rescuing her little son from a like fate; it happened at the time when father was some distance from home but becoming verry uneasy and hurring home as fast as he could, but being detained about an houre, or he would have been here on time for the funeral. We are all well except Sister Mary who has had two teeth extracted, and her jaw is likely to gather. Father and mother wish to be remembered to you all, particularly thy father and mother. I wish thee to write to me if any suittible oppertunity should offer. I conclude with my love to you all.

I remain thy Cousin Susan Hicks.

CHAPTER V

1. The theatre curtain of Robert Owen's short-lived socialist colony in New Harmony, Indiana, painted by the famous French zoölogist and nat-

uralist, Charles Alexandre Le Sueur (1778-1846), showed the Falls of Niagara and a rattlesnake as typically American features. The drop was painted in 1828. Le Sueur's earlier water color sketch of the Falls bears no resemblance either to Vanderlyn's or Hicks's works. Neither did the drop, or curtain, which featured lightning, a rainbow, and double columns with the snake between them. The colony stirred up so much national interest that Hicks undoubtedly heard and read about it. Maclure, Le Sueur, Say and other Philadelphians were such leaders that the Pennsylvania papers would have had to take note. But the rattlesnake was becoming a firmly established American symbol due to its keen interest for foreign scientists. Audubon delivered an address on its tree-climbing habits which made the snake a center of controversy, printed and oral, both in London and Philadelphia. His friend John Bachman wrote a defense of Audubon in 1835, published by the *Bucks County Intelligencer,* which Hicks is almost certain to have read. What year Hicks painted the Falls, and what he used for his animal models, remain a mystery. But Vanderlyn seems to have been his basic aide, after the Falls and the Wilson poem as inspiration.

2. "The Old Testament . . . Illustrated with engravings . . . from the designs of Richard Westall, Esq., R. A. . . . Published by Daniel D. Smith, 190 Greenwich Street, New-York, 1826." (Also 1824 and earlier.) Frontispiece by Westall: "The Peaceable Kingdom"; engraved by O. Pelton; it is the design which Hicks copied and which appeared in numerous American Bibles and the Book of Common Prayer. It was also engraved by "P. Maverick, Durand & Co.," "Tanner, Vallance, Kearny & Co.," and others.

Kimber & Sharpless, Quaker book publishers and booksellers of Philadelphia, included the Westall design, which they "acquired from Tanner, Vallance, Kearny & Co.," in numerous "Stereotype" editions of the 1820's. The American Bible Society of New York has editions from 1824 to 1830. Kimber and Sharpless were in business several years prior to 1824. Thomas Kimber was publishing as early as 1816.

Dr. Arthur E. Bye and Dr. Julius S. Held share the belief that Hicks may have seen engravings of the "Paradise" pictures of Roelandt Savery (1576-1639). That he saw pirated and altered versions of such oils in prints seems somewhat likelier. Bibles helped themselves to Renaissance designs of

all kinds. A "Creation" scene illustrated on page 148 suggests the type of source material which must surely have helped Hicks evolve his own more elaborate "Kingdoms."

The Hicks Collection in Newtown includes an invitation to Edward and his wife to visit a traveling "Menagerie." He may well have seen wild animals on such occasions.

Virgil Barker suggests in his "American Painting" (1950) that Hicks may have been influenced in his "Kingdoms" by an Englishman, Charles Catton, who settled in America in 1801 and died in Albany in 1819. But this writer agrees with Dr. Held that the picture of "Noah" by Catton has little bearing on the question.

Bewick's woodcuts of quadrupeds do not suggest any derivation by Hicks. However, two by Anderson[1], which are illustrated on page 154, found among the scrapbooks of the Print Room of the New York Public Library may well be Hicks's models—the bear especially. Hicks had simply to change the lion's expression from fierce to benign.

Pennsylvania almanacs contribute no likely sources. We have seen, however, that Bibles, prints in books and on neighbors' walls, and perhaps popular books on animal husbandry and natural wonders which were so much in vogue, gave Hicks his ideas for working out the "Kingdoms," "Noah's Ark," "Penn's Grave," and so on. Those prints doubtless belong to the stream of European pictorial tradition.

Some "Kingdoms" are distinctly inferior to others. Often the superior charm of one over another will be the artist's choice of animal models from oil to oil, in numerous combinations of more or less stock figures which he shuffled and repeated endlessly. The composition of some is far more effectively integrated than that of others. The cruder they are the more collage-like is the effect. Were it possible to compare all the oils or all the photographs of them, one could determine how many stock figures of each species Hicks employed, particularly the lions and leopards. Even so, many are familiar to those who know the artist's work. The children in the landscape vary likewise, the most notable difference among them being in the degree of ugliness and charm of their small countenances, and in the degree of primitive technique in their presentation. Hicks could paint a captivating face, almost cor-

[1] He pirated his own designs freely, from European sources.

rectly, beside one with the linear crudity of a mask. Witness the pretty child leading the cat in the St. Etienne Gallery canvas, one of his last and very similar to his last. The head of the woman, probably "Justice" (judging from his poetry), looming from behind the group of Quakers in a Carle Collection "Kingdom," is skilfully painted if gauged by primitive standards.

CHAPTER VI

1. The following memorandum was apparently kept by Hicks for reference in pricing his carriage business services. Now in the Bucks County Historical Society, it sheds light, even though it is undated, on an industry vital to the subject of this biography; his addition was faulty:

MEMORANDUM BILL

2 sets of mounting for Harness	$13.75
4 sides of harness and of bridle leather	21.62½
2 saddle trees and tickin for pad	2.00
3 moldings and sheep skins for pad	1.50
Bill for making harness, etc.	15.00
Bill for making braces	2.00
Black varnish for Harness	.50
	$56.87½

VALUE OF THE THINGS MADE

2 sets of Harness worth	$50.00
3 sets of 1 brace worth	13.00
1 pr. of check & 1 of gig lines	3.00
Pole straps & breast straps	2.75
2 sets of reins for bridles	0.50
4 check braces	1.00
mending old harness & braces	2.25
	$72.50

PRIME COST OF NEW GIG

Iron work	$26.00
Wheels & carriage Body	13.00
Still springs, Harness & leather	16.00
Axle tree, boxing wheels & fitting	6.00
Putting on molding & turning axle tree	1.18¾
Wooden springs & bows	3.00
Blue cloth & trimmings	15.37
Hide for top	8.50
Carpet, black varnish & stump joints	2.18¾
Coped (?) Bassed (?) plated (almost illeg.)	2.75
Plating dash, handles joints & moldings	9.50
Plating bolts, heads	1.00
Plated nobs	.50
Leather for rockers	.75
Trimer's bill	7.00

Collar	1.50
Three feet more molding	.25
Prime cost of harness, braces & checks	19.27½
	$136.61½

2. From the Hicks Collection:

1823. Erwinna, Pa.

Dear Brother:

. . . Please inform Samuel Hicks that I wish Augustin to go to sea with a view of becoming a master of the art of navigation, pursuing it as a business (and not merely for an idle voyage) . . . But I am so entirely ignorant of mercantile as well as maritime customs and usages that I know not what proposals are either necessary or proper for me to make . . .

I have been advised to place him in a store, or, to speak more fashionably, in a mercantile house. This plan, however, has passed my mind in review before, and received its negative reaction . . . I have not money to place capital in his hands to commence business on; and, if I had, am I certain it might not prove his ruin? He must either solicit a salary clerkship or form some petty partnership where every dirty art of sycophantic flattery, praising goods beyond their merits, in short of lying, deception, frauds, over-reaching and meanness, must be resorted to in place of capital, to gain at best but a precarious subsistence; perhaps in a year or two, after a vain shew of business and bustle, prove insolvent, wrong honest creditors, lose reputation and, what is worse, have trafficked away all honourable and manly feelings into the bargain . . . I have no doubt your observation may have furnished you at least *some* instances in support of this view . . .

I have been informed that the custom in Philadelphia is to place the lad who is intended for the sea as an apprentice to the merchant or ship-owner and not to the captain. Whether it is so in New York I know not, but from the high regard I feel for the Hickses of N. Y. (perhaps derived in no small degree from my very great admiration of Elias as an upright man and a Christian), I would feel a preference to placing him under the general care of Samuel Hicks, with a wish that he might send him out in such of his vessels and under such masters as he should believe best calculated to promote his welfare and accomplish his thorough instruction in the science of navigation, as well as where his services might be the most useful. . . . Please communicate with Samuel Hicks on the subject. . . .

On April 15, 1823, Samuel Hicks's engaging reply to Edward's inquiry about Augustin Kennedy's prospects was received. It is also in the Hicks Coll.:

New York, 4 mo. 15, 1823.

My dear Cousin . . . I have been reflecting about

thy nephew's going to sea and have several good ships and first rate masters, but whether they would wish to take an apprentice I cannot say, but I have no doubt there are good masters who would take him. I am hourly expecting a first rate ship in, and the master is a proper person to take him, having been brought up a Friend. And he never allows any swearing on board his ship. She will remain in port about 3 to 4 weeks after her arrival and will probably go to France and Russia and return here next autumn. If he should determine to go to sea, and will let me know, I will advise thee when my ship, the 'Baltic,' arrives and expects to sail . . . Enclosed I hand a picture of an English ship handled by my Henry (Hicks), which is not such as he liked but it is the best he could procure . . . Samuel Hicks.

3. A letter in the Friends Historical Library of Swarthmore College:

Newtown, 9 mo. 24th, 1823.

Dear Elias:

I this evening sent my little Isaac to the post office to see if thee has any letter for me. . . . It is really a cause of rejoicing to hear from thee, and encouraging to find thou hast me in remembrance and think my poor scrawls worth reading. I do most cordially unite with thy views and observations, and am encouraged to find that as I advance in religious experience that I can more and more see eye to eye with thee, and am renewedly convinced that all outward preaching (whoever may be the instruments) will eventually do more harm than good. And those Friends that hold up the efficacy of the outward sacrifice of Jesus Christ and the outward knowledge of the scriptures are certainly very little ahead of those hirelings that are pleading for the sabbath Baptism and other superannuated rituals of the law of Moses. Thy description of thyself under the figure of a miller is very interesting and instructive, and should I speak of myself in a similar way I should make the comparison to some idle shuckling miller, whose mill was on a poor little stream that was the greater part of the year dry. . . . To do business [he] must take advantage of showers, and sometimes, when they come, there is such a slough of muddy water with briers and weeds . . . as to stop the water's course. . . . At other times the idle miller strides so far away from the mill that, notwithstanding a cleaner shower, by the time he gets back to the mill, the water is nearly run off. Although he can grind a little grist he has no water to bolt it. . . . Such a miller must be poor and discouraged. . . .

Farewell, sayeth thy sure Friend,

Edw. Hicks.

CHAPTER X

1. Isaac, Edward Hicks's son, asked that this miniature of himself in his youth by Thomas Hicks—

supposedly painted for the lady whom he had wished to marry but somehow lost—be placed in his coffin. His daughter, Sarah Worstall Hicks, who saved rather than destroyed family treasures (see dedication), could not bring herself to comply with this request. It remains in the family collection in Newtown.

2. The Bi-Centennial Report included these Hicks paintings: "A picture painted by Edward Hicks for Samuel Hart"; " 'Penn's Treaty' by Edward Hicks, owned by J. P. Hutchinson"; "Painting, 'The Grave of William Penn,' at Jordans England, owned by S. C. Paxson"; "Portrait of George Washington: 'Washington Crossing the Delaware,' painted by Edward Hicks"; "Oil painting, 'The Peaceable Kingdom,' by Edward Hicks"; "Portrait of Edward H. Kennedy, one of Edward Hicks's first paintings, owned by Mrs. Blaker"; "An Indian summer view of the farm stock of James C. Cornell, of Northampton, Bucks County."

The Bi-Centennial was an important event, with Executive, Finance, Concert, and Banquet Committees, as well as Literary Exercises. The exhibits featured about a hundred treasures: old textiles, books, documents, silver, costume, furniture, and pictures owned by citizens of Bucks County.

3. Edward Stabler, a prominent member of Fairfax Monthly Meeting, was the proprietor of a popular apothecary shop in Alexandria, serving such notables as Martha Washington. The portrait, which is unsigned, is now owned by a descendant in Alexandria. It is obviously by a trained artist and possesses dignity and beauty, and is up to the standards of Hicks, who copied prints after such painters as Sully, West and Trumbull. Yet "Bownian," as the name appears in a legible hand, is unlisted in such biographical dictionaries as Dunlap and Fielding. From a letter to Edward from Richard Price of Philadelphia, dated "12 mo. 3rd day. 1836":

Edward H. Stabler has sent to me, by request of his brother William, a Box containing a Portrait of their Father, to be sent to thee. As I know of no safe means of sending it, I wish thee would request some careful person coming to the City, to call at our Store, No. 133 High Street for it. Please give him a few lines to me.

William Stabler in his letter to me says: "I have requested my relative Thos. P. Stabler to send to thy care, via Baltimore, a Portrait of my Father, for Edward Hicks, who wishes to have the use of it for a while. Wilt thou be kind enough to take care of it, when it gets to

hand, and let Edward Hicks know of its arrival. This portrait was taken by Bownian, an artist who resided some time in Alexandria, and drew it without having my Father to sit, or letting him know anything of it. He went to meeting sometimes for the purpose of seeing my Father there, and would often come in an purchase some trifling article at his shop, and get him into an interesting conversation in order that his countenance might assume its most pleasing expression. Considering the circumstances, I think it a tolerably good likeness, but it wants a good deal of animation to make it look much like the Original."

4. Among the Cox-Parrish-Wharton papers in the Historical Society of Pennsylvania there is a small photograph of a crude drawing, a copy of one of the three Thomas Hicks portraits of Edward. The drawing is labelled: "By Dr. Hallowell with a pen." Its origin and history are not made clear. The three by T. Hicks are identical in composition.

CHAPTER XII

1. Rachel Hunt of Darby, a leading Friend among Hicksites of her day, was the author of a book of verse: "Autumn Fruits and Flowers. . . . Effusions of a Reflecting Mind in the Decline of Life."

CHAPTER XIV

1. Bye, Arthur Edwin. Remarks in "Art in America," February 1951, based on the records of Makefield Monthly Meeting, on deposit in Newtown, Pennsylvania:

p. 31: ". . . One Sunday in meeting he [spoke] of the value of art in life . . . [and] evidently felt the rancor of long criticism of his painting of imaginative scenes, and pleaded the cause of art with the same vehemence he used so successfully in his sermons. This so surprised the meeting that many members were upset. A committee was appointed to visit him, and to condemn him for his testimony. Needless to say, Edward defended himself satisfactorily to all concerned. He was proud to write [in his memoirs] that a fellow minister of the Society had said to him, 'Edward, thee has now a source of independence within thyself. Keep to thy painting. . . .' "

CHAPTER XV

1. A letter to Benjamin Ferris from Amos Willets, in Friends Historical Library, Swarthmore, dated "New York 8th mo, 30th, 1849":

"My dear friend. . . . How soon thy apprehension of an early release of our beloved friend Edward Hicks is realized. I think it must be a great satisfaction to thee and Eli in having so recently made the visit to him. I understand he was in his shop on Fourth day, and got a letter that day from Henry Hicks, relative to some of his writings and also that he, Henry, was coming to see him on the Seventh day following. After reading the letter he expressed great satisfaction in getting it, and observed his work was now all done, and he felt great peace and love for everybody, and that Henry would not get on *in time to see him*, but he would be there to attend his funeral, which was the case, though it is probable thou hast more of the particulars than I have. I hear it was a very large funeral at which his daughter Elizabeth appeared in a short but most pathetic supplication. . . ."

2. Edward Hicks's land transactions are recorded in the Doylestown Courthouse. He was a principal in thirteen deeds listed in the Deed Books, ranging from October 14, 1804, to April 1, 1827. In "Miscell. 14, p. 235," occurs a homestead item drawn up in January 26, 1856, seven years after the painter's death, and it placed a valuation of $2,400 on his mansion and surrounding twelve acres.

The Hicks collection in Newtown has the following memorabilia: Hicks's spectacles, watch, mortar and pestle, sand-dryer, copper pot for heating glue, animal figurines, coach lamp, coach door, carriage monogram stencil for the letter "H," sandstone for shop use, apprentices' bench and a set of painted Windsor chairs, Gilbert Hicks's pre-Revolutionary mahogany high-backed chairs, Gilbert Hicks's grandfather clock, Edward's canopied bed, his bedwarming stone, his father's hour-glass for timing eggs, his medicine glass, pictures of Phebe Ann, her sister Sarah and many other relatives of the Hickses and Worstalls.

3. On April 10, 1951, the Makefield Monthly Meeting of Friends placed among their minutes:

"A Testimony of Makefield Monthly Meeting, concerning our beloved Friend, Edward Hicks, deceased." It was transcribed and published as a preface to the *Memoirs*. Besides the lines 'Know ye not that there is a prince fallen this day in Israel?', quoted in connection with his large funeral, these also were quoted in conclusion: 'Mark the perfect man, and behold the upright, for the end of man is peace.'

Bibliography

Letters, Manuscripts, Deeds, etc.

The Hicks Collection, Newtown, Pennsylvania. Includes numerous family letters; will of Gilbert Hicks; manuscript of the *Memoirs* of Edward Hicks.

Friends Historical Library, Swarthmore College, Swarthmore, Pennsylvania. Numerous letters catalogued under "Edward Hicks"; Benjamin Ferris Collection items, uncatalogued.

* * *

Historical Society of Pennsylvania, Philadelphia. Manuscript Room:

Pemberton Papers. Vol. 36, p. 53. Concerning Gilbert Hicks's unfinished business after he turned Tory.

Provincial Delegates. Vol. 5, p. 45. "Recognizance of Isaac Hicks," while he was under bond to the State of Pennsylvania, after the Revolution, for his Crown offices before the war.

Logan Collection: Dickinson Papers. Vol. 41, p. 60. A letter to John Dickinson from Isaac Hicks dated "Attleborough, Sept. 27, 1779."

Folio A. L. S. (Autograph Collection): A letter from Isaac Hicks to Thomas Ricke, "New Winsor," dated "Newtown, 15 May 1791."

Logan Collection: Dickinson Papers. Vols. 40, 41. "Estate of William Hicks." Miscellaneous letters pertaining to care of his children, etc.

Logan Collection: Dickinson Papers. Vol. 40, p. 107. Isaac Hicks's appointment as Prothonotary of Bucks after death of William Hicks in 1772.

Edward Hicks. Letters, to and from; catalogued. Acknowledgment (of inciting division) to Makefield Meeting.

* * *

Friends Meeting (Orthodox), 304 Arch Street, Philadelphia. Minutes of the "Yearly Meeting held in Philadelphia by adjournments from the 21st of the 4th to the 28th of the same inclusive— 1828." Pp. 34, 37. (Referred to by Edward Hicks in his *Memoirs*, pp. 128-29.)

Philadelphia. Registrar's Office, City Hall.

Last Will and Testament of William Hicks, dated October 8, 1771; No. 189-1765, in Box 1766-67. Date of probate: May 13, 1776. Signed and sealed Dec. 11, 1772: a codicil revoking his sister Catherine's share.

* * *

Doylestown Court House, Doylestown, Pennsylvania:

Edward Hicks. Last Will and Testament dated August 3, 1849. Will Book No. 13 (refers also to file 8723) p. 244. Probated Oct. 16, 1849.

David Twining. Last Will and Testament (died 1791) in Will Book No. 5, p. 280. Inventory: file 2349. Made Oct. 25, 1791; registered Nov. 30, 1791.

Renunciation of Edward Hicks. Renounces administration of his father's will in favor of his son Isaac W. Hicks. No. 7010. Filed Nov. 16, 1836.

* * *

Smith, Josiah B. (1809-1888). *Historical Recollections of Persons, Land, Business and Events in Newtown, and other Places in the Middle and Lower parts of Bucks County*. 4 v. 1873-1888. Doylestown, Bucks County Historical Society, 1941. (Typewritten copy of manuscript.)

* * *

Bucks County Historical Society, Doylestown. [Miscellaneous letters of Edward Hicks, Squire Isaac Hicks, William Hicks, etc. A rare Hicks shop ledger, the contents of which make their first published appearance in these pages. Ledger and bills of Squire Isaac Hicks.]

Trimble, James. [Unpublished notes, containing a brief paragraph on Edward Hicks, his appearance, ministry, etc. In Trimble Family Archives.]

Carle, Robert W. [A letter from Edward Hicks to "Luis Jones."]

Barnsley, Edward R. [Information about Edward

Hicks, author of the "Peaceable [sic] Kingdom."]
Typewritten. 1935. 13 f. Copies on file at New
York Public Library and Frick Art Reference
Library, New York City.

Selected Books and Periodicals

Barker, Virgil. *American Painting* . . . New York,
1950.

Barnsley, Edward R. *Newtown Library Under Two
Kings.* Newtown, 1938.

———. *Historic Newtown.* Newtown, 1934.

———. *Presses and Printers of Newtown before
1868.* 1934. (See also under Bucks County His-
torical Society Papers.)

———. *Bibliography of newspaper announcements
(regarding Hicks): Herald of Liberty,* June 21,
1815; *Star of Freedom,* May 21 to June 5, 1817;
Newtown Journal & Workingmen's Advocate,
May 9, 1843, April 11, 1843; *Doylestown Dem-
ocrat,* Oct. 19, 1845, Oct. 27, 1847, May 31, 1848;
Newtown Journal & Dollar Weekly, April 7,
1846; *Daily State Gazette,* June 27, 1871; *New-
town Enterprise,* July 10, 1875.

Brey, Jane Taylor. "The Peaceable Kingdom."
Germantowne Crier, a quarterly. Vol. 2, no. 4,
pp. 9-10, Dec., 1950.

Buck, William J. *History of Bucks County.* Doyles-
town, 1853.

* * *

Bucks County Historical Society. *Papers:*

Vol. I: "Edward Hicks." (A paper by Dr. Lettie
Smith, read before a meeting of the Bucks
County Historical Society in Solebury Meeting,
Nov. 18, 1884.)

Vol. I: "The Doans and Their Times." (A paper
by Henry C. Mercer, read at Doylestown,
Jan. 21, 1885.)

Vol. III: "Bogart's Inn, An Old Hostelry." (A paper
by Warren S. Ely, read at Doylestown, Oct. 1,
1901; mentions Hicks's signs.)

Vol. III: "Old New Hope. . . ." (A paper read on
Oct. 13, 1908, at Doylestown; about Hicks's
tavern and bridge signs.)

Vol. IV: "Langhorne and Vicinity, in Olden Times."
(A paper by S. C. Eastburn . . . 1917.)

Vol. VI: "Edward Hicks and His Paintings." (A
paper by H. D. Paxson, Jr., read at Newtown in
June, 1922.)

Vol. VII: "Paintings and Other Works of Art in the
Auditorium of the Bucks County Historical So-
ciety." (A paper read by B. F. Fackenthal at
Doylestown, May 4, 1935. Illustrated.)

Vol. VIII: "Snapshots of Revolutionary Newtown."
A paper by Edward R. Barnsley, read at New-
town, Oct. 22, 1938.)

Bye, Arthur Edwin. "Edward Hicks." Chapter in
Primitive Painters in America, 1750-1950 (ed. by
A. Winchester & J. Lipman). N. Y.

———. "Edward Hicks," *Art in America,* February,
1951.

———. "Edward Hicks," *The Magazine Antiques,*
June, 1936. (See its Cumulative Index for other
references to Hicks.)

Comfort, William Wistar. *Quakers in the Modern
World.* New York, 1949. (Pages 56-57 refer to
Edward Hicks and the Separation.)

Comly, John. *Journal of the Life and Labours of
John Comly, late of Byberry, Pennsylvania.* Pub-
lished by His Children. Philadelphia, 1853. (Con-
tains several references to Hicks.)

D'Arusmont, Frances Wright. *Views of Society and
Manners in America* . . . London, 1821. (Contains
description of a visit to Friends Meeting, Phila.)

Davis, W. W. H. *The History of Bucks County* . . .
Doylestown, 1876.

Day, Sherman. *Historical Recollections of the State
of Pennsylvania.* 1843.

Dickens, Charles. *American Notes.* London, 1842.
(Describes New York City; Philadelphia; and a
Temperance celebration.)

Earle, Alice Morse. *Stage Coach and Tavern Days.*
New York, 1900. (Mentions Hicks signs in Bucks
County; an important early reference.)

Eberlein, Harold . . . *The Practical Book of Ameri-
can Antiques.* Philadelphia, 1927. (Illustrates a
Hicks fireboard.)

Friend, The: (Orthodox)

Vol. 2 (1829): pp. 390-91 (article on the beliefs of
Edward Hicks).

Vol. 3 (1829): p. 6 (discussion of a discourse by
Edward Hicks).

Vol. 3 (1830): p. 156 (extracts from Bates's "Miscel-
laneous Repository" as to Edward Hicks's visit
to Mount Pleasant Meeting in Ohio).

* * *

Friends Historical Association, *Bulletin:*

Brinton, Ellen Starr. "Benjamin West's Painting of
Penn's Treaty with the Indians." Vol. 30, no. 2,
p. 136, 1941.

Bye, Arthur Edwin. "Edward Hicks." Vol. 32, no. 2,
1943.

Friends Intelligencer. "Edward Hicks, Friend and

Painter." An article by Helen S. Bell. March 15, 1947, pp. 131-32.

Futhey, J. Smith, and Cope, Gilbert. *History of Chester County . . .* Philadelphia, 1881. (Contains sketch of life of Hicks's friend Benjamin Price.)

Held, Julius S. "Edward Hicks and the Tradition." In *The Art Quarterly*, Vol. XIV, no. 2, Summer, 1951, pp. 121-36.

Hicks, Edward. *Memoirs of the Life and Religious Labors of Edward Hicks, late of Newtown, Bucks County, Pennsylvania.* Written by himself. Philadelphia, 1851. (Includes also a "Diary," "A Little Present for Friends and Friendly People . . ," "A Word of Exhortation to Young Friends . . .") (The latter two—sermons—were also published separately before the death of Hicks.)

Hicks, Edward. "Sermon by Edward Hicks, at Green Street Meeting, Philadelphia, August 19, 1827." In *The Quaker*, Vol. II, no. 4, pp. 145-207.

Hicks, Edward and Elias. "Sermons delivered by Elias Hicks and Edward Hicks; in Friends Meetings." New York, 1825. (1. Sermon by Edward Hicks in the Friends Meeting House in Rose-Street, New York, 1st day morning, the 15th of the 5th month, 1825: pp. 35-55. 2 . . . at Hester Street Meeting, New-York, 1st day afternoon, the 15th of the 5th mo., 1825: pp. 56-74.)

Hicks, Elias, "Sermon at Newtown, Bucks County, Pennsylvania, Dec. 18, 1826." In *The Quaker*, Vol. IV, pp. 161-84.

Hicks, Elias. *Journal of the Life and Religious Labours of Elias Hicks.* New York, 1832.

Hicks, Elias. *Letters . . .* New York, 1834. (Pp. 101-105, a letter "To Edward Hicks, Newtown, Pa.," dated "Jericho, 4th mo. 9th, 1822"; the original is in the Friends Historical Library, Swarthmore, Pa.) (Also contains letter to Hugh Judge, probably his last; referred to in the present text.)

Hinshaw, William Wade. *Encyclopedia of American Quaker Genealogy.* Vol. 3: Records of New York City and Long Island. Ann Arbor, Mich., 1940.

Historical and Biographical Annals of Columbia and Montour Counties, Pennsylvania . . . 2 v. Chicago, 1915. (Vol. I, pp. 648-49, refers to Edward Hicks's elder brother, Dr. Gilbert Hicks of Catawissa, Pa.)

National Anti-Slavery Standard, April 16, 1846, p. 184: "From the Baltimore Visiter." (Anecdote about Edward Hicks and the fence of his rich neighbor.)

New York Public Library. *Bulletin:* "Bibliography of Early Philadelphia Engravers . . . and Publishers . . . to 1820. . . ." Vol. 53, No. 10, p. 501, Oct. 1949. Notes on the Kimbers, Quaker booksellers and publishers; and on Kimber & Sharpless, Bible publishers.

Papers read before the Centennial of Newtown Friends' Meeting, Fourth Month 10th, 1915, and Others Not Read There But Applicable Thereto. Printed by the *Newtown Enterprise*, 1915.

Price, Frederick Newlin. *Edward Hicks.* Swarthmore College, Pa. (A pamphlet published by the Benjamin West Society, 1945.)

Roberts, Clarence V. *Early Friends Families of Upper Bucks.* Philadelphia, 1925. (Contains paragraph about Isaac W. Hicks, Edward's son, and Isaac's wife Hannah L. Penrose: p. 408 #89.)

Russell, Elbert. *The History of Quakerism.* New York, 1943.

Sewel, William. *The History of the Rise, Increase, & Progress of the Christian People called Quakers, Intermixed with Several Remarkable Occurrences . . .* Philadelphia, 1728. (An important influence on the vocal ministry of Edward Hicks.)

Trollope, Mrs. *Domestic Manners of the Americans.* London, 1932; 4th ed. (References to Quakers, Abolition, etc.)

Twining, Thomas Jefferson, comp. *The Twining Family.* Descendants of William Twining, Sr., of Eastham, Mass., where he died 1659. With notes of English, Welsh and Nova Scotia Families of the Name. Ft. Wayne, Ind., 1905 (revised ed.).

Exhibition Catalogues (Selected Bibliography)

Doylestown, Pa. *Complete Report of the Bucks County Bi-Centennial Celebration, Held at Doylestown, Pa., August 31, Sept. 1 and 2, 1882;* prepared by Henry C. Michener and published in Doylestown [1882]. (Lists seven Hicks oils shown with the Newtown exhibit entries, which included rare books, souvenirs of early settlers, furniture, antiques, and a few contemporary items.)

London. Tate Gallery. *Outline of the Development of American Painting . . .* mimeographed pages based on a lecture delivered by John Walker of the National Gallery, Washington, at the Courtauld Institute of Art in connection with an exhi-

bition: "American Paintings," held June 14 to August 2, 1946. (A Hicks oil was shown along with works by such formal American masters as Copley and West.)

Newark. *American Primitives.* An Exhibit of the Paintings of Nineteenth Century Folk Artists; November 4, 1930 to February 1, 1931. The Newark Museum, Newark, N. J., 1930.

New York. *American Folk Art, the Art of the Common Man in America, 1750-1900.* An Exhibition at the Museum of Modern Art. New York, 1932.

New York. *Edward Hicks.* First one-man exhibition of the work of Hicks. National Committee on Folk Arts of the United States. Spring, 1935.

New York. *A Century of American Landscape Painting, 1800-1900.* Whitney Museum exhibition, Jan. 19-Feb. 25, 1938.

Paris. *Trois siècles d'art aux États Unis, Exposition Organisée en Collaboration avec le Museum of Modern Art, New York.* Paris, Musées Nationaux, 1938.

Philadelphia. *Exhibition of the Paintings of Edward Hicks,* at the Atwater Kent Museum, Philadelphia, December 1946, in connection with the Friends Historical Society's annual meeting. Friends Historical Association.

Philadelphia. Pennsylvania Academy of the Fine Arts: *A Gallery of National Portraiture and Historic Scenes,* June 13, 1926-Oct. 10, 1926. Exhibition held in connection with the "Sesqui-Centennial Celebration." (No. 9: "Edward Hicks. The Grave of William Penn . . ." Loaned by Miss Cornelia Hicks of Newtown, Pa.)

Philadelphia. *Masterpieces from Philadelphia Private Collections, Part II.* Second exhibition of the Diamond Jubilee Year (1950-51) at the Philadelphia Museum of Art, with Bulletin Vol. XLV No. 225, Spring 1950, serving as catalogue. (Four Hicks oils, two of which are now in the permanent collection.)

Philadelphia. *Memorial Exhibition of Edward Hicks, Quaker Primitive Painter.* Robert Carlen Gallery, January, 1949. (No catalogue; described in the *Philadelphia Inquirer,* January 9, 1949.)

Pittsburgh. Carnegie Institute: Department of Fine Arts: *Survey of American Painting,* Oct. 24-Dec. 15, 1940.

Pittsburgh. *American Provincial Paintings, 1680-1860,* shown at Carnegie Institute from April 17 to June 1, 1941. From the collection of J. Stuart Halladay and Herrel George Thomas.

Williamsburg. An exhibition at Ludwell-Paradise House: *American Folk Art, a Collection of Painting and Sculpture Produced by Little-known and Anonymous Artists of the 18th and 19th Centuries.* Catalogue text by Edith G. Halpert. Colonial Williamsburg, 2d ed. 1947.

HICKS FAMILY CHART

Showing ancestry of Edward Hicks, his parents, and his distinguished cousins, Elias Hicks, eminent Quaker minister, and Thomas Hicks, outstanding painter:

ROBERT the Pilgrim
 (came in the "Fortune," which followed the "Mayflower" in 1622)

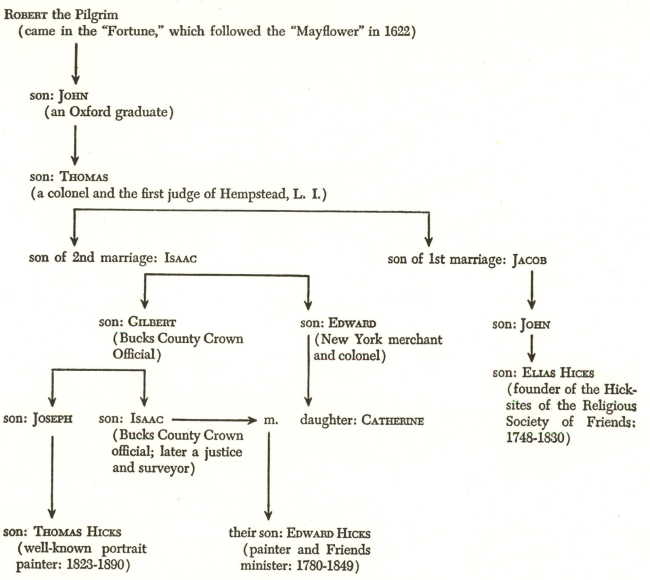

son: JOHN
 (an Oxford graduate)

son: THOMAS
(a colonel and the first judge of Hempstead, L. I.)

son of 2nd marriage: ISAAC

son of 1st marriage: JACOB

son: GILBERT
 (Bucks County Crown
 Official)

son: EDWARD
 (New York merchant
 and colonel)

son: JOHN

son: ELIAS HICKS
 (founder of the Hick-
 sites of the Religious
 Society of Friends:
 1748-1830)

son: JOSEPH

son: ISAAC ⟶ m.
 (Bucks County Crown
 official; later a justice
 and surveyor)

daughter: CATHERINE

son: THOMAS HICKS
 (well-known portrait
 painter: 1823-1890)

their son: EDWARD HICKS
 (painter and Friends
 minister: 1780-1849)

Index

Illustrations

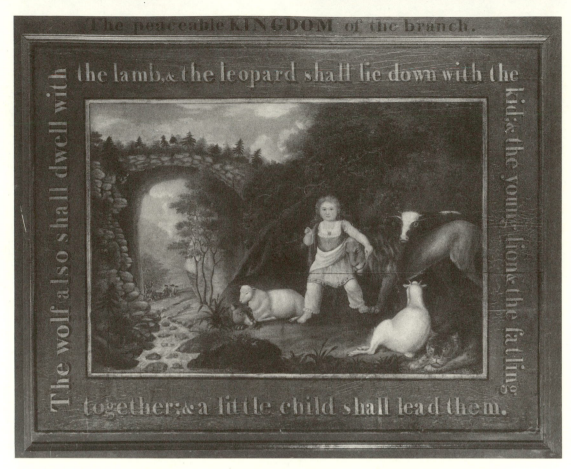

1. **THE PEACEABLE KINGDOM OF THE BRANCH.** Fireboard. 35½″ × 44″.
c. 1825–30. *Courtesy Yale University Art Gallery: Gift of Robert W. Carle, B.A. 1897*

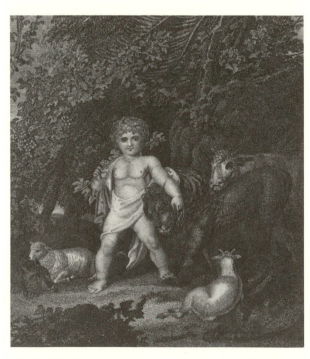

2. THE PEACEABLE KINGDOM. By Richard Westall, R.A. Engraved by P. Maverick,
Durand & Company for a *Book of Common Prayer. Photograph courtesy American Bible Society*

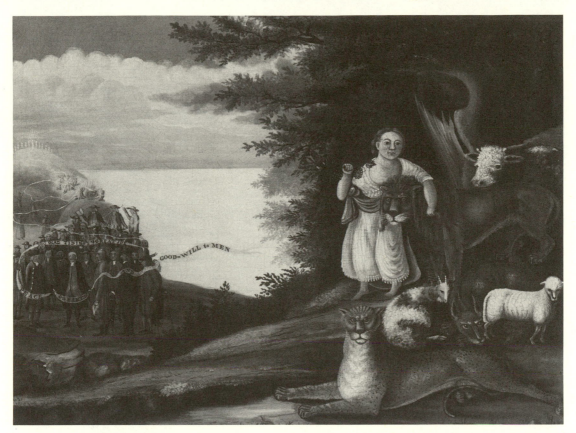

3. THE PEACEABLE KINGDOM. Oil on canvas. 17½″ × 23½″. c. 1832.
Courtesy Yale University Art Gallery: Gift of Robert W. Carle, B.A. 1897

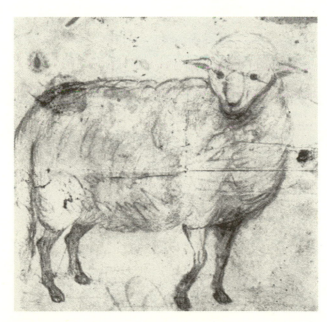

4. LAMB. Pencil on paper. c. 1832. *Courtesy Mr. and Mrs. J. Stanley Lee*

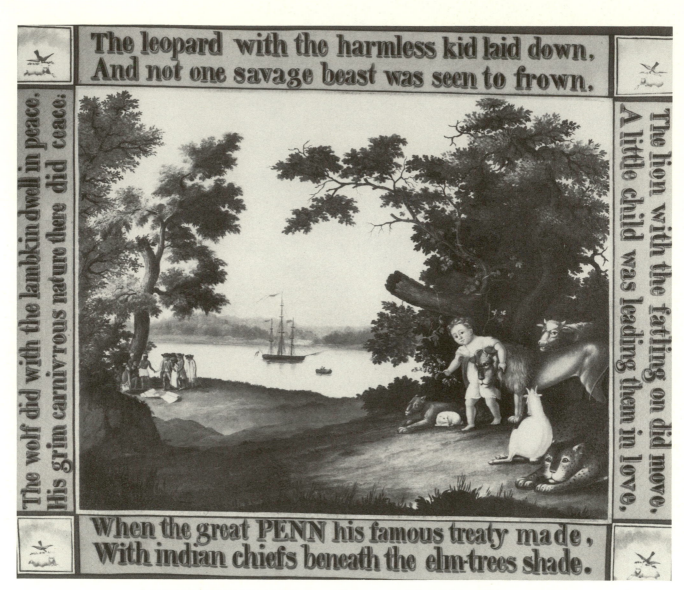

The leopard with the harmless kid laid down,
And not one savage beast was seen to frown.

The lion with the fatling on did move,
A little child was leading them in love.

When the great PENN his famous treaty made,
With indian chiefs beneath the elm-trees shade.

The wolf did with the lambkin dwell in peace.
His grim carnivrous nature there did cease:

5. THE PEACEABLE KINGDOM. Oil on canvas. 30″ × 36″. c. 1825–30.
Courtesy New York State Historical Association, Cooperstown. Photo by Richard Walker

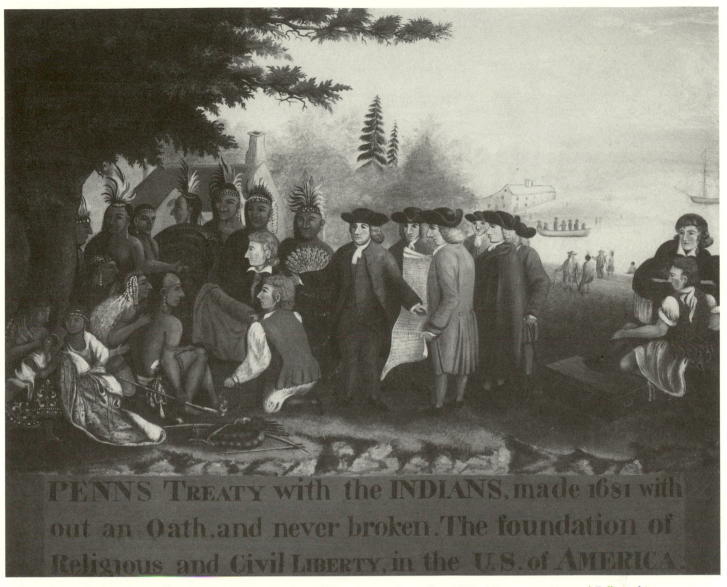

PENNS TREATY with the INDIANS, made 1681 with out an Oath, and never broken. The foundation of Religious and Civil LIBERTY, in the U.S. of AMERICA.

6. PENN'S TREATY WITH THE INDIANS. Oil on canvas. 24″ × 30″. c. 1830–40. *Courtesy National Gallery of Art, Washington, © 1997 Board of Trustees: Gift of Edgar William and Bernice Chrysler Garbisch*

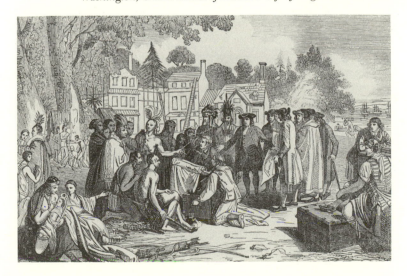

7. PENN'S TREATY WITH THE INDIANS. By Benjamin West. Engraved by H. B. Hall. *Courtesy Portrait File, Miriam and Ira D. Wallach Division of Art, Prints and Photographs, New York Public Library, Astor, Lenox and Tilden Foundations*

141

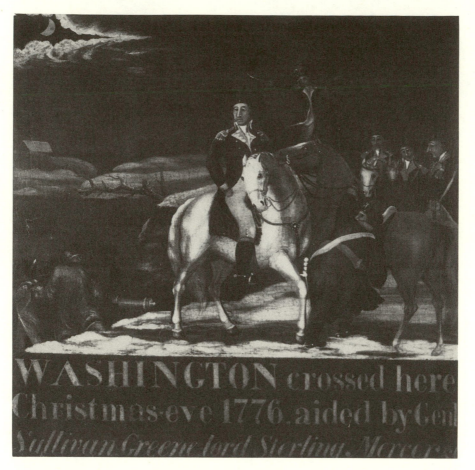

8. WASHINGTON AT THE DELAWARE. Bridge Sign. *Courtesy Collection of the Mercer Museum of the Bucks County Historical Society*

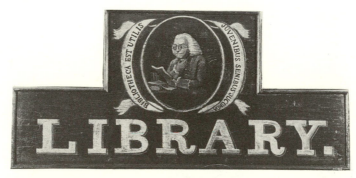

9. SIGN OF THE NEWTOWN LIBRARY COMPANY. Oil on board. 1825. *Courtesy Newtown Library Company. Photograph courtesy Frick Art Reference Library*

142

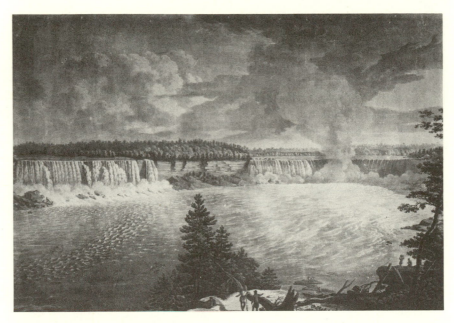

10. A DISTANT VIEW OF THE FALLS OF NIAGARA. By John Vanderlyn. Engraved by Merigot, 1804. *Courtesy Print Collection, Miriam and Ira D. Wallach Division of Art, Prints and Photographs, New York Public Library, Astor, Lenox and Tilden Foundations*

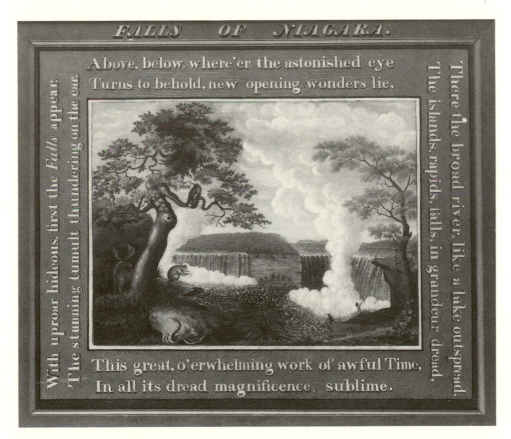

11. FALLS OF NIAGARA. Fireboard. 38″ × 44½″. n.d. *Courtesy Abby Aldrich Rockefeller Folk Art Center, Williamsburg, Virginia*

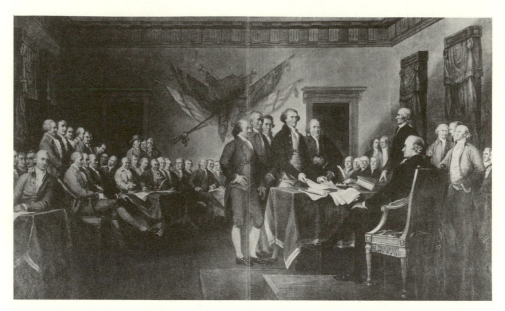

12. SIGNING THE DECLARATION OF INDEPENDENCE. By John Trumbull.
Engraved by Illman & Pilbrow. *Courtesy Emmet Collection, Miriam and Ira D. Wallach Division of Art, Prints and Photographs, New York Public Library, Astor, Lenox and Tilden Foundations*

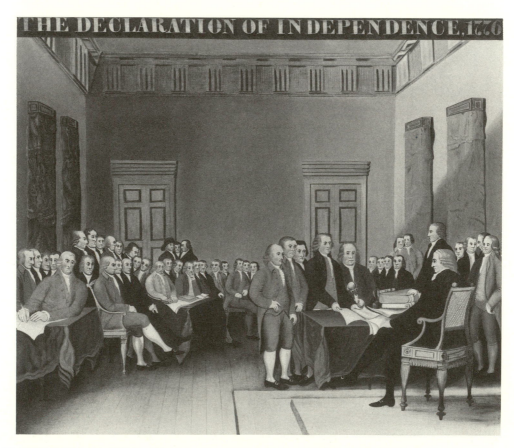

13. THE DECLARATION OF INDEPENDENCE, 1776. Oil on canvas. 26″ × 30″. n.d.
Courtesy the Chrysler Museum of Art, Norfolk, Virginia: Gift of Edgar William and Bernice Chrysler Garbisch

14. LANDING OF COLUMBUS. By John G. Chapman. Engraved by M. I. Danforth.
Courtesy Portrait File, Miriam and Ira D. Wallach Division of Art, Prints and Photographs, New York Public Library, Astor, Lenox and Tilden Foundations

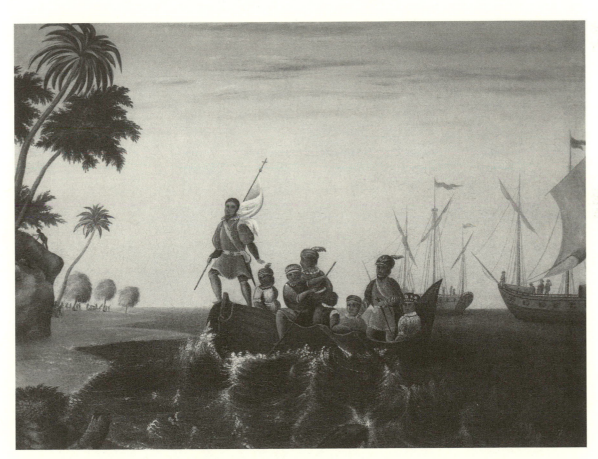

15. COLUMBUS. Oil on canvas. 17½″ × 23½″. c. 1837. *Courtesy National Gallery of Art, Washington, © 1997 Board of Trustees: Gift of Edgar William and Bernice Chrysler Garbisch.*

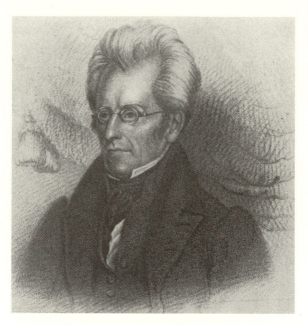

16. ANDREW JACKSON. By Ralph E. W. Earl. Engraved by T. Illman, after a drawing by Hoppner Meyer copied from the oil. *Photograph courtesy Historical Society of Pennsylvania*

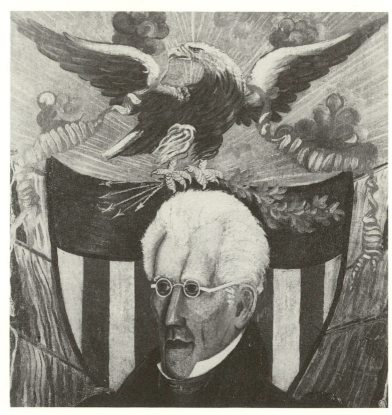

17. ANDREW JACKSON. Oil on carriage curtain cloth. 21½″ × 20″. n.d. *Courtesy Mr. and Mrs. J. Stanley Lee. Photograph courtesy Frick Art Reference Library*

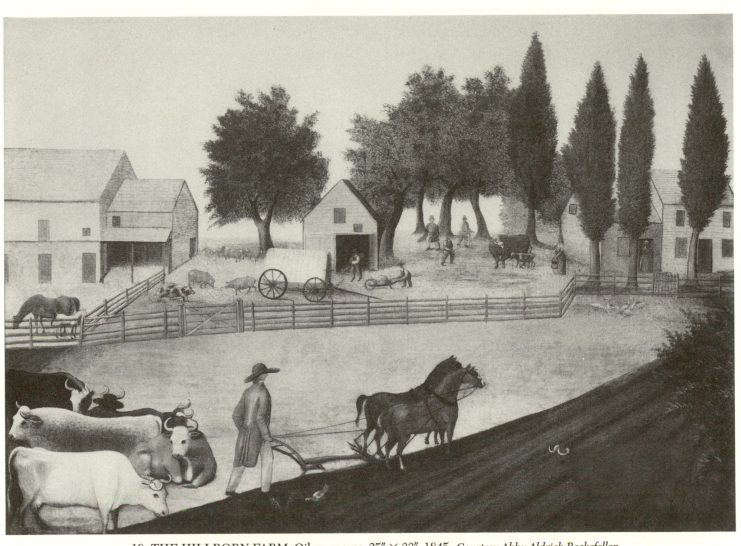

18. **THE HILLBORN FARM.** Oil on canvas. 25″ × 33″. 1845. *Courtesy Abby Aldrich Rockefeller Folk Art Center, Williamsburg, Virginia*

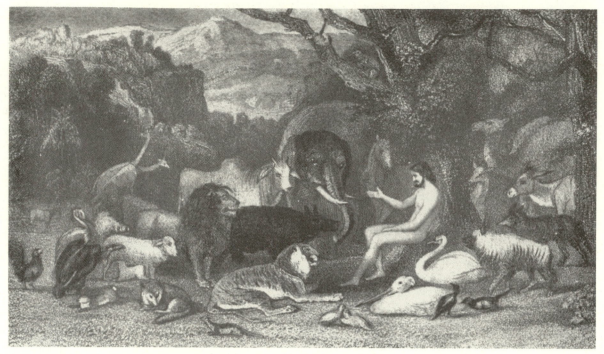

19. CREATION SCENE. Artist unknown. Engraved for an American Bible.
Courtesy American Bible Society

20. THE HAPPY STATE OF THE CHURCH UNDER THE REIGN OF
THE MESSIAH. Artist unknown. Engraved by John Scoles.
Courtesy American Bible Society

148

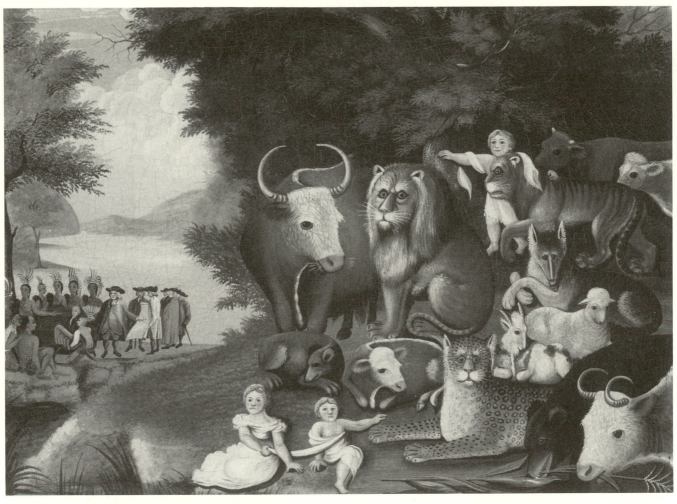

21. **THE PEACEABLE KINGDOM.** Oil on canvas. 17½″ × 23″. 1830–40. *Courtesy Worcester Art Museum, Worcester, Massachusetts, Museum purchase*

22. **HAPPINESS.** Detail. Print, after Rigaud, 1799. *Courtesy Mr. and Mrs. J. Stanley Lee*

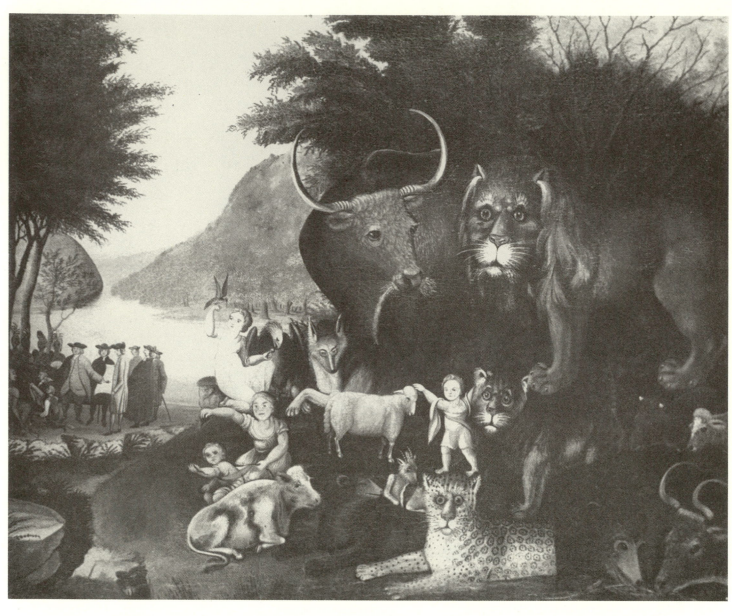

23. THE PEACEABLE KINGDOM. Oil on canvas. 29″ × 30″. 1830–40. *Courtesy Graduate School of Industrial Administration, Carnegie Mellon University. Photograph courtesy Frick Art Reference Library*

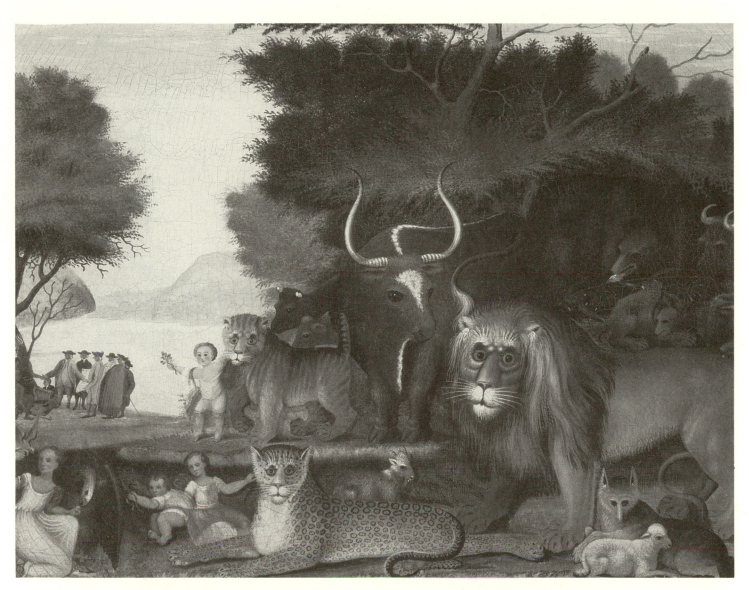

24. **THE PEACEABLE KINGDOM.** Oil on canvas. 17¾″ × 23½″. 1830–40. *Courtesy private collection. Photograph courtesy Reid White*

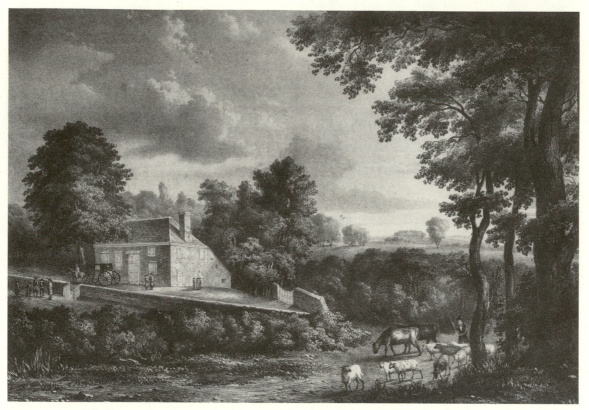

25. GRAVE OF WILLIAM PENN. By H. F. de Cort. Lithograph on stone by Paul Gauci. Printed by Graf & Soret. *Photograph courtesy Historical Society of Pennsylvania*

26. GRAVE OF WILLIAM PENN. Detail. Oil on canvas. 1847. *Courtesy National Gallery of Art, Washington, © 1997 Board of Trustees: Gift of Edgar William and Bernice Chrysler Garbisch*

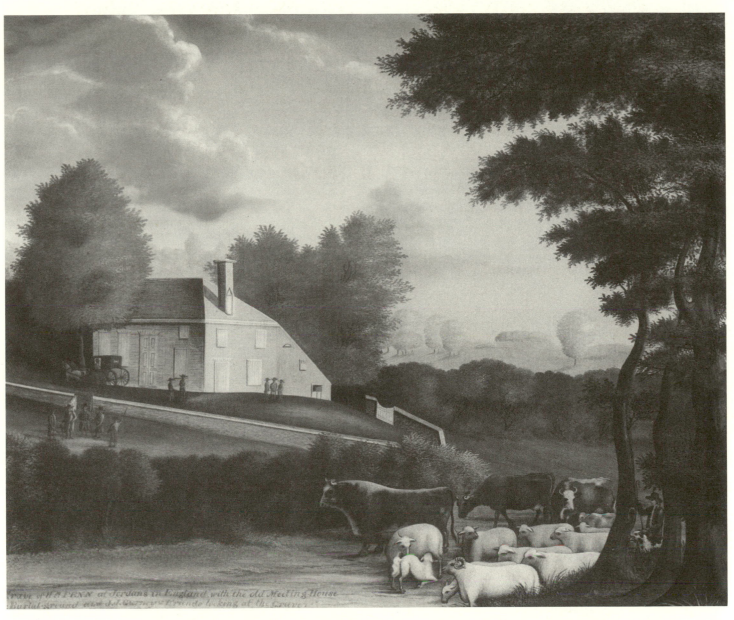

27. THE GRAVE OF WILLIAM PENN. Oil on canvas. 23½″ × 29½″. 1847. *Courtesy the Newark Museum/Art Resource, New York*

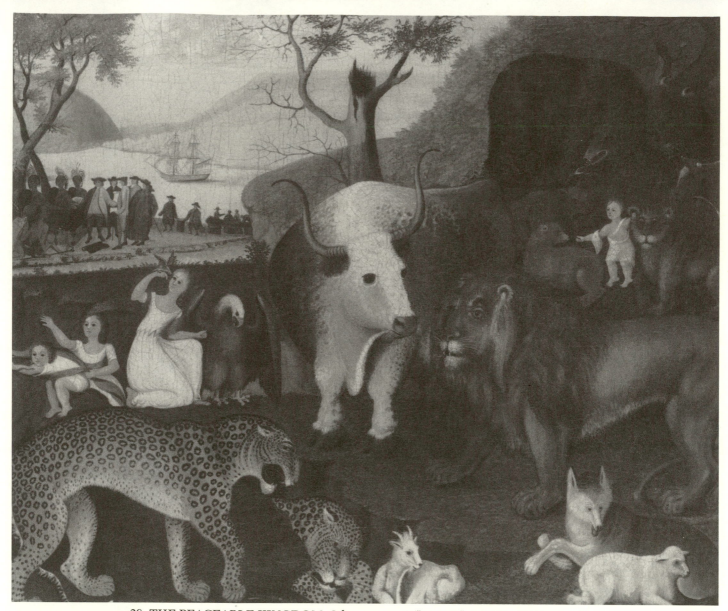

28. THE PEACEABLE KINGDOM. Oil on canvas. 25″ × 28½″. c. 1845–47. *Courtesy Fine Arts Museums of San Francisco: Gift of Mr. and Mrs. John D. Rockefeller 3rd, 1993.35.14.*

30. Woodcuts by Alexander Anderson.
Courtesy the New York Public Library: Print Collection, Miriam and Ira D. Wallach Division of Art, Prints and Photographs, Astor, Lenox and Tilden Foundations

29. Detail of engraving by Edwin & Maverick, after Raphael.
Courtesy American Bible Society

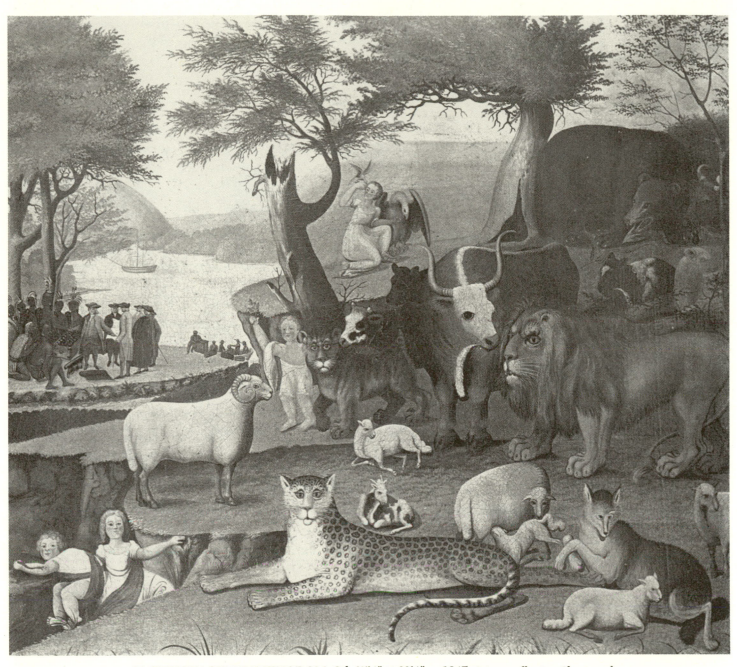

31. THE PEACEABLE KINGDOM. Oil. 25½″ × 29½″. c. 1847. *Private collection. Photograph courtesy Frick Art Reference Library*

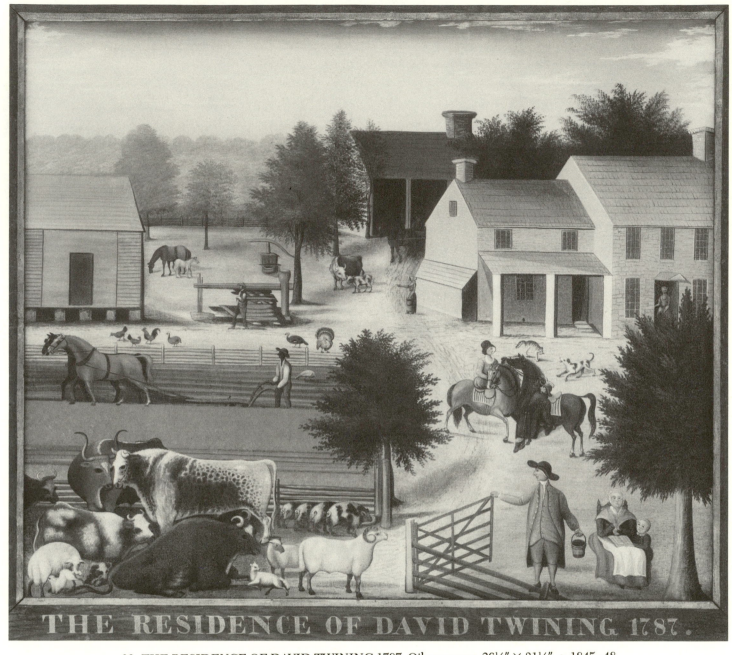

THE RESIDENCE OF DAVID TWINING. 1787.

32. THE RESIDENCE OF DAVID TWINING 1787. Oil on canvas. 26½″ × 31½″. c. 1845–48.
Courtesy Abby Aldrich Rockefeller Folk Art Center, Williamsburg, Virginia

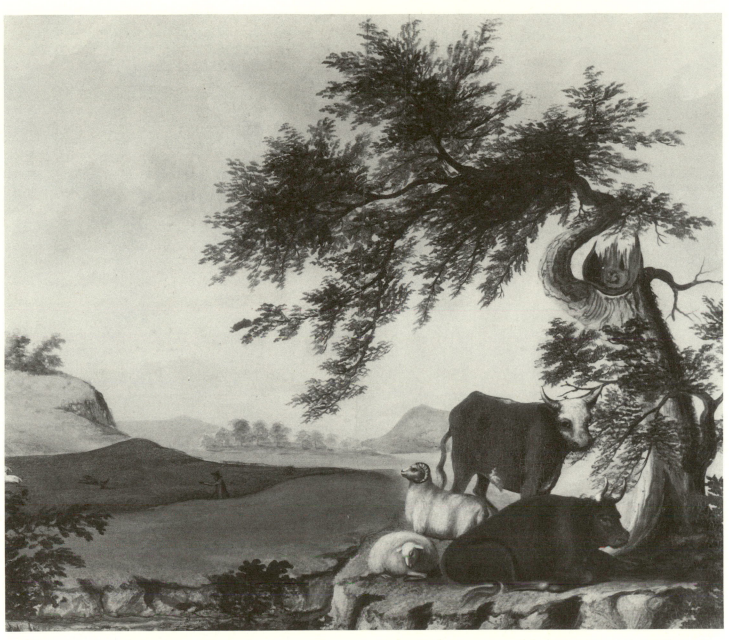

33. LANDSCAPE. Oil on canvas. 16¾″ × 20″. c. 1845–49. *Courtesy Abby Aldrich Rockefeller Folk Art Center, Williamsburg, Virginia*

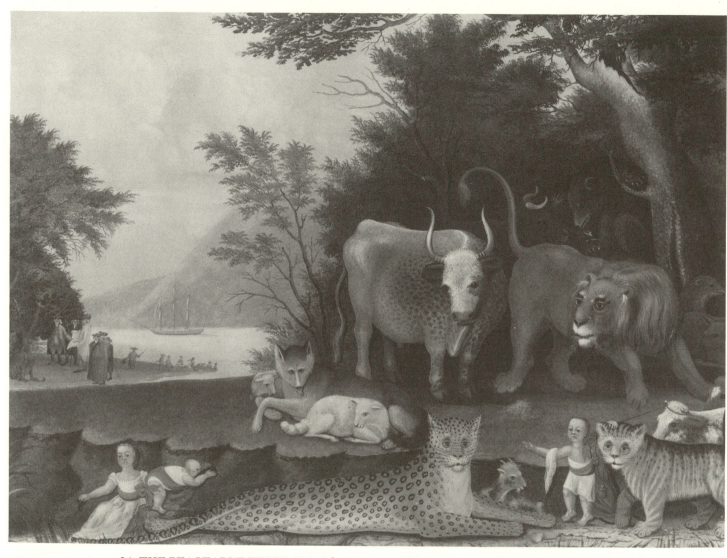

34. THE PEACEABLE KINGDOM. Oil on canvas. 24″ × 32″. c. 1848. *Courtesy Albright-Knox Art Gallery, Buffalo, New York: James G. Forsyth Fund, 1940*

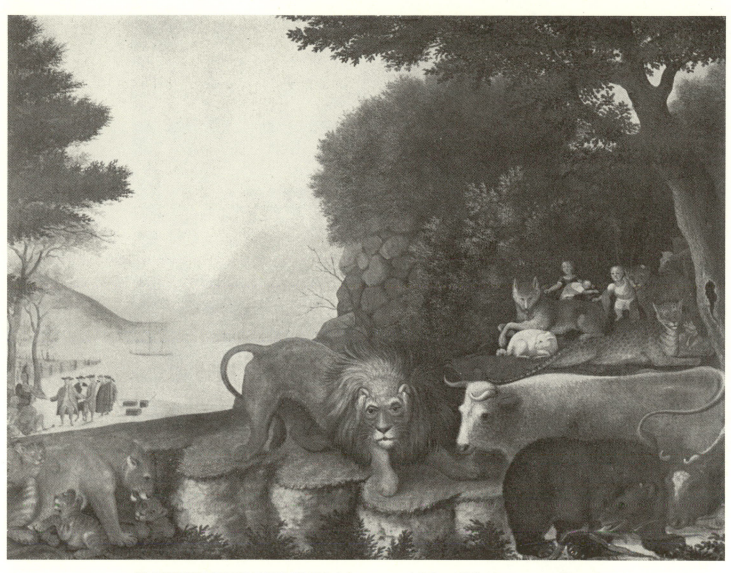

35. THE PEACEABLE KINGDOM. Oil on canvas. 24½″ × 32½″. 1848. *Courtesy Mr. and Mrs. Robert Carlen*

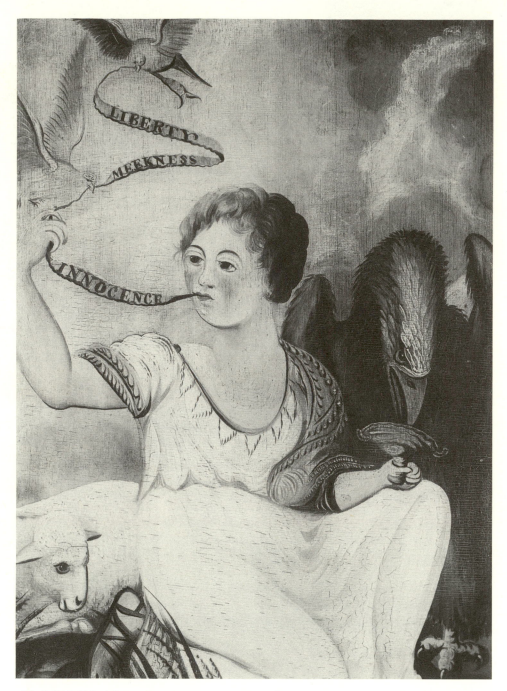

36. INNOCENCE, MEEKNESS, LIBERTY. Oil on canvas. 14″ × 9¾″. c. 1840. *Courtesy Mr. Robert W. Carle. Photograph courtesy Frick Art Reference Library*

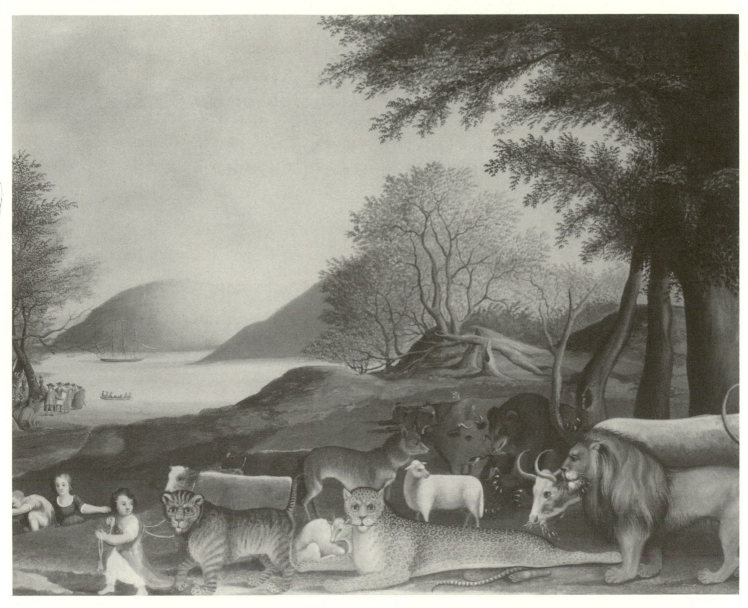

37. **THE PEACEABLE KINGDOM**. Oil on canvas. 24″ × 30¼″. c. 1849. *Courtesy Galerie St. Etienne, New York*